DRAW
ANIMALS
USING GRIDS

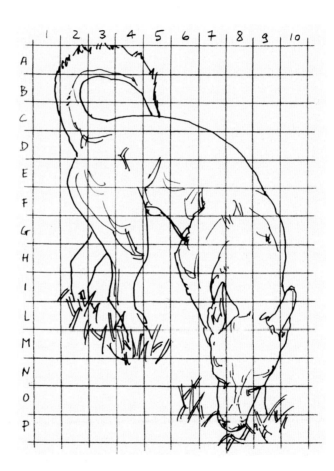

Giovanni Civardi

SEARCH PRESS

First published in Great Britain in 2021
Search Press Limited,
Wellwood, North Farm Road,
Tunbridge Wells, Kent TN2 3DR

All titles originally published in Italy by Il Castello Collane
Techniche, Milano:
Modelli per disegnare con griglia: Cani (2019)
Modelli per disegnare con griglia: Cavalli (2017)
Modelli per disegnare con griglia: Gatti (2017)

Copyright © Il Castello S.r.l., via Milano 73/75, 20010
Cornaredo (Milano) Italy

English Translation by Burravoe Translation Services
English translation copyright © Search Press Limited

ISBN: 978-1-78221-799-2
ebook ISBN: 978-1-78126-756-1

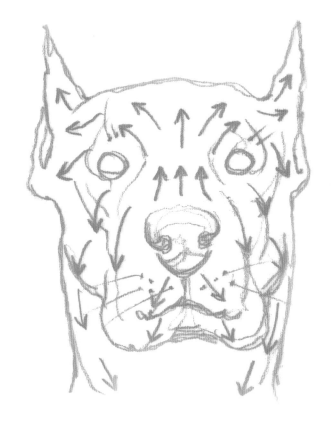

SUPPLIERS
If you have difficulty in obtaining any of the materials
and equipment mentioned in this book, then please visit
the Search Press website for details of suppliers:
www.searchpress.com

AUTHOR'S NOTE
The drawings and photographs in this book that include
a human figure are of consenting models and have
been authorized. Any similarity to other people
is purely coincidental.

In addition, I would like to thank
Mr. Emiliano Datola, the executive
manager of Bongiorni Quarter
Horses in Voghera, for making
the horses at his farm available
for me to study, draw and admire.

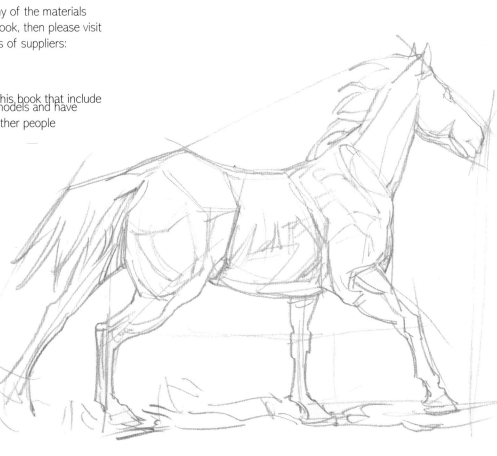

CONTENTS

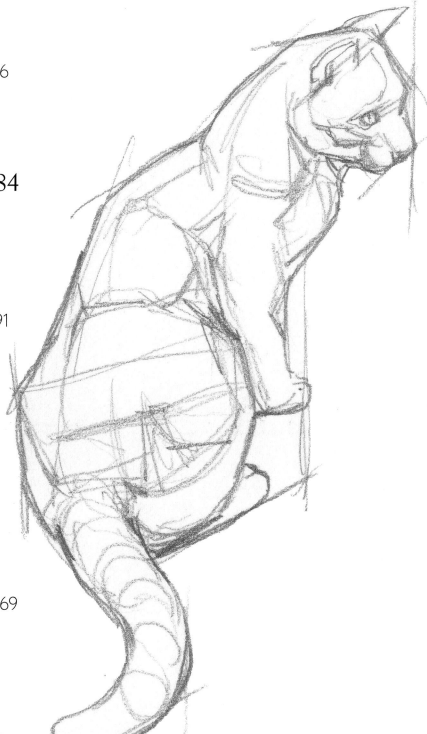

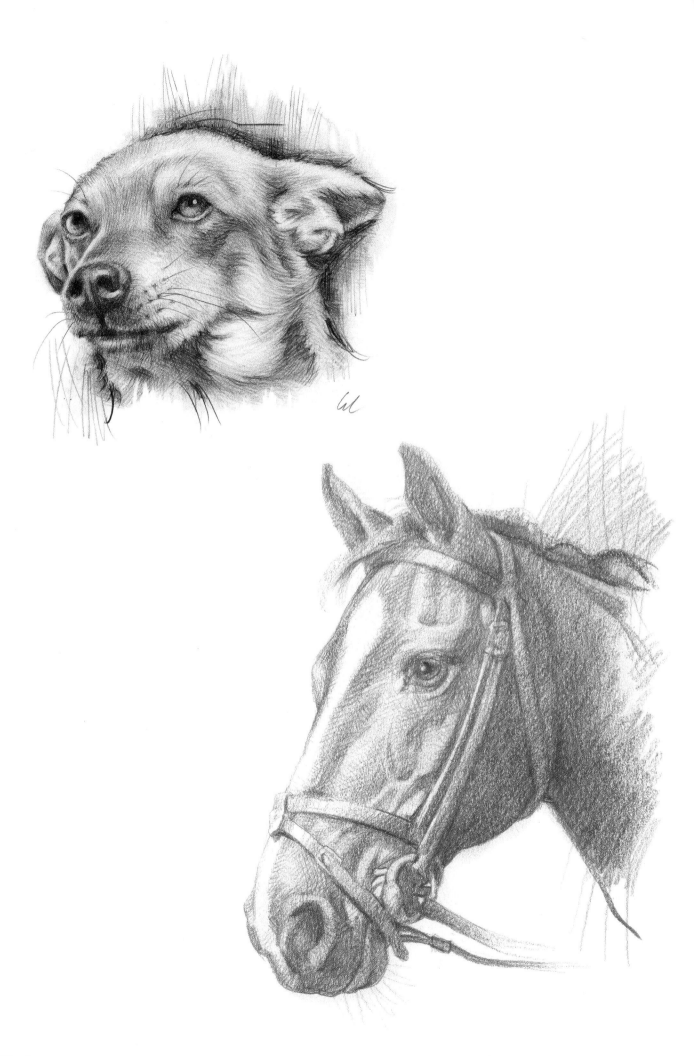

WHAT IS THE GRID METHOD?

The principle on which this book is based is an extremely old and simple one, and can be summarized best by looking to some reflections of the art historian Ernst Gombrich (1909–2001) on an artist's training (for example, in his book *Art and Illusion*).

In the Medieval and Renaissance art studios (and after that, in the academies) there was a belief that art was 'conceptual', in the sense that it was necessary first to learn, in theory and practice, how to draw the structural outline of an object – including human beings and animals – before the artist was allowed to use a living individual as a model.

Many model sketchbooks could be found in the studios too. These were collections of drawings – produced by the Masters, or reproduced from their best works – that pupils had to copy as practice to build up a useful collection of pictures for conceptualizing and executing commissions.

Many manual and mechanical procedures have been developed to exactly reproduce an image. Some allow the artist to retain the original dimensions, others to alter them proportionally in order to enlarge or reduce the resulting image. The most common procedures include photocopying; photograph printing; distance projection (with an episcope, for opaque images, or using a projector for translucent images); tracing (using tracing paper or a lightbox); and digital computer processing. These methods all aid the artist's practical and preparatory work, but they also undoubtedly slow learning and the skill of interpretation.

It is therefore better to resort to an older, simpler, more intuitive method – that of drawing a grid or mesh, which can be used for portraying complex forms from a live model and for reproducing a flat image on the same or a different scale. In both cases, it means placing a grid of squares between the artist's eye and the image he or she intends to portray. The images with which Albrecht Dürer (1471–1528) describes this procedure are well-known.

To work in a fixed position from life, a physical frame can be used: a wooden square onto which thin threads have been fixed horizontally and vertically to form a grid. The number of threads can be chosen at will to alter the number of squares. After tracing a similar grid onto your paper or other working surface, it is simple to outline the details of what you see in each corresponding square.

To reproduce a flat image such as a photograph or drawing, the grid can be drawn either directly or indirectly on the image itself or copied onto the sheet, using the principles summarized on pages 19, 93 and 171.

The grid used by artists to copy drawings is inspired by, and is similar to, the one used in Ancient Egyptian art to calculate the proportions of figures and find the position of their anatomical parts. However, in this case, the grid was used to create a drawing in an established style, or to give instructions for such an image to be drawn accurately, while today it is used to reproduce an already existing image.

Although the procedure has been applied by many artists from various eras (David, Degas, Ingres, Boldini and Klimt, amongst others), it is obvious that the use of a grid to reproduce an image is simply an almost mechanical expedient to aid the work. It must not be allowed to lower the artist's vital capacity for observation, understanding and interpretation, nor to let the direct gesture of the drawing itself 'waste away' or prevent other developments in a personal style. We can therefore say that it is not a 'method' for learning to draw, or to avoid the difficulty of assessing proportions, but is rather an aid for an artist's first steps, making him or her reflect and study the subject more closely. On the other hand, almost all modern conceptions of art shun the rigid 'academic' training of an artist and shy away from (or totally reject) traditional procedures and methods, aiming more at the pure management of a 'good skill'.

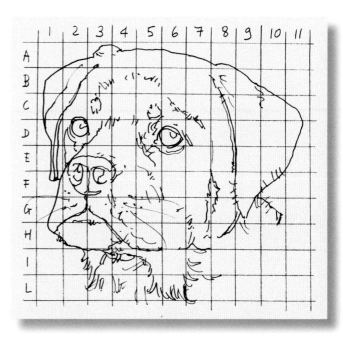

DRAWING DOGS

When you teach, you go back to being a student.
M. M.

Growth lies in the 'risk' of dialogue.

INTRODUCTION

It is almost certain that the dog was the first animal to be domesticated, and in various regions of the northern hemisphere, about 12–15,000 years ago. In its various types, species and breeds, it is, in fact, a descendent of the wild wolf and belongs to the larger family of the *Canidae*. Domesticated dogs were first used for practical purposes, working alongside humans or to help in defending flocks. Then, gradually, they were selected according to their particular characteristics and needs for more specific purposes, to use in hunting and in emergencies, to name a few, up to the now most common one – as company. So, since ancient times, the fates of dog and man have been closely intertwined.

It is difficult to find another animal like a dog, that is so loved, used and looked after by man. From remote Eastern and Western civilizations up to modern times, artistic manifestations (especially figurative but also literary) bear witness to this relationship of affectionate cooperation (which we could call 'friendship') with dogs, identifying them as the most marked symbols of loyalty and dedication to man. It is a well-known fact that the company of a dog brings man peace, distraction and comfort, but also encourages action and socializing. Unlike a cat, which tends to be an opportunist and is an equal in any group, a dog has a warmer, more affectionate character, and has a temperament that leans towards competition and hierarchy.

When drawing a dog, therefore, it is useful to observe the overall outer appearance first, then the individual details, followed by its stance, corresponding the latter to the character, mood and age of the dog. In fact, especially with posture and movements of the head and tail, a dog expresses its state of mind in a kind of 'body language'. For example, a dog tends to crouch down to get ready to play; it raises its head when on guard; it tenses when it is aggressive or defensive; or puts its tail between its legs if afraid.

The body (which varies greatly depending on the breed, gender or size, but is basically the same in structure) can be evaluated and interpreted better by making a preliminary anatomical study that helps to recognize the particular characteristics live, even if they are hidden by thick fur. Dogs, like all animals, live in both natural and man-made environments, but in many cases it is more effective to draw the dog separately from its surroundings, in order to make its shapes and stance stand out more. These are some of the considerations that the 'animal' artist should evaluate when he or she is about to draw 'man's best friend'!

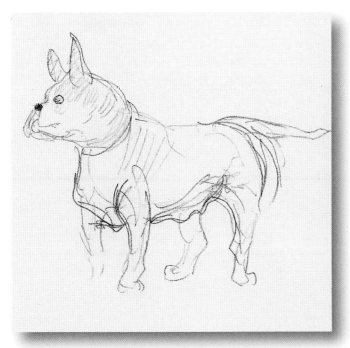

Above: study of a dog. Henri de Toulouse-Lautrec, Boulou, 1891. Graphite on paper, 21.6 x 17.7cm / 8½ x 7in (part.). Courtesy of San Diego Museum of Art.

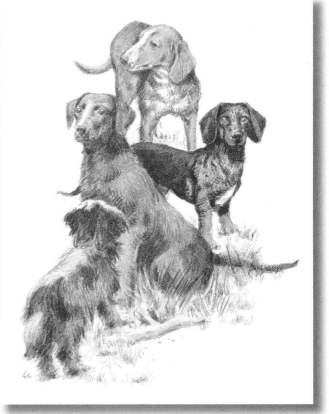

ANATOMY

A summary knowledge of animals' anatomical structures (of dogs, in this case) is even more necessary than that of human anatomy. In fact, the presence of fur in animals (which can vary in thickness and length, but is always present) tends to hide the outer body shape, which is essential for an effective artistic representation. Moreover, rapid, sudden movement that is extremely characteristic of animals prevents or reduces the occasions and possibilities of directly observing (at least for the time required to draw them) the play of muscles and joints.

The pet dog is a mammal that belongs to the *Canidae* family. It is basically a carnivore, with an anatomical structure suited to pursuing and catching prey and with acute senses (especially hearing and smell) that can perceive the surrounding environment. A dog has powerful muscles, especially in its rear limbs, which are suitable for fast running and for high or long jumps.

The anatomical structure of *canids* – from wolves (which is the original wild species) to the pet dogs that we are familiar with today – is very similar. However, natural evolution and selective breeding by man have led to some differentiations, especially in the shape of a dog's head and the length of its limbs. For example, the shape of the skull shows the effects of human influence: observe the differences between the skull in

a Pekingese dog (which is small and round) and that in a wolf (which is much longer), or the difference in limb length in breeds of dogs intended for hunting or racing. Some characteristics that have been selected for aesthetic reasons can even sometimes be the cause of physiological disadvantages: for example, a short snout can limit respiratory capacity.

A dog's overall bone structure is similar to that of other carnivorous vertebrates: schematically, the structure is made up of a wide arch (the spine) that, attached to the shoulder girdle and the pelvis, rests on two pillars (the two front limbs and the two rear limbs). The head is supported by the cervical vertebrae, by the powerful neck muscles and by a strong nuchal ligament. A large part of the body weight is carried through the front limbs, while the rear limbs, which have stronger muscles, have the function of propulsion. A dog's rib cage (comprising 13 pairs of ribs) has a flattened oval shape, which is thinner towards the attachment to the sternum and towards the neck. Some useful characteristics for correctly drawing the essential shape of a dog can be noticed in the arrangement of the bones. For example, the bones in the front limbs are attached to each other at opposite angles to those of the rear limbs, meaning that the slope of the humerus and scapula are the opposite of those of the femur and the pelvis.

BONES AND ARTICULAR COMPONENTS

The skeleton of a dog can be separated into two sections: the axial part (head, spine, rib cage) and the appendicular part (front and rear limbs), attached to each other through the shoulder girdle and the pelvic girdle. Each bone is attached by the joints that, depending on their conformation and functional characteristics, permit various breadths of movement or restriction.

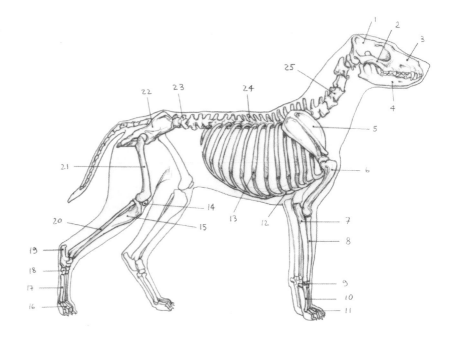

Diagram of the bone structure (in a right-hand lateral projection):

1 – cranium	11 – phalanges	21 – femur
2 – zygomaticus	12 – sternum	22 – pelvis (ileum)
3 – maxilla	13 – ribs	23 – lumbar vertebrae
4 – mandible	14 – patella	24 – dorsal vertebrae
5 – scapula	15 – tibia	25 – cervical vertebrae
6 – humerus	16 – phalanges	
7 – ulna	17 – metatarsus	
8 – radius	18 – tarsus	
9 – carpus	19 – calcaneal tuberosity	
10 – metacarpus	20 – fibula	

MUSCULAR COMPONENTS

The muscles in the locomotor system vary in shape (flat, fusiform, for example) and are voluntary muscles, each comprising a contractile centre (striated muscles) and tendons that attach to the bones. In animals, the fleshy fatty tissue – the thin, superficial, cutaneous muscle seen especially on the head, neck and back – is extensive. This acts on the skin and coat, shaking them vigorously during movement. The rapidity and power of movements that are so typical of dogs are owed to the especially strong muscles located in the lumbar dorsal region and in the rear limbs, as well as in the shoulders and neck.

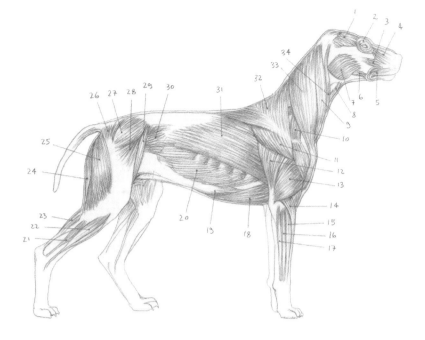

Diagram of the superficial muscle layer (after removing the cutaneous muscle), in a right-hand lateral projection:

1 – frontal
2 – orbicularis oculi
3 – caninus
4 – nasolabial levator
5 – orbicularis oris
6 – malaris
7 – masseter
8 – sternohyoid
9 – sternomastoid
10 – omotransversarius (levator scapulae)
11 – deltoid
12 – triceps brachii (lateral head)
13 – triceps brachii (long head)
14 – extensor carpi radialis
15 – extensor digitorum communis
16 – extensor digitorum lateralis
17 – extensor carpi ulnaris
18 – pectoralis profundus
19 – rectus abdominis
20 – abdominal external oblique
21 – flexor hallucis longus
22 – tibialis
23 – flexor digitorum superficialis
24 – semitendinosus
25 – biceps femoris
26 – gluteus maximus
27 – gluteus medius
28 – tensor fasciae latae
29 – sartorius
30 – abdominal internal oblique
31 – latissimus dorsi
32 – trapezium
33 – brachiocephalicus
34 – auricular-parotide

MAIN SUBCUTANEOUS BONY LANDMARKS

On the surface of various regions of the body, it is possible to see reference points (or landmarks) that are determined by skeletal sections positioned just under the skin, and are therefore visible or palpable. These 'landmarks' are extremely useful for the artist as they can be used to evaluate body proportions. These are easy to observe in many breeds of dogs; in those with thick, long fur, it is more difficult but still possible.

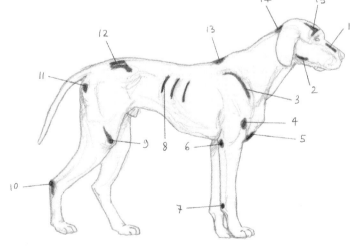

1 – nasal bone
2 – corner of the mandible
3 – cranial rim of the scapula
4 – humerus head
5 – sternum
6 – olecranon
7 – carpus
8 – ribs
9 – femur
10 – calcaneal tuberosity
11 – ischiatic tuberosity
12 – sacrum and iliac tuberosity
13 – withers (spinous processes of the first dorsal vertebrae)
14 – occipital
15 – frontal

EXTERNAL MORPHOLOGY

To identify a domestic dog and its particular breed (or whether it is a crossbreed), we must look at its main physical characteristics.

There are many dog breeds which show great morphological differences between each other and even within each breed. One common, simple classification considers the animal's function: for hunting (such as the Bracco, Pointer, Setter and Bloodhound); for herding (Collie, German Shepherd); for guarding (Newfoundland, Mastiff, Boxer, Great Dane); and as companions (Poodle, Pomeranian, Maltese). Breeds can also be divided into groups referring to their size (small, medium, large); the shape of their heads (round, long, square); their type of ears (long, short, erect); or the type of coat and their markings. These are some of the elements that should be immediately observed and captured in an artist's drawing.

Compared with the adult dog, puppies have interesting, pleasing morphological details that should be observed. For example, the head and outer ears appear to be large in comparison with the body; the eyes are big while the mouth and nose are tiny and dainty; the neck is very short; and the paws are short with large, short 'digits'.

Diagram of the main topographical regions and morphological landmarks:

1 – skull (head)
2 – stop
3 – nose
4 – snout
5 – shoulder
6 – arm
7 – elbow
8 – fleshy pad
9 – spur (residue of fifth digit)
10 – chest
11 – stomach
12 – stifle fold
13 – hock (metatarsus)
14 – knee
15 – thigh
16 – tail
17 – buttock tip
18 – back
19 – kidneys (loins)
20 – back
21 – withers
22 – neck ridge
23 – nape (occiput)

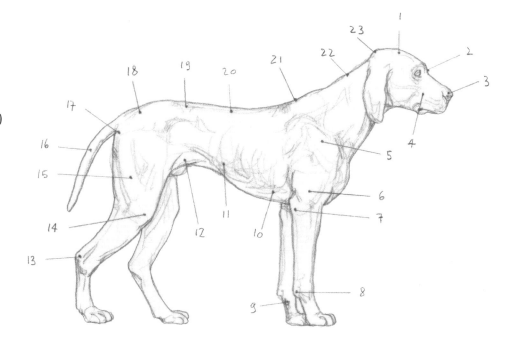

A typical dog's body, seen in a zenithal projection. The dog seems to be rather thin in relation to its length: for example, the width of the head is only slightly less than that of the shoulders and pelvis.

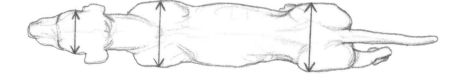

TYPICAL MORPHOLOGICAL CHARACTERISTICS

The head and types of skull

The shape of the head differs across the various breeds. Generally, there are three broad categories: rounded, long or triangular, and square. Depending on the profile, the head may be straight, concave or convex. In breeds with round heads, the snout is very short; in those with long heads, the snout is prominent; in those with square heads, the jaws are short and sometimes have varying degrees of prognathism. The forehead may be wide, less wide, high or flat. Between the forehead (skull) and the nose (snout), and at eye level, the profile has a hollow (stop) which varies in size: in this way, a 'step' is formed between the forehead and the nasal channel (the part of the snout that goes from the stop to the nose).

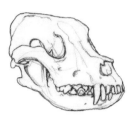

Long skull (dolichocephalic): Greyhound, German Shepherd, Great Dane, for example.

Medium skull (mesocephalic): Terrier, Labrador, Mastiff, for example.

Short skull (brachycephalic): Pekingese, Bulldog, for example.

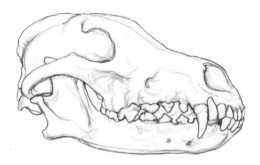

Body profiles

When drawing a dog, especially if portraying it in its surroundings alongside a human, it is wise to assess its size immediately. This is its height, measured from its head to the withers – a small area corresponding to the spinous processes of the first four to five dorsal vertebrae. It is also useful to consider the overall body profile, observing the typical form of the breed the dog belongs to but also the form of the dog being portrayed. Usually, a male dog is stockier and larger than a female dog of the same breed.

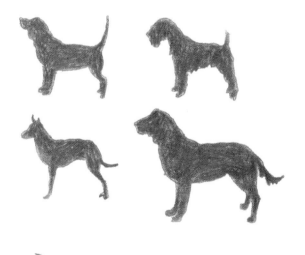

Tails

The tail is an important part for a dog: it helps it to maintain balance when running, but also it is an indicator of the dog's character and emotions – a kind of 'language'. For example, a lowered tail shows submission or fear; a raised tail shows aggressiveness or attention; and a rapid wagging movement shows a friendly nature. The size of the tail (usually no longer than half the body) varies depending on the various breeds and is a precise characteristic: it may be curly or rolled up (in companion dogs) or thick with long hair (in hunting dogs). In relation to aesthetic or functional purposes, the tail may be reduced in length by amputation during the animal's early days of life.

Coat and fur

The coat and length of the fur are characteristics that attribute a dog to a certain breed. Fur, the outermost part of the coat, is linked to the dog's breed but also seasonal conditions (mainly winter or summer). For example, dogs bred in cold regions tend to have long, thick fur whereas dogs bred in warm climates or for hunting tend to have short, smooth fur; moreover, in more changeable climates, dogs shed their winter undercoat in summer, or develop thicker, fuller coats as the months get colder. However, some breeds have hard, rough fur, owing to the characteristics of their original habitat or purpose of the breed. The colour and 'design' of the coat is also characteristic of a breed; it can be single colour and uniform, or have marks (spots or dappled) of various shapes and sizes.

When drawing a dog's coat, much attention must be paid to recognizing and complying with the underlying anatomic forms, which are often hidden by the dog's fur. It is also wise to draw in these areas so that they follow the direction of the fur's growth, but avoid tracing in too many, and making the drawing too detailed and analytical: it is enough and more effective to hint at the volume through the most important tonal 'masses'.

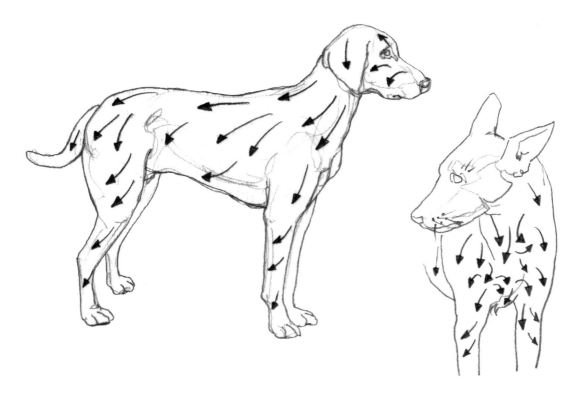

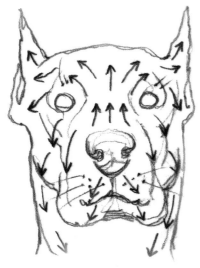

Diagrams of the direction of growth of the fur on a dog's head and body. When drawing a dog's coat, especially if the fur is short or medium in length, do not resort to drawing too much detail or analytically. Trace the structure and *chiaroscuro* (highlights and shading) lines generally, while following and hinting at the fur's natural direction of growth. Pay attention to the places where the hairs form a fringe or create whirls, also.

Eyes

Like all carnivorous predators, pet dogs have eyes facing forwards: this limits the width of the visual field, but makes the judgement of distances more precise when pursuing and attacking prey. The eyeball is spherical and is a similar size in all breeds. It juts out a little compared to the eye socket that contains it and the volume of the head. We should note that the sockets are slightly oblique, laterally, and the upper socket rim is incomplete. There are eyelids – two mobile skin folds (one upper, one lower) – that form a protective barrier for the eye and provide humidification. Usually, the upper eyelid is larger and more mobile than the lower one, and when open it forms a deep groove along the upper eye socket. There is also a third 'eyelid', the nictitating membrane, at the inner corner of the eye. This also has a protective function. We find eyelashes on the outer rim of the eyelids, which protect the eyeball from mechanical and light stimuli: they are long and thick, implanted into the upper eyelid, while they are short and sparse on the lower eyelid.

Overall, the open eye appears to be circular, slightly 'almond-shaped' and internally, below the cornea, shows only the iris and the pupil (both circular and concentric). The lacrimal caruncle is found at the inner corner of the eye, which continues in a short, pigmented groove (lacrimal groove) that heads downwards towards the nose, and is more evident from a side view of the head. From a frontal view, the distance between the medial corners of the two eyes corresponds to little more than the width of one eye and is almost the same width as that of the dog's nose. Each corner of the eye is located on a slightly different level: the inner corner, at the bridge of the nose, is slightly lower than the outer corner. There are almost always tactile hairs just above each eye.

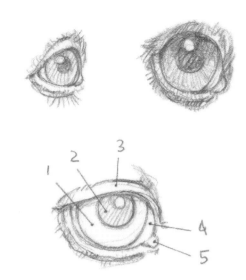

Schematic drawing of the right eye:

1 – iris (it occupies almost the entire exposed part of the ball)
2 – pupil
3 – upper eyelid and eyelashes
4 – nictitating membrane
5 – lacrimal caruncle

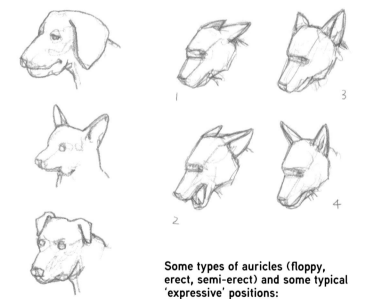

Some types of auricles (floppy, erect, semi-erect) and some typical 'expressive' positions:

1 – submission 3 – attention
2 – in defence 4 – aggression

Some examples of common dog ear shapes.

1 – Henry's Pocket, skin fold along the outer edge

Ears

In dogs, the shape of the auricle (i.e. the outer ear) differs depending on the breed that the dog belongs to. In fact, it is useful to see how many different shapes and sizes there are, and their positions, as these characteristics are important for distinguishing breeds. The outer ear is flexible and concave, with a cartilaginous structure that surrounds the auditory canal. The widest part of the cartilage provides support and shape to the visible part of the ear. It is extremely mobile, for orientation purposes to listen to sounds better, but also for expressive purposes to indicate various emotional states (fear, submission, aggressiveness, for example). The outer ear can vary in conformation, which is related not only to protecting the internal organ, but also to their auditory function: for example, erect ears (long or short) direct sounds well, while pendulous ears protect the auditory canal from foreign agents and bodies, thanks to their fleshy flap.

The outer skin of the auricles is covered with thick, long hairs, while the interior surface (which is rather rough and has a ridged texture) has shorter, sparser hairs. At the base of the ears, some coarser hairs (tragi hairs) also have a protective function. Dogs' ears (just like cats' and other carnivores' ears) have a small, pocket-shaped fold of skin on the outer edge of the ear. Subcutaneous veins can sometimes be seen in wide, pendulous ears, especially those with short hair.

Nose

A dog's nose has two nostrils that are separated internally by a cartilaginous septum. The tip of the outer nose juts out of the facial block and joins with the upper lip, forming a vertical groove on the median line (labial groove or philtrum). As in all carnivores, nostrils have a round front opening, with a sideways extension in a groove created by a fold in the mucosa.

In almost all breeds, a dog's outer nose is dark in colour (brown or black), is hairless, has a slightly uneven surface, is flattened at the front (nasal plane) and always appears wet, with a sometimes shiny reflection. The wings of the nostrils expand laterally, opening into the thin transversal slit: the overall appearance of the outer nostrils is therefore almost wedge-shaped, with the front plane slightly tilted downwards in order to be able to sniff out trails as fast as possible.

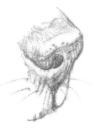

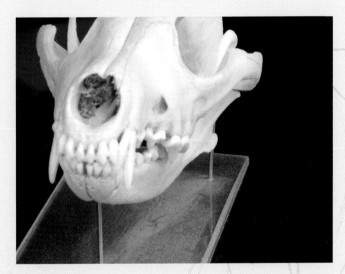

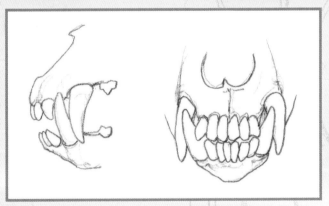

Diagrams of normal occlusion between the two dental arches.

Mouth, teeth and tongue

The dog's mouth is used for grasping, tearing and mechanically crushing food – in short, mastication and in salivation. The entrance to the mouth (the oral cavity) is bordered by the edges of the upper lip and the lower lip, which join to form the rima oris.

The lips are extremely mobile and extend to different extents: the upper lip is much more mobile than the lower lip. Both continue laterally into the dog's cheeks. The upper lip has a deep, almost hairless medial groove (philtrum), while to the side of it, the hair is much thicker: here, on three or four parallel rows, some long tactile hairs grow.

In dogs, the oral cavity has considerable differences in shape and size, depending on the breed and the corresponding conformation of the skull: for example, in dolichocephalic dogs, it is long and narrow; in brachycephalic dogs, it is short and wide. The mouth opening (from the lowering of the mandible) is especially wide in breeds with a long snout. This makes almost all the teeth visible, and also shows the tongue, to a varying extent.

All dog breeds have 42 permanent teeth arranged in the upper and lower dental arches. In the upper arch, from the medial plane, we find: three incisors, one canine, four premolars, two molars. In the lower arch: three incisors, one canine, four premolars, three molars. The occlusion (or contact) of the teeth depends on the typical shape of the skull in the different breeds. For example, with a 'pincer' occlusion, the edges of the upper and lower incisors touch; in the 'scissor' occlusion, the lower canines are usually in front of the upper canines (see middle diagram, left).

A dog's tongue is made of extremely mobile muscle tissue, which is almost permanently exposed to regulate breathing and to take on liquids and taste stimuli. The tongue is pink in colour in almost all breeds. It is long, thin and rectangular in shape, and has a rounded tip. The top has a rather clear central groove, that separates the surface into two symmetrical halves.

Paws

Dogs are digitigrade, which means they walk on the tips of the 'toes', placing their phalanges – the extreme portion of their limbs – on the ground. Dogs' limbs differ in length depending on the breed and size, but in all of them the front limbs are column-like, vertically straight and support a large part of the dog's body weight, while the rear limbs, which have more marked angles between the joints, have powerful muscles that are suited to propelling the body.

The paws (especially the front paws) have the most characteristic external shapes, which must be taken into consideration in portraits as they are common to all breeds to varying extents. A dog's front paws have five digits on each 'foot': four rest on the ground and a fifth (dewclaw) is rudimentary and short, and is located on the medial surface of the limb, slightly higher up than the other digits. It is a residual structure which can be analogous to a human thumb. Sometimes this fifth digit is absent, depending on the breed's characteristics or whether it has been surgically removed immediately after

the puppy is born. The rear paws have four digits on each foot and all rest on the ground. Each digit ends with a claw, a strong, curved, horny, pointed, non-retracting formation that emerges from the end of each digit and turns downwards to the ground without however touching it.

There is a fleshy elevation known as a carpal pad on each of the front limbs, at the base of the paw and slightly raised, which corresponds to the pisiform bone. It sometimes also exists in the rear paws, depending on the breed. There are other pads on the sole of each foot called digital pads, which are small and oval in shape and correspond to the plantar surface of each digit. They are also elastic and elevated skin formations with no hair and are often dark brown in colour. There is one large metacarpal pad on each front paw (and one metatarsal pad on each rear paw) and these are roughly triangular in shape. The pads have a mechanical function: they absorb impact and provide greater stability when the dog is resting on the ground.

Skeleton of the front right foot

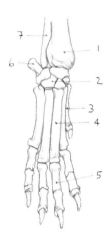

Plantar surface of the front right and rear right paws

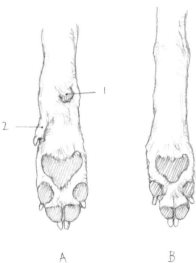

Dorsal surface of the front right (1) and rear right (2) paws

1 – radius
2 – carpal
3 – fifth digit
4 – metacarpus
5 – phalanges
6 – accessory carpal
7 – ulna

A – Metacarpal pad and digital pads on the front paw
 1 – carpal pad
 2 – dewclaw (fifth digit)
B – metatarsal and digital pads on the rear paw

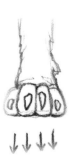

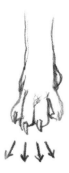

The phalanges are arranged almost parallel with each other when resting on the ground, but diverge a little (to increase the 'grip' surface) when the dog flexes its paws when running or when jumping. The tip of the claw, that is always exposed, does not touch the floor.

PROPORTIONS AND PERSPECTIVE

PROPORTIONS AND RATIO

The side profile view allows the best opportunity for measuring the height and length ratios of an animal's body. Therefore, generally, a dog's body can be easily placed in a square or a rectangle – choosing one of these geometric views based on the size and breed conformations of the dog in question. The length of the dog's head can be used as a unit for assessing the measurements of the entire body, and thus aid the artist in grasping the proportions of the various parts that make up the body. As proportions vary depending on the breed, it is necessary – more so than with other animals – to carefully study each individual dog that will be drawn, understanding the main anatomical reference points (especially as they are often hidden by the length and thickness of the dog's fur, or are changed by the effects of foreshortening or posture). The same considerations also apply to portraying solely the dog's head, although a different unit of measurement may be needed: the width of the eye or nose, for example, can be adopted as a comparative unit size. It is worth noting that, if a portrait of only the head will be made, there will be more anatomical reference points to indicate in the drawing, and the conformation and proportions of the various morphological features on the head will depend on the breed.

Some simplified diagrams of the main proportion ratios for drawing a dog's head or body in the simplest, most obvious projections, i.e. in lateral and frontal projections.

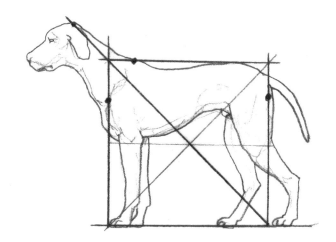
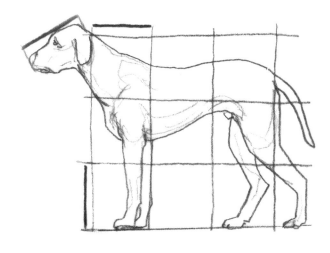
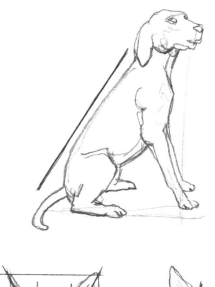
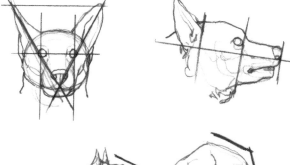
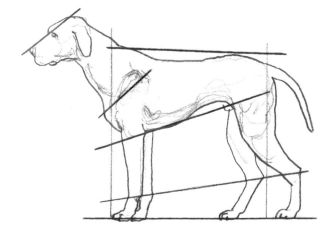

PERSPECTIVE

Like all three-dimensional objects, a dog's body is located in a space and an environment. An oblique linear perspective can be useful for placing it correctly in relation to other animal figures or with other surrounding elements, and for evaluating the foreshortening of individual body parts, and to outline the extension and direction of the projected shadows. An oblique linear perspective requires that the subject (the dog's body) is placed in relation to the horizon (which is always at the observer's eye level) and two vanishing points at varying distances on the horizon, with which the imaginary oblique lines tangential to the body converge. Sometimes, it is sufficient to use only one of the two vanishing points, entrusting a kind of simplified, intuitive perspective.

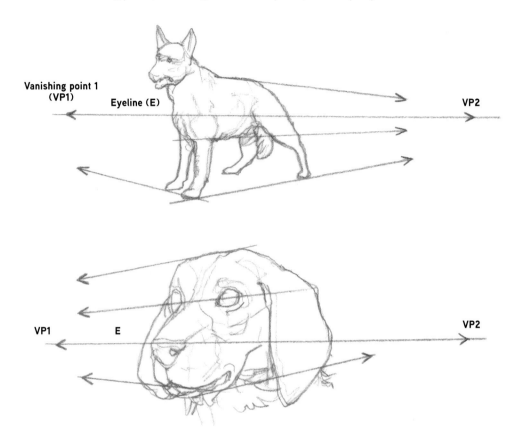

Observation method

An animal portrait drawing is largely founded on the observation and good understanding of the overall shapes and body mass – even more than when drawing the human body, where there is clear anatomical structure. For example, it may be useful first to look at the positions and perspectival directions of the various segments (axes) of the dog's body (see no.1 below), then to develop a geometrized breakdown of the main sectors (limbs, head, torso – see no.2 below), from which the volumetric and structural size of the body can progressively be deduced (see no.3 below). These preliminary lines are indispensable for progressing to the subsequent modulation of the *chiaroscuro* tones.

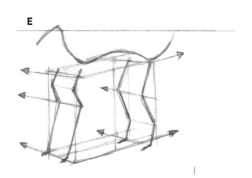

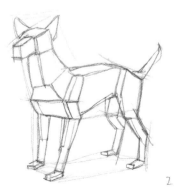

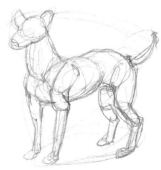

1

2

3

APPROACHES TO DRAWING

There are almost as many ways, techniques and styles of drawing as there are individual styles of writing: from objective, analytical and documentary drawings to summary and emotive drawings; and from patiently elaborated drawings to the rapid 'gestural' drawings. In fact, when drawing animals, it is important to render their vitality and agility in the portrait, adopting a technique and style that are suited to a rapid, 'free' work that can capture the expressive nature of the gesture. I would like to spend a moment on two sometimes antithetical, but more often complementary, procedures that are especially useful when drawing natural, biological forms. As the two procedures are based on the observation method (see page 17), any of the traditional graphic techniques can be used; however, some recommended drawing tools are detailed under their respective procedures.

Linear drawing

The purely linear procedure requires an analysis of the shapes, 'constructive' structures and the outline of the subject. It is a summary observation that attempts to identify the line where it actually does not exist, but separates and defines the relations between the individual body parts. 'Sharpened' tools such as graphite and pen will be preferred for linear drawing.

Tonal drawing

The purely tonal procedure, on the other hand, only tends to evaluate the body volume by resorting to the variation of *chiaroscuro* tones, the borders of each are not drawn but can be seen from contrast between the intensity of tonal values, whether more or less. Tools which offer greater texture (charcoal, brush, etc.) are ideal for tonal drawing.

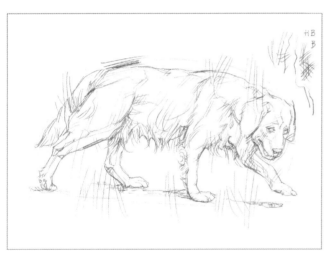

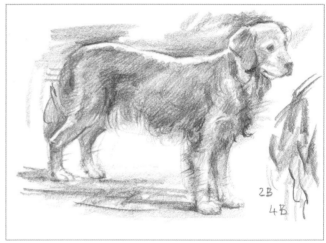

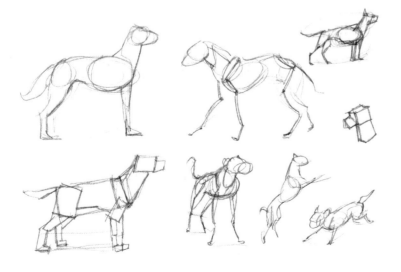

STRUCTURAL DIAGRAMS

Through practice and experience, every artist finds their own way of starting their portrait. Some begin by portraying the outer appearance of what they wish to represent. Others prefer to investigate the structural, constructive lines first of all, building a kind of 'skeleton' with shapes that helps to define the different ratios between the body parts and the entire shape of the body, or simply the 'gesture' of the movement.

The diagrams, left, are simple examples of the second approach, and are sufficient for suggesting a few ways on interpreting the shape of the dog. In several of the examples the structural relation lines between the limbs and spine can be identified, or the main articular joint points, or the slight variations in the overall shape of the head that – while on average is round – can appear to be oval or triangular in some breeds.

THE GRID METHOD

Of the many 'mechanical' procedures – which includes photocopying, projection, photographic and digital zooming – that can be used to reproduce a flat reference picture (whether drawing or photograph), that of using a grid is the simplest and oldest. While providing great precision for transferring the outlines of an image's basic structure, it also allows full freedom for the artist to develop the drawing further. The procedure is simple and intuitive, and can be summarized as described below.

Step 1 – A number of parallel lines (horizontal and vertical) are traced directly (or onto tracing paper) onto the reference image (or a photocopy) to form a grid of squares which vary in size, depending on the degree of precision with which one wishes to transfer the image.

Step 2 – Lightly drawn pencil lines are used to produce the same grid on the drawing surface (paper, canvas, etc.). Changing the distance between the lines creates larger or smaller squares.

Step 3 – The main outlines and shapes within each square on the reference image are transferred to the corresponding square on the drawing surface's grid, until the whole outline of the subject has been traced. Before working on the transferred image and applying more free-hand procedures, it is advisable to rub out the grid lines.

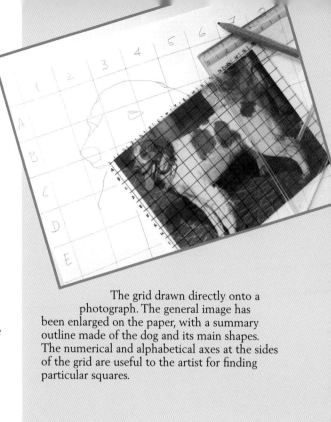

The grid drawn directly onto a photograph. The general image has been enlarged on the paper, with a summary outline made of the dog and its main shapes. The numerical and alphabetical axes at the sides of the grid are useful to the artist for finding particular squares.

PRACTICAL CONSIDERATIONS

Where to find dogs Crossbred dogs or more common breeds can easily be found in homes or roaming almost anywhere: there are many of them in the countryside (on farms) and in towns (stray sometimes, or in dogs' homes or shelters). Purebred dogs, on the other hand, are known as 'companion' pets, or home pets, and can be seen less frequently unless the artist is on good terms with an owner who owns the breed. These dogs can be found more commonly at breeders' farms or in competitions and exhibitions. Of course, there is a great abundance of photographs published in newspapers, magazines and books, or images available on the internet. In addition, footage of dogs can be found online or on the television, to use as references for movement. Generally, these are images protected by copyright, but can be consulted for reference and as sources of inspiration.

Understanding dogs The dog is a domestic animal with a marked personality. It is a sociable, outgoing animal in groups, albeit with hierarchical tendencies. It has an extremely strong sense of smell that it uses to mark territory or the environment and to recognize its 'friends'. Dogs are agile and can move rapidly and often suddenly, but they also tend to assume characteristic and repeated positions. For example, they lie down to rest in quiet, isolated places, or they spend a lot of time sleeping. These are the best moments to draw a dog. A dog has distinct attitudes and behaviours (aggressiveness, submission and protection, for example) that are linked to its breed and the individual, although generally they are friendly with humans, showing loyalty and affection (as all those who have a pet dog know only too well). The age of the dog you are intending to draw should also be taken into consideration, as age characterizes the proportions of the body and the dog's demeanour. A young dog (puppy) is lively and extremely agile, whereas an old dog prefers

peace and quiet and not to move around too much. The average life span of a dog is approximately 12–15 years, which varies according to breed and individual characteristics.

How to portray dogs A dog's movement is often sudden and unpredictable, so it is advisable to position yourself at a certain distance to avoid alarming or disturbing it. Observe the dog carefully and commit salient elements to memory before starting to draw. Naturally, the most suitable poses are static ones, but those in 'tension' also work – ones where the start or conclusion of an action is shown. It is advisable to choose (if possible) the position from which to portray the dog: in most cases, dogs are small or medium in size so are usually seen from the top, with high perspective angles and foreshortening. However, the artist can change perspective by positioning themselves at the same level as the dog, sitting on the floor or placing the dog on a table or an armchair. Using photographs as sources, especially when working from a 'live model' is almost always essential for 'fixing' an interesting or temporary rapid stance. Photographs are even more useful if preceded or accompanied by quick summary sketches, drawn with the purpose of capturing the 'nature' of the action or of the position and overall conformation of the dog. This avoids having to depend unquestioningly on the photograph and allows information to be added, correcting potential, unavoidable errors in perspective. A dog's fur, however thick and long (except in some breeds that have hardly any fur), hides the actual anatomical shapes, and so suggests the use of certain drawing tools (such as charcoal, soft graphite, watercolour and pastels) that are suited best for rendering the soft, blurred outlines. In all cases, it is generally best to consider the body and fur as an 'overall volume', and avoid extraneous detailing such as denoting the fluffiness of the fur.

HOW TO FOLLOW THE GALLERY

The drawings printed in this section (from page 20 to page 83) are intended to give ideas and elements for practice, in order to be able to observe and study the proportions and shapes of a static or moving dog. The graphic style that I have used in drawing them is somewhat 'neutral': it involves a light use of *chiaroscuro* and soft indications of some details such as the direction of fur. However, there was the desire to provide the artist with a more general drawing of the subject to use as a starting point, for him or her to then elaborate on with his or her own graphic interpretation, according to the styles and techniques believed to be the most suitable and fitting for his or her own aesthetic awareness and sensitivity. Each dog is accompanied by rapid preliminary studies, or 'steps' – these are drawings of the outlines, shapes and tones seen in the dogs, carried out in a short time with a soft lead pencil, in a much more liberal style than the one then applied to the more elaborate, contemplated drawing (see large drawing, below). These preliminary studies serve almost as 'visual notes', to aid in the making of the final, elaborate drawing.

Of the two types of drawing, on the face of it one would assume the elaborate drawing is a kind of 'emotive version' of the observation process, while the studies are a 'canonical version' – steps of the actual execution. Rather, the three steps indicate the 'stages of reflection' – the main characteristics of the dog's shape and structure analyzed through separate studies. For example, in step 1, the overall size of the dog is considered along with the space it takes up on the sheet and a suggestion of its action are indicated; in step 2 the supporting structure of the dog is focused on (mainly trying to guess what is underneath its fur), along with its general volume and the direction of its main axes; finally, in step 3, the tonal effects are introduced to suggest the volume of the dog further.

Most of the more elaborate drawings in this section of the book were drawn using graphite (HB and B) on paper (15 x 21cm / 6 x 11in). The tonal studies that accompany almost all the portraits were drawn using softer graphite (4B and 6B) sticks on larger sheets of paper (21 x 28cm / 8¼ x 11in, or US letter).

The grid suggested for each figure can be used as an initial guide to reproduce the basic outlines of the dog's body (after having also traced it on to the drawing surface at the desired size). After this summary indication of the overall dimensions, the next developmental stages involve analyzing proportions, identifying the constructive planes and establishing tonal effects. The grid can be drawn directly onto the reference image that is to be reproduced, be it a photograph or drawing. I prefer to use tracing paper and then use this to draw only the most summary body parts on it, just enough to begin the next drawing stage.

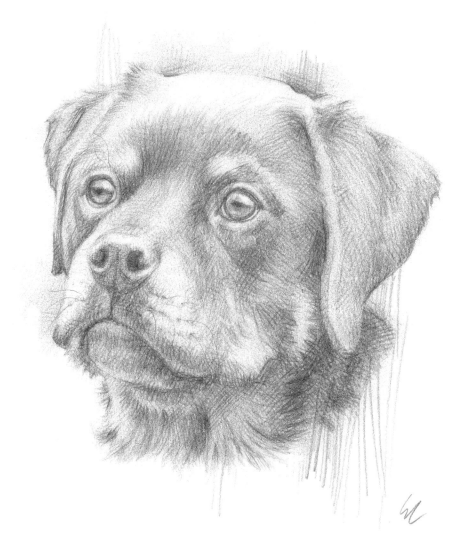

Step 1: Overall shape and size

Step 2: Structure and proportions

Step 3: Volume and shadows

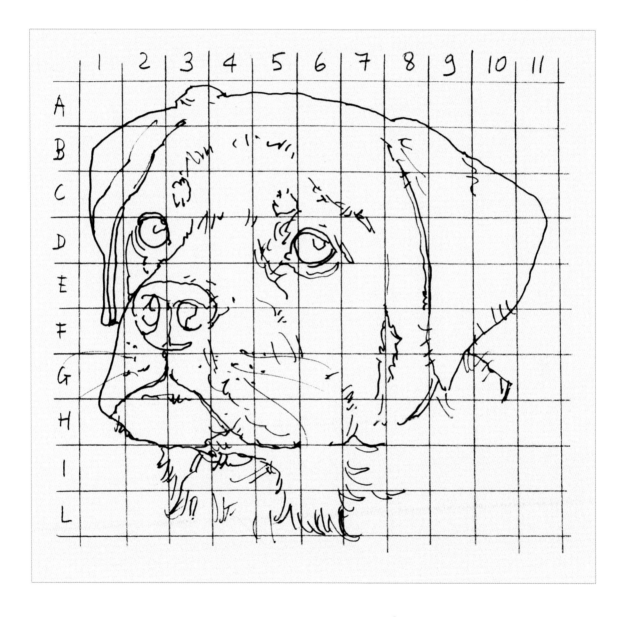

Linear study

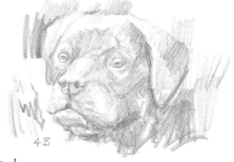

Tonal study

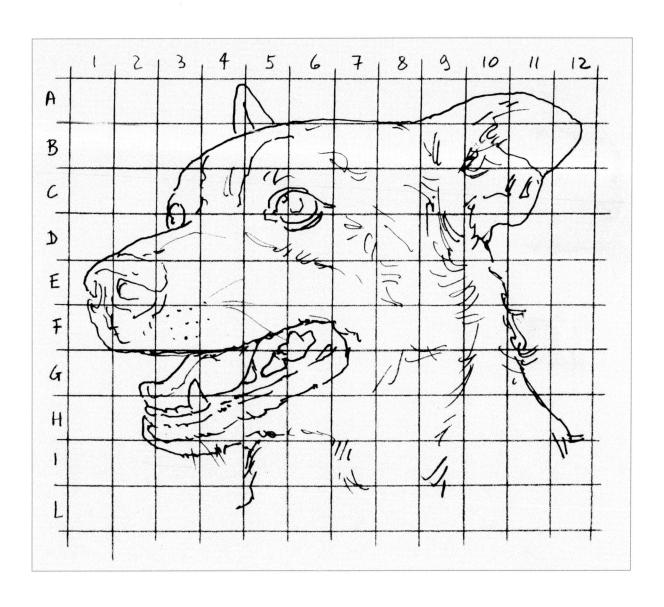

Step 1: Overall shape and size

Step 2: Structure and proportions

Step 3: Volume and shadows

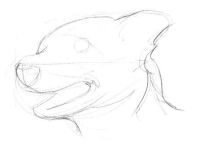

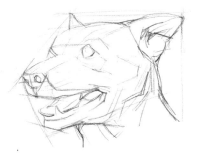

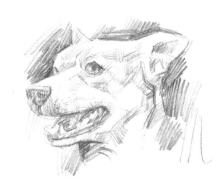

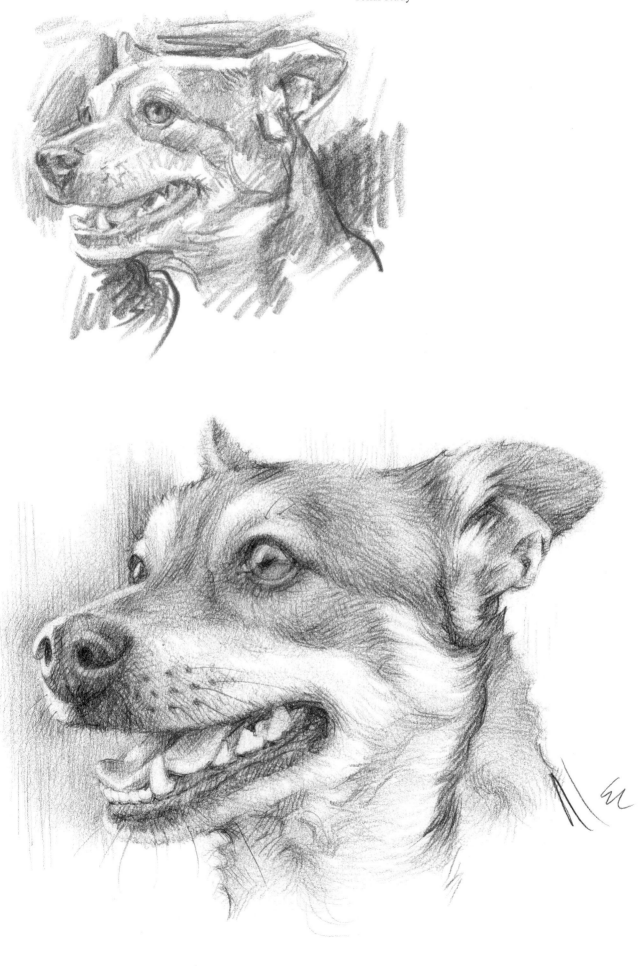

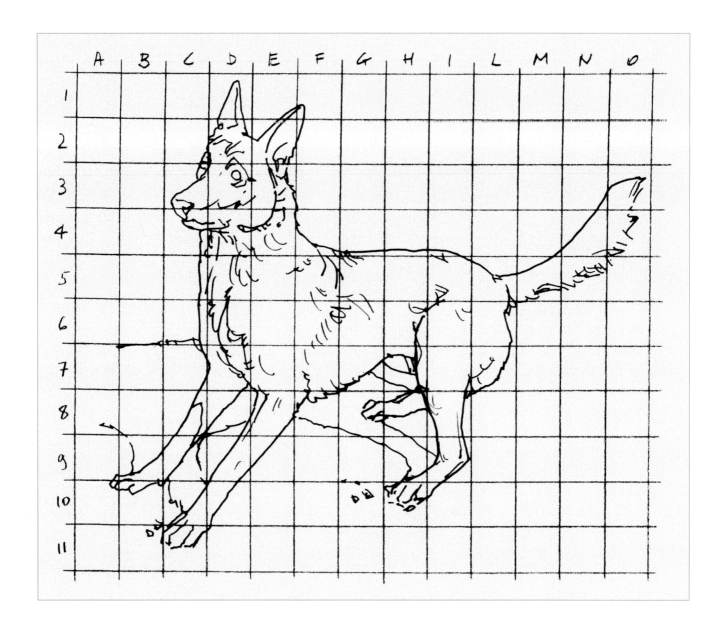

Step 1: Overall shape and size

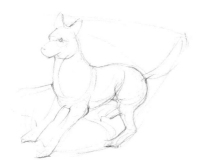

Step 2: Structure and proportions

Step 3: Volume and shadows

Tonal study

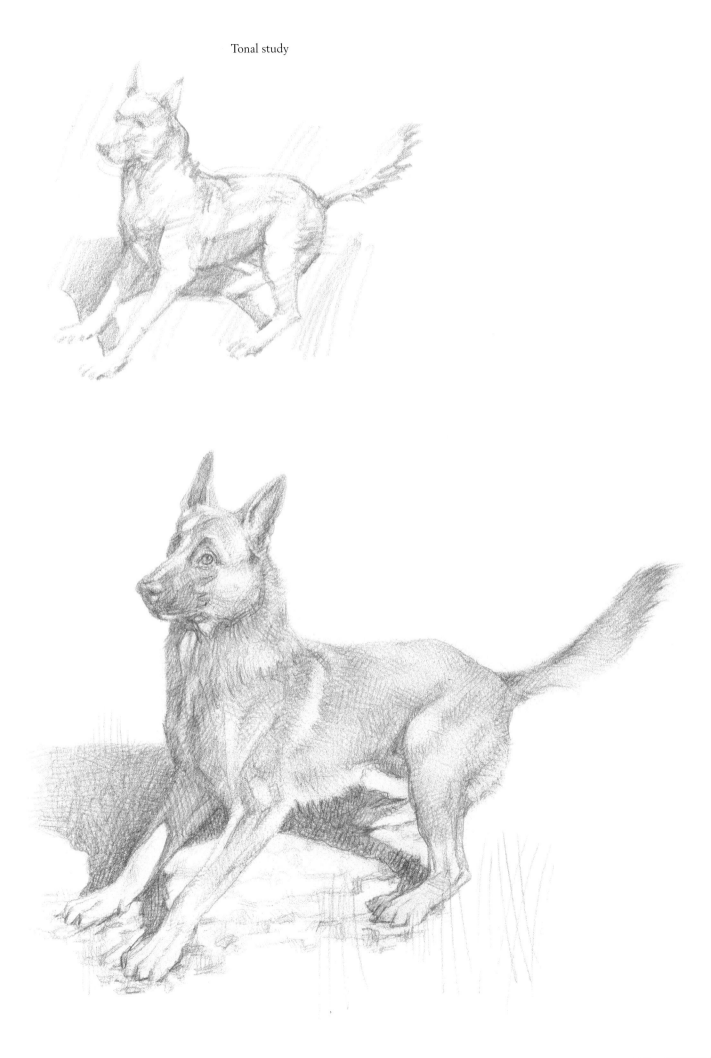

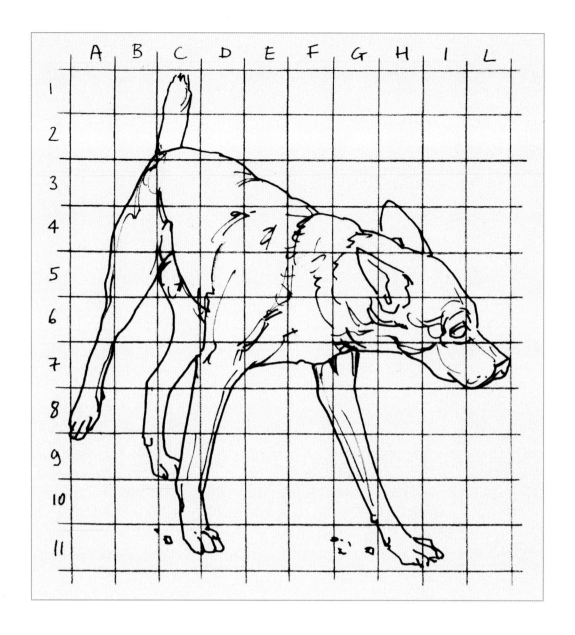

Step 1: Overall shape and size

Step 2: Structure and proportions

Step 3: Volume and shadows

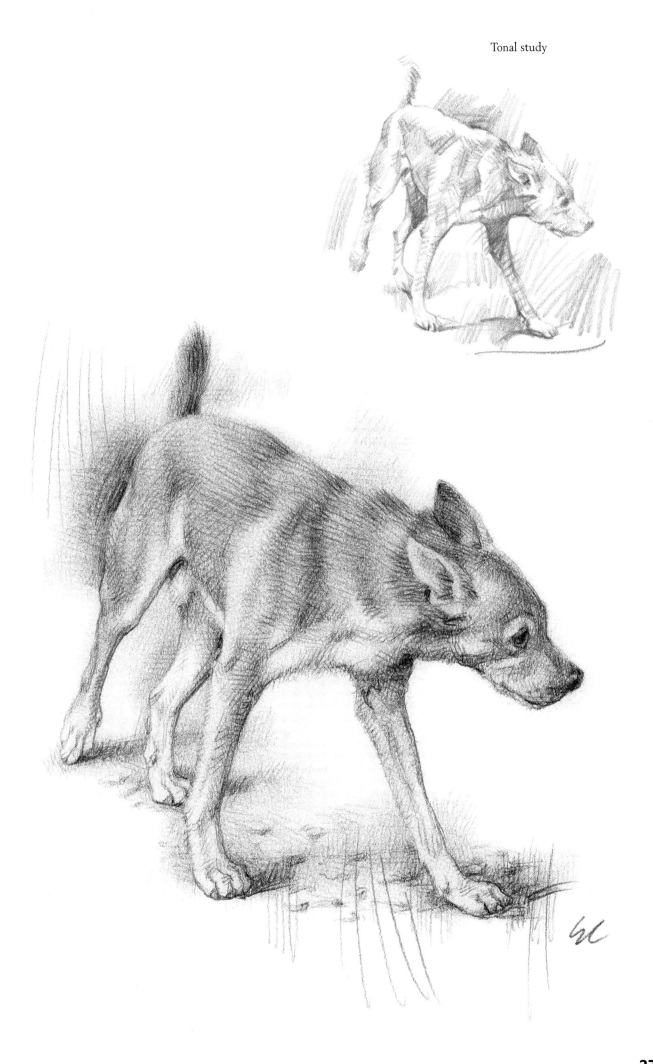

Tonal study

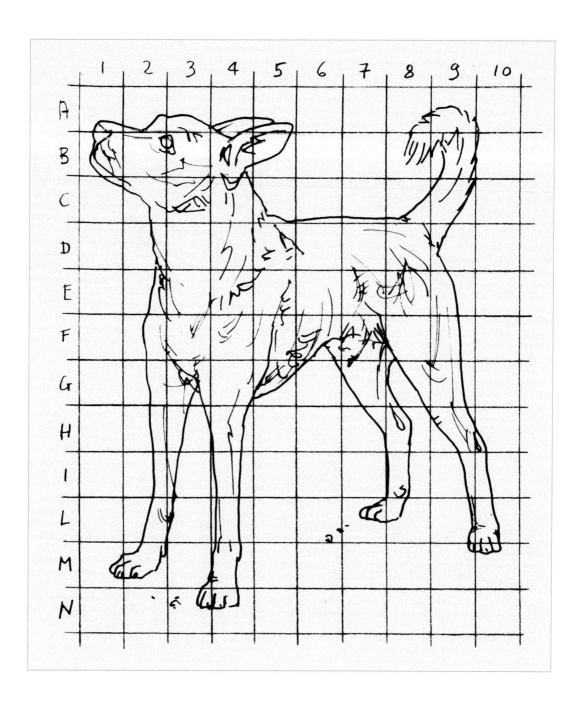

Step 1: Overall shape and size Step 2: Structure and proportions Step 3: Volume and shadows

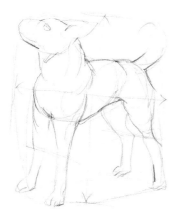

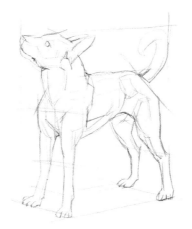

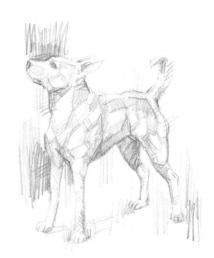

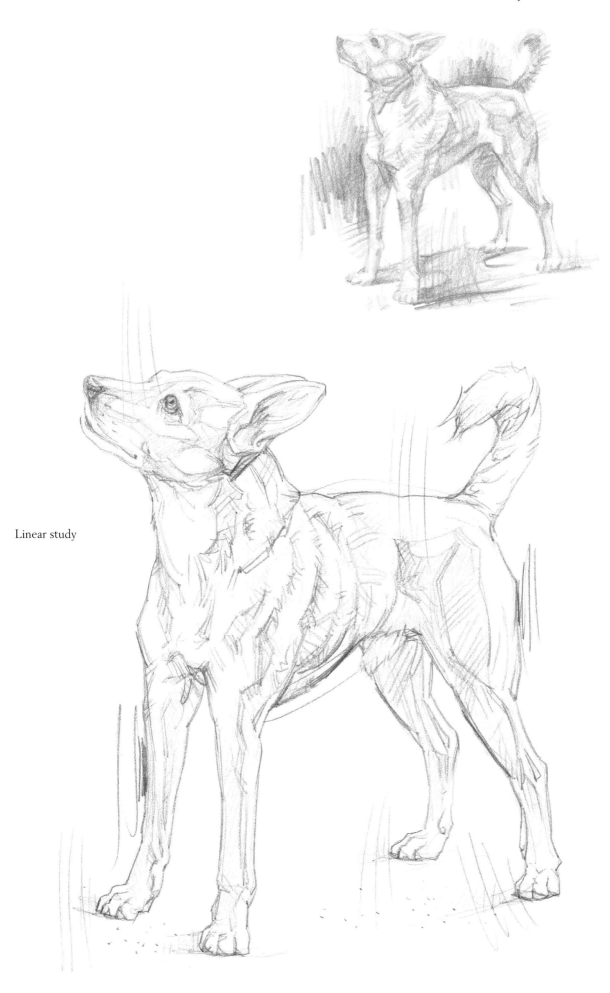

Tonal study

Linear study

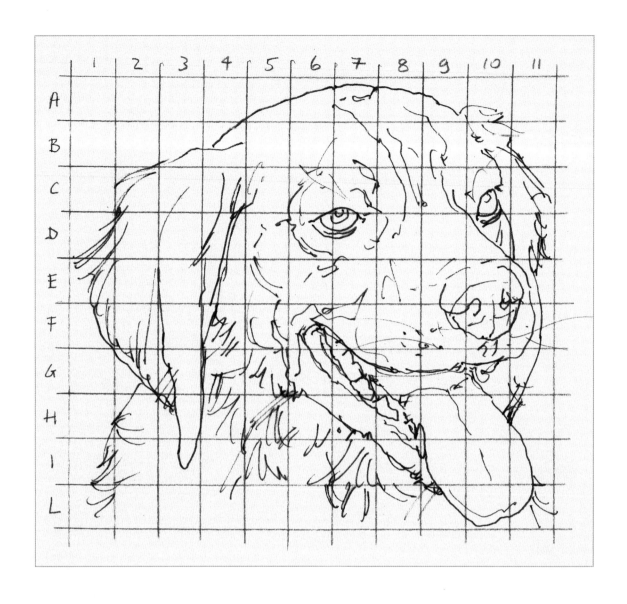

Step 1: Overall shape and size

Step 2: Structure and proportions

Step 3: Volume and shadows

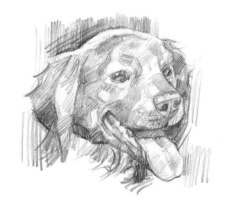

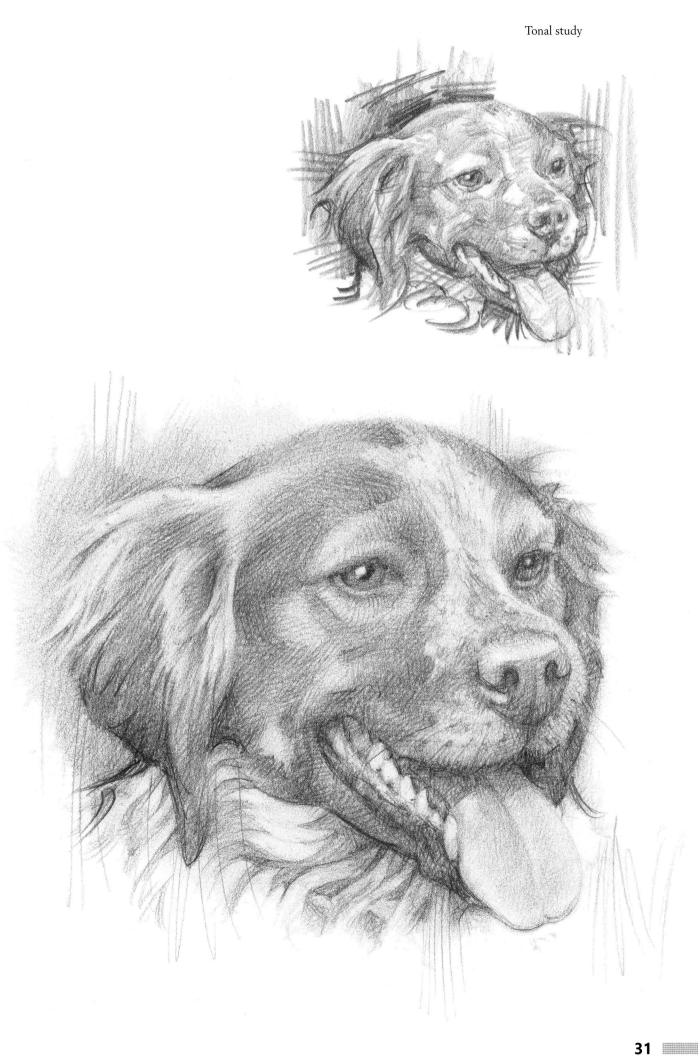

Tonal study

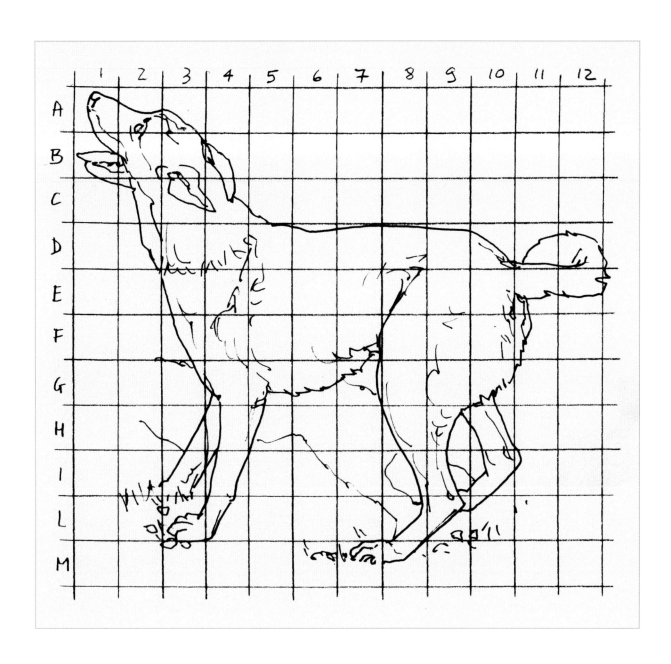

Step 1: Overall shape and size

Step 2: Structure and proportions

Step 3: Volume and shadows

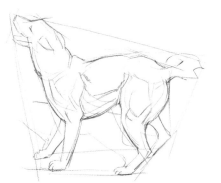

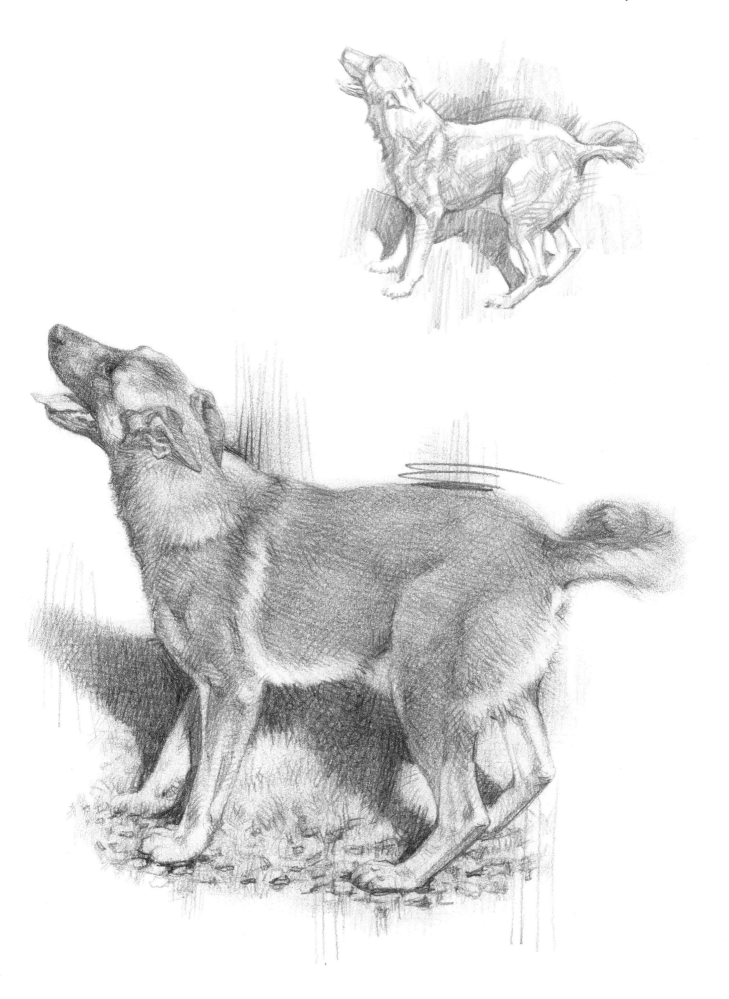

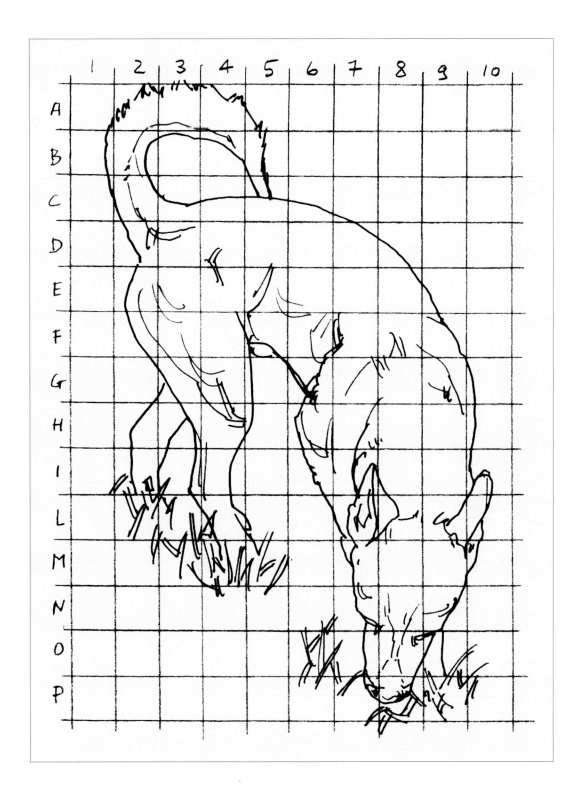

Step 1: Overall shape and size Step 2: Structure and proportions Step 3: Volume and shadows

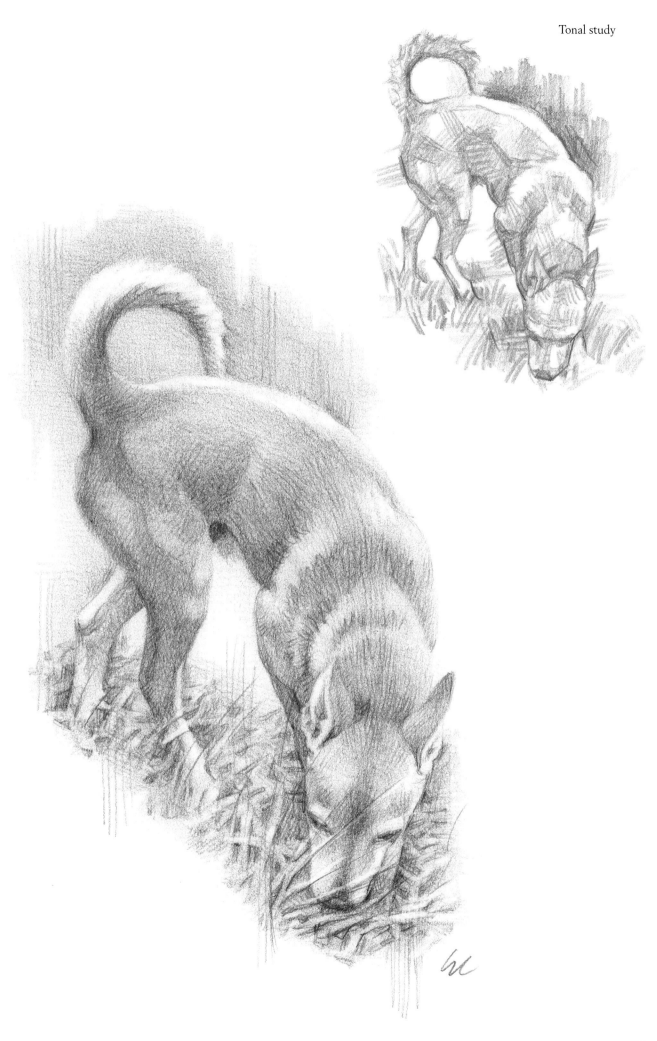

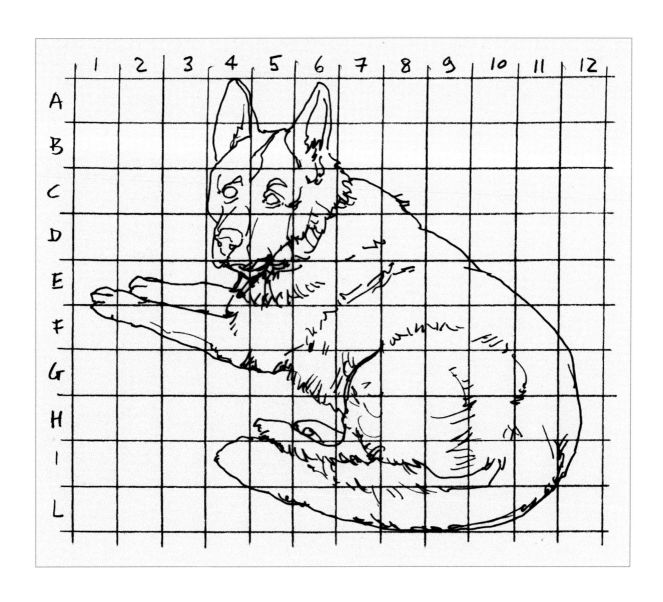

Step 1: Overall shape and size

Step 2: Structure and proportions

Step 3: Volume and shadows

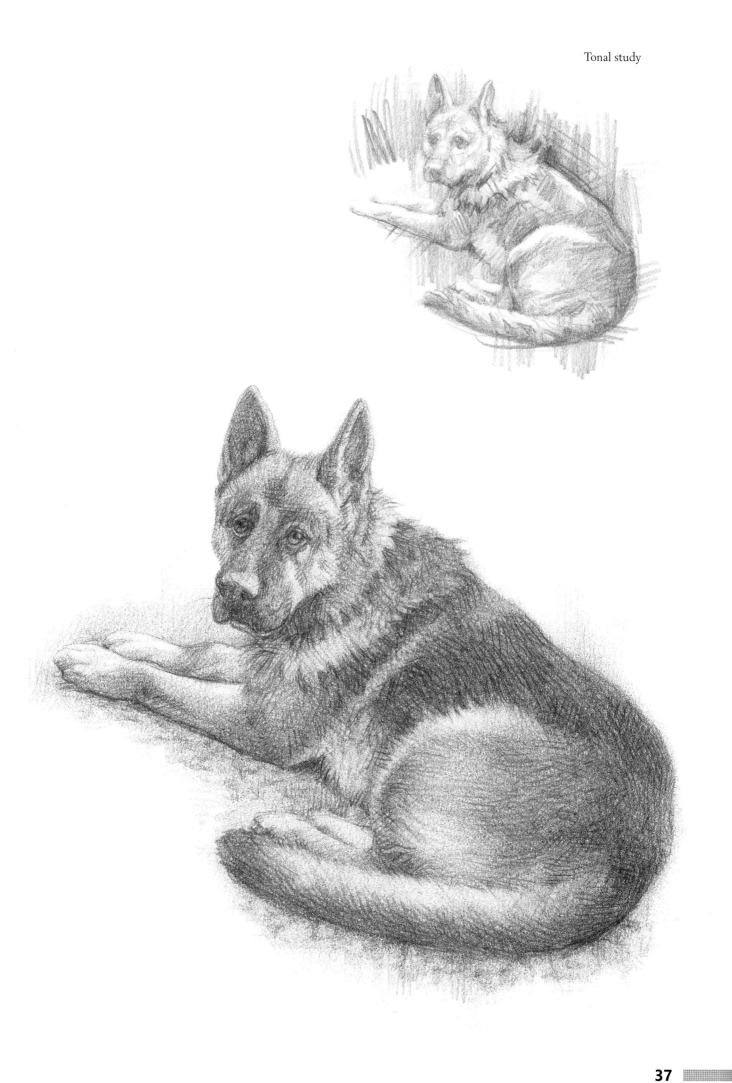

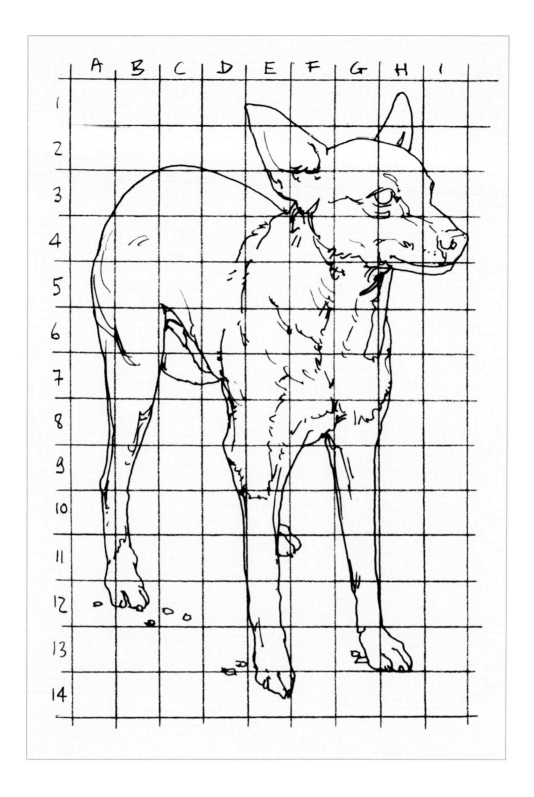

Step 1: Overall shape and size

Step 2: Structure and proportions

Step 3: Volume and shadows

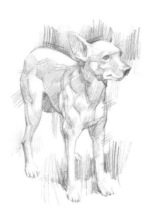

Tonal study

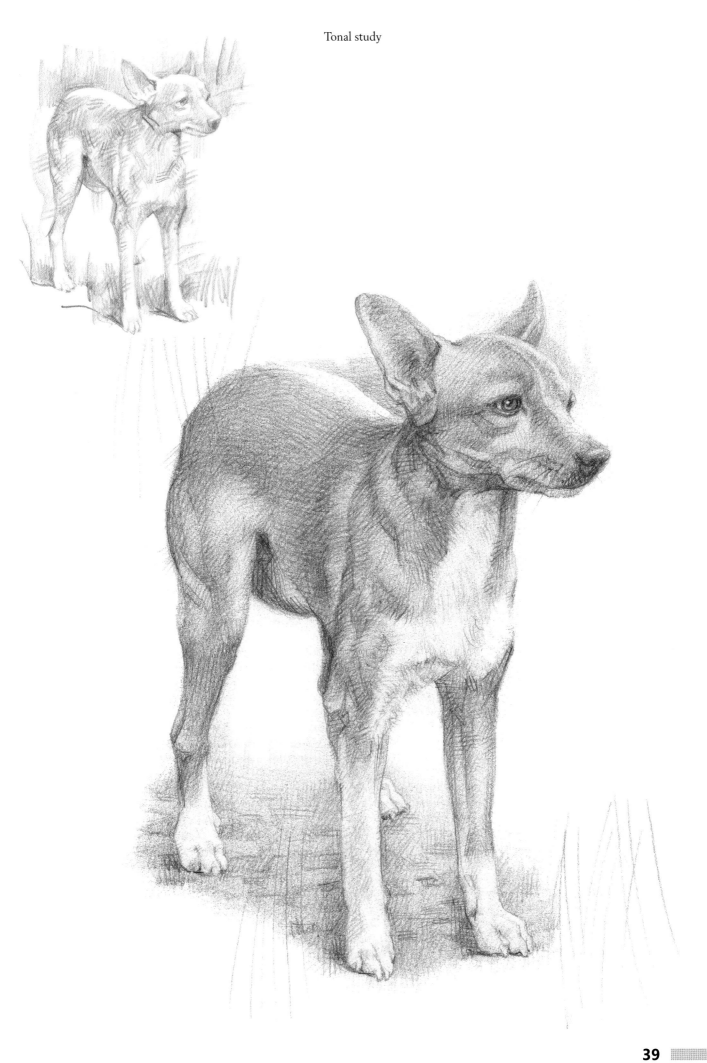

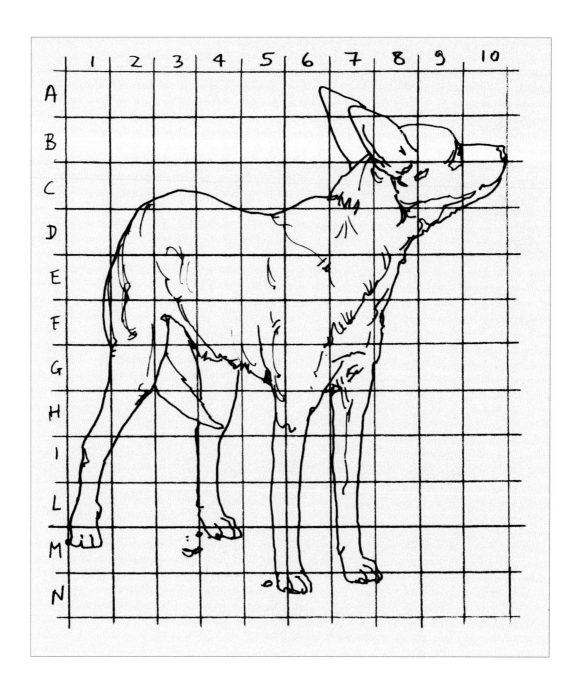

Step 1: Overall shape and size Step 2: Structure and proportions Step 3: Volume and shadows

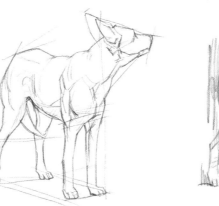

Tonal study

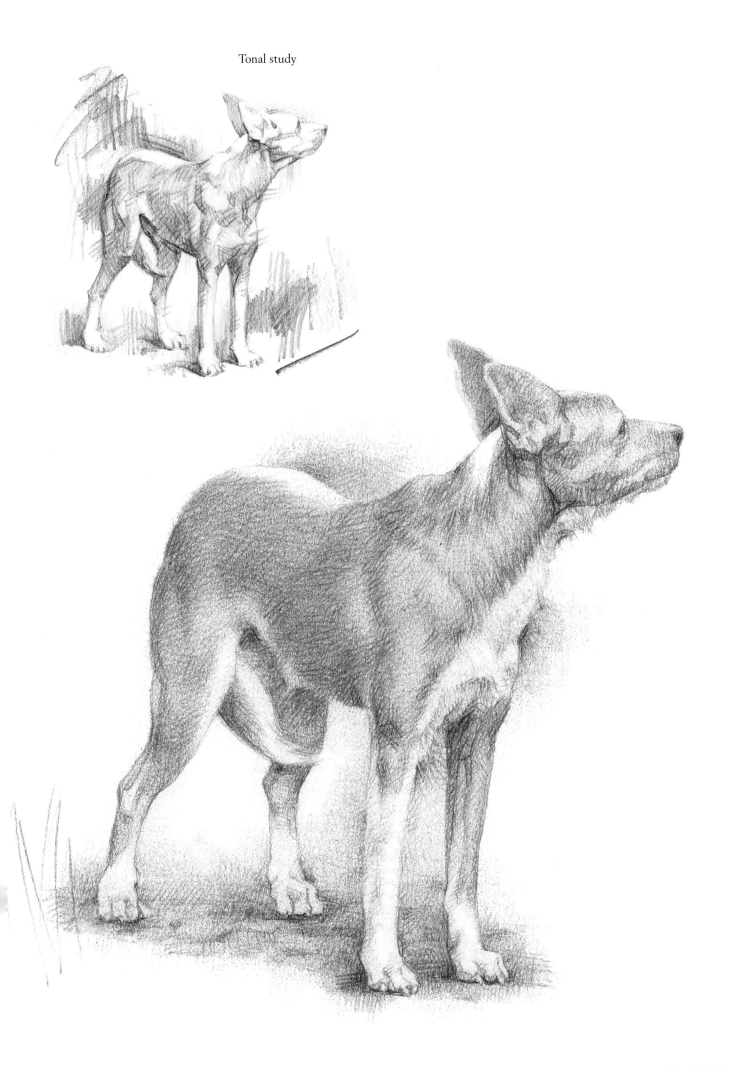

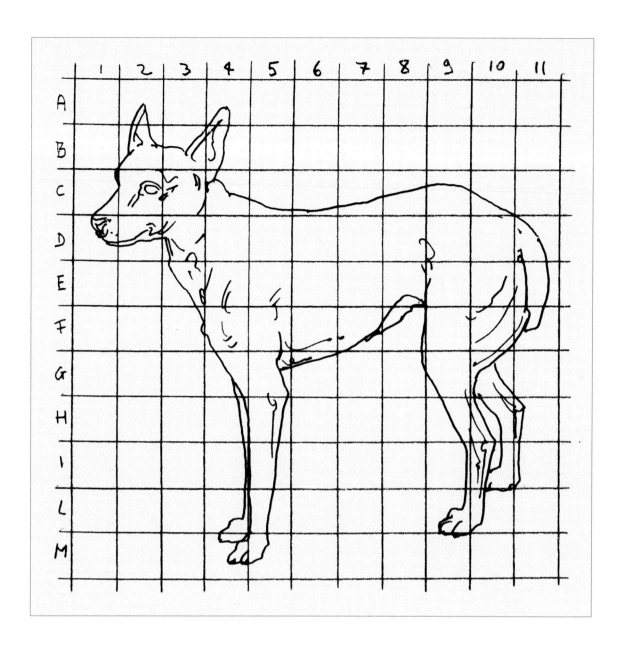

Step 1: Overall shape and size

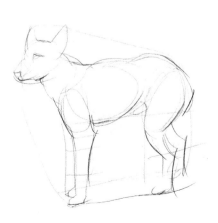

Step 2: Structure and proportions

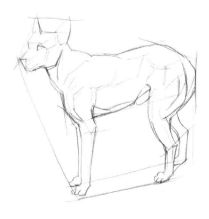

Step 3: Volume and shadows

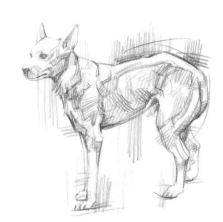

Tonal study

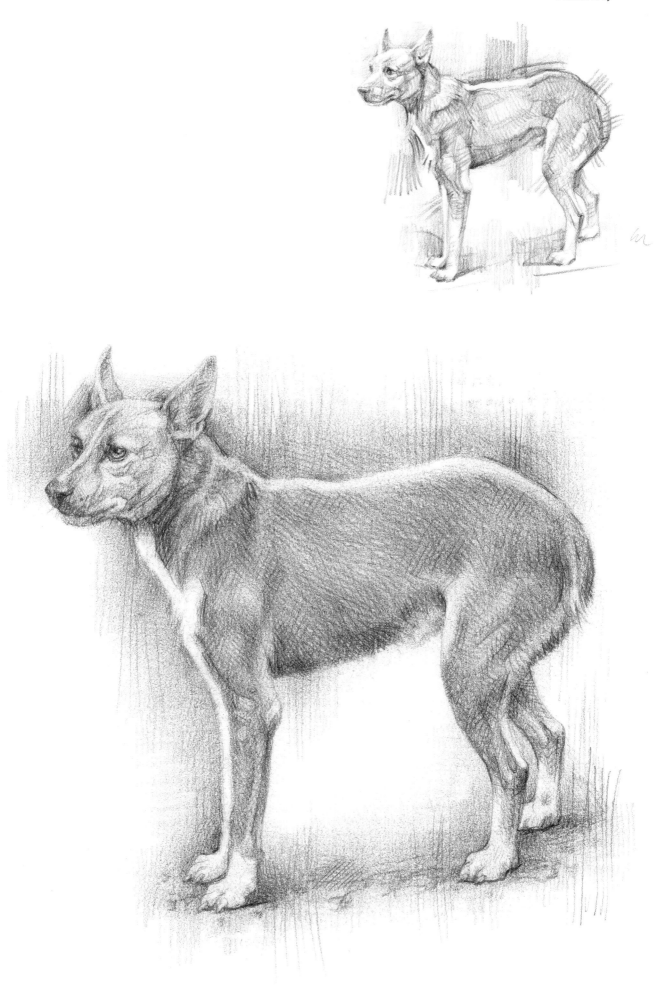

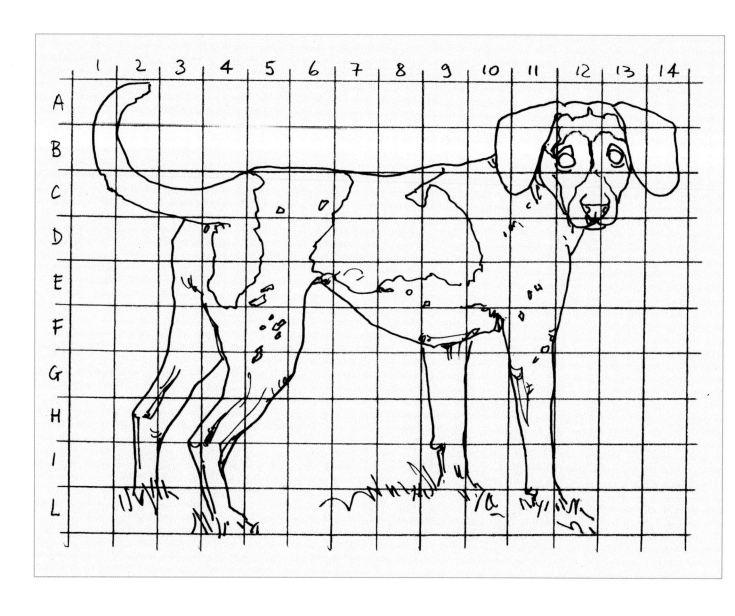

Step 1: Overall shape and size Step 2: Structure and proportions Step 3: Volume and shadows

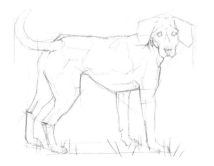
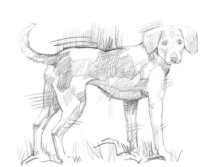

Tonal study

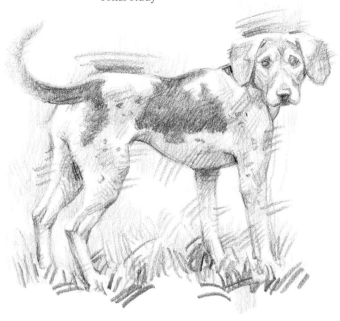

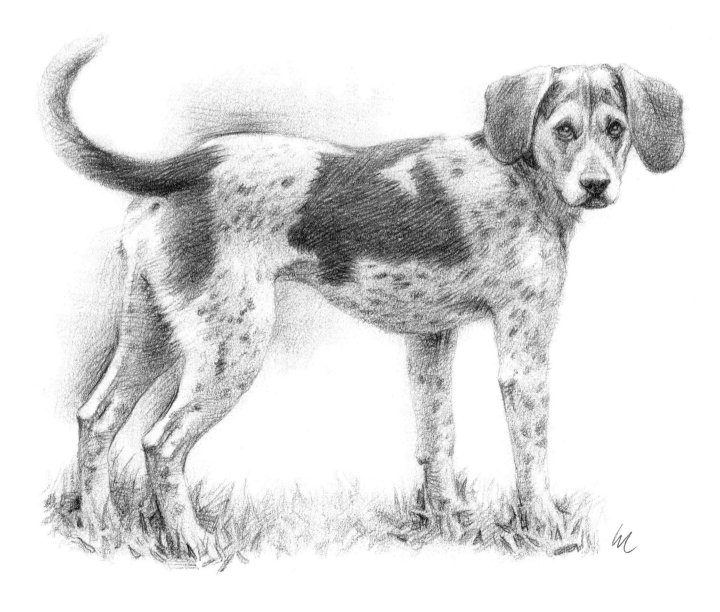

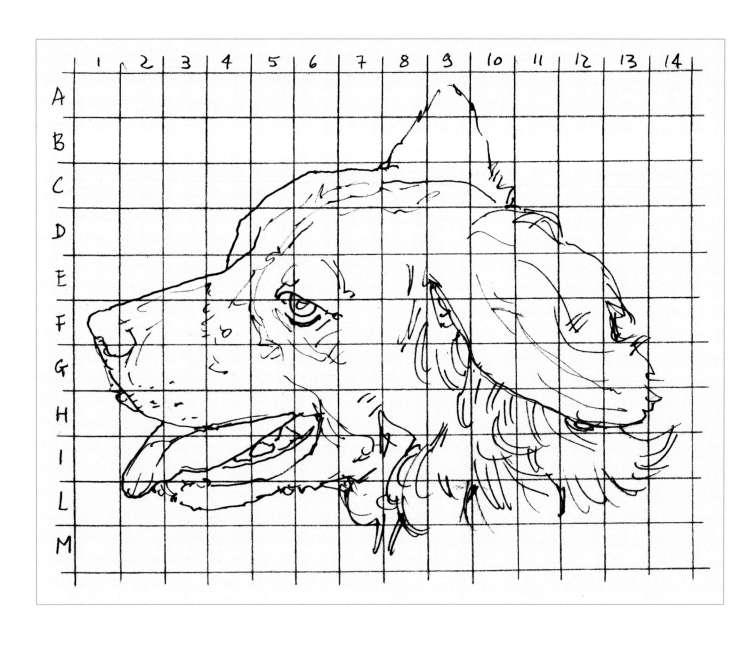

Step 1: Overall shape and size Step 2: Structure and proportions Step 3: Volume and shadows

Tonal study

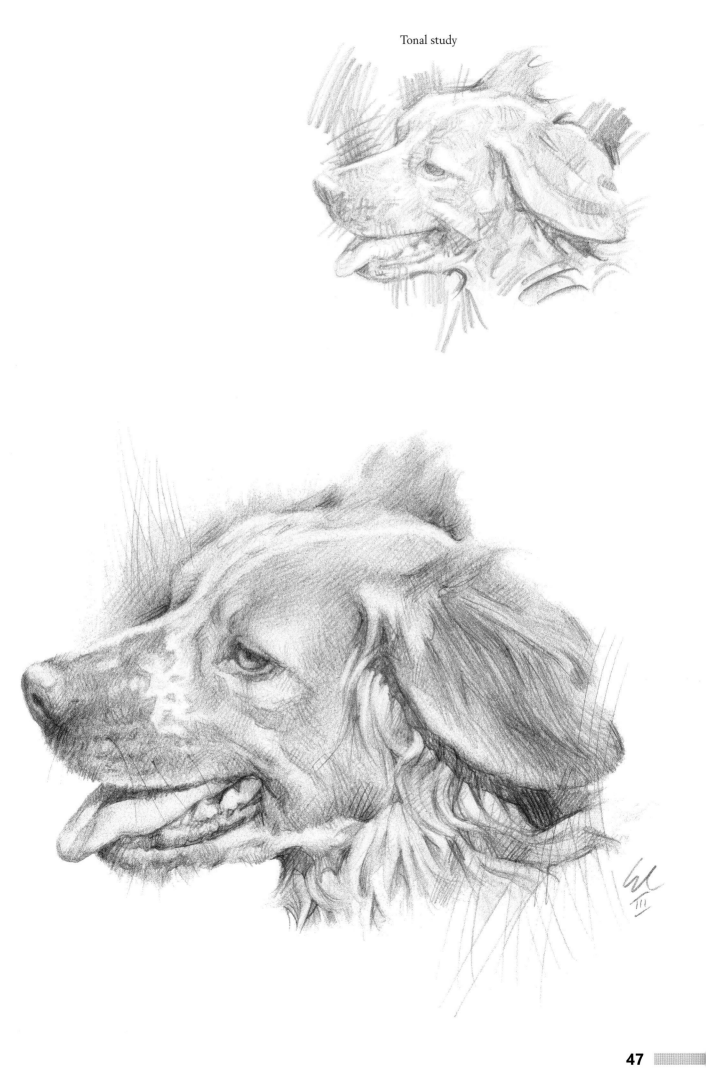

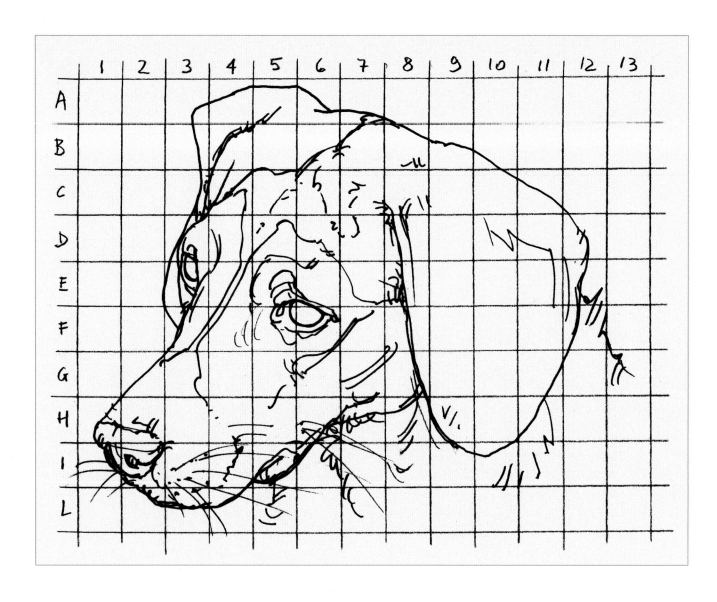

Step 1: Overall shape and size

Step 2: Structure and proportions

Step 3: Volume and shadows

Tonal study

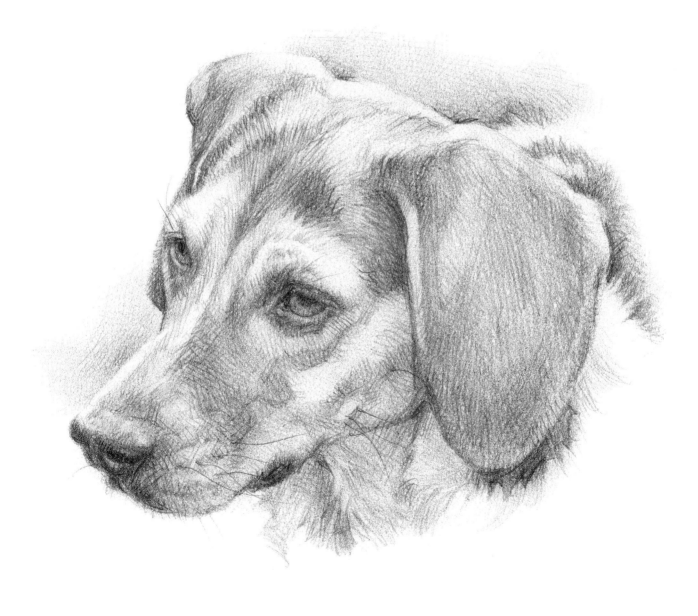

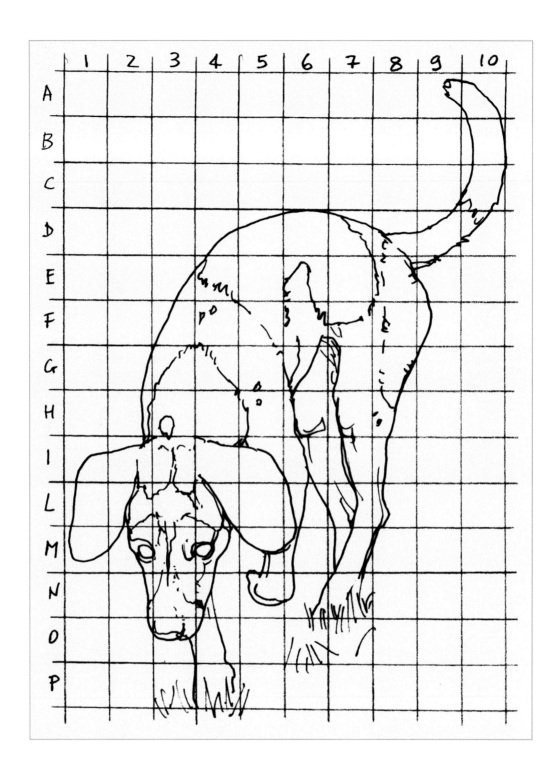

	1	2	3	4	5	6	7	8	9	10
A										
B										
C										
D										
E										
F										
G										
H										
I										
L										
M										
N										
O										
P										

Step 1: Overall shape and size Step 2: Structure and proportions Step 3: Volume and shadows

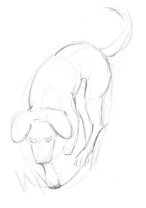 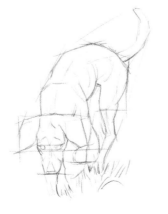 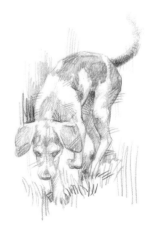

50

Tonal study

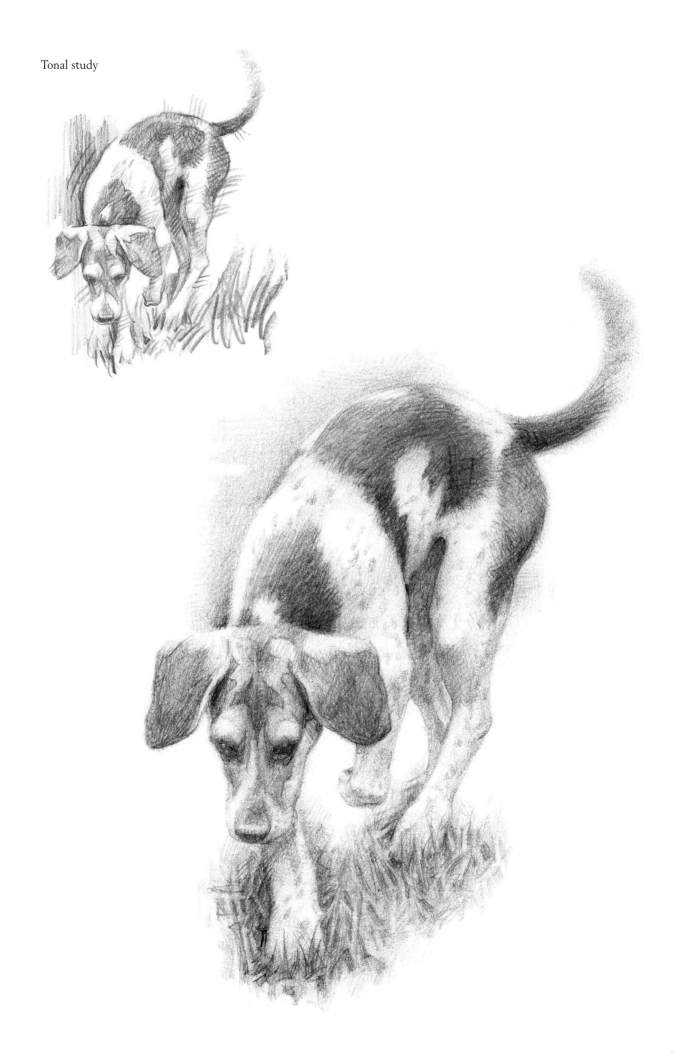

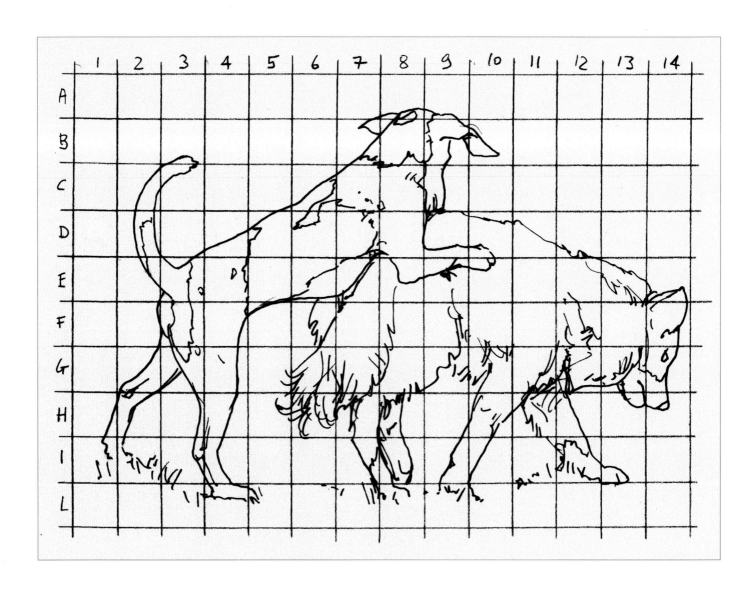

Step 1: Overall shape and size

Step 2: Structure and proportions

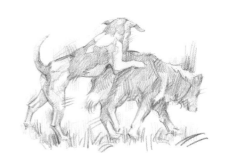

Step 3: Volume and shadows

Tonal study

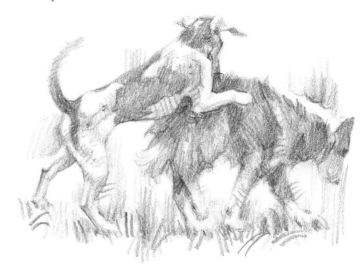

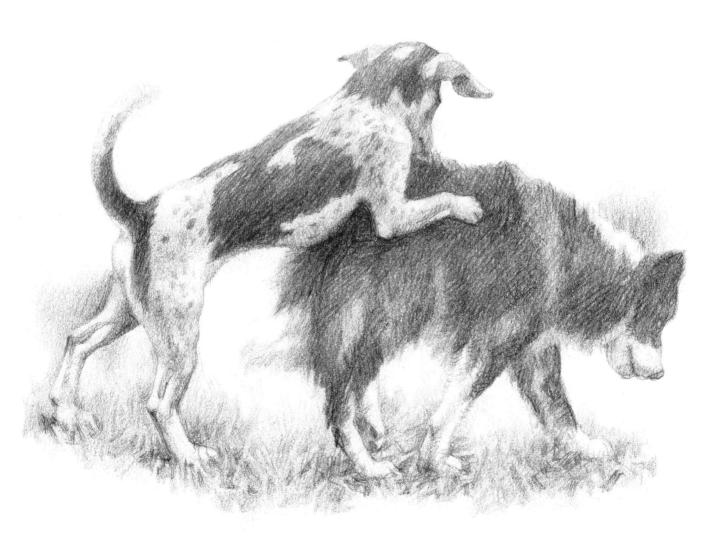

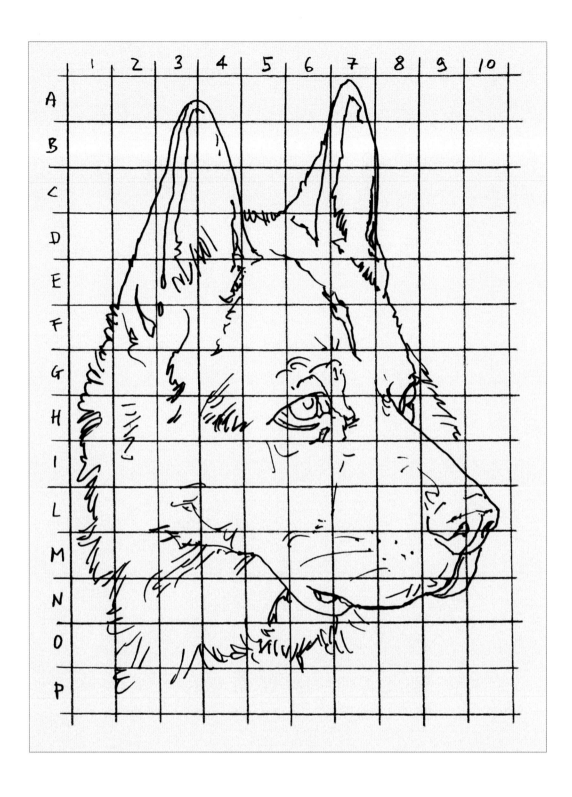

Step 1: Overall shape and size Step 2: Structure and proportions Step 3: Volume and shadows

Tonal study

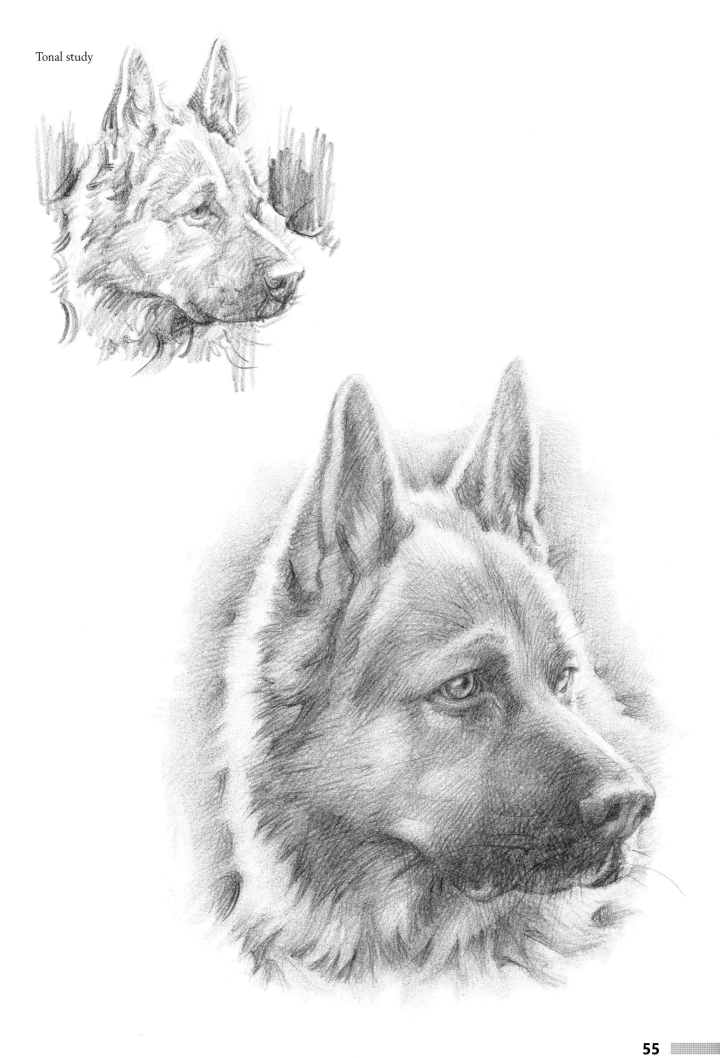

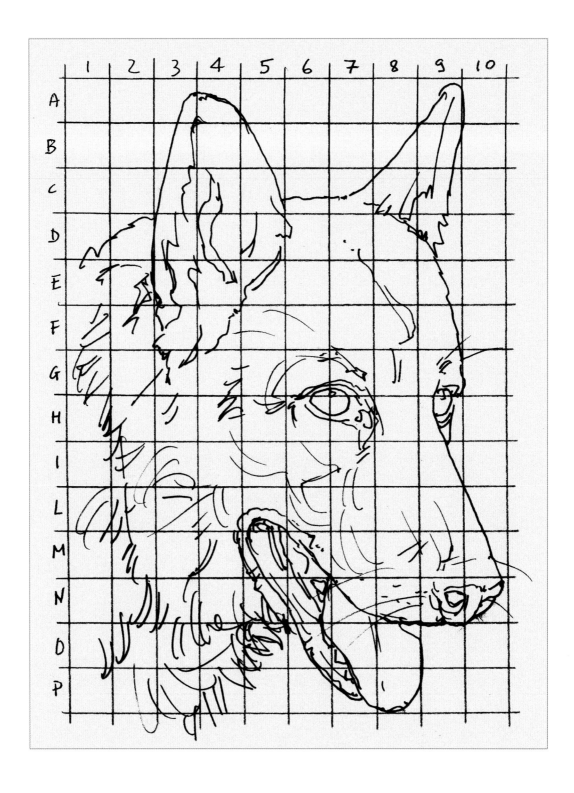

Step 1: Overall shape and size

Step 2: Structure and proportions

Step 3: Volume and shadows

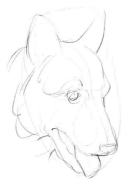

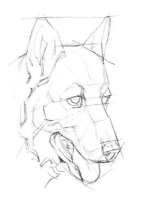

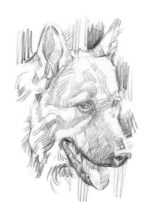

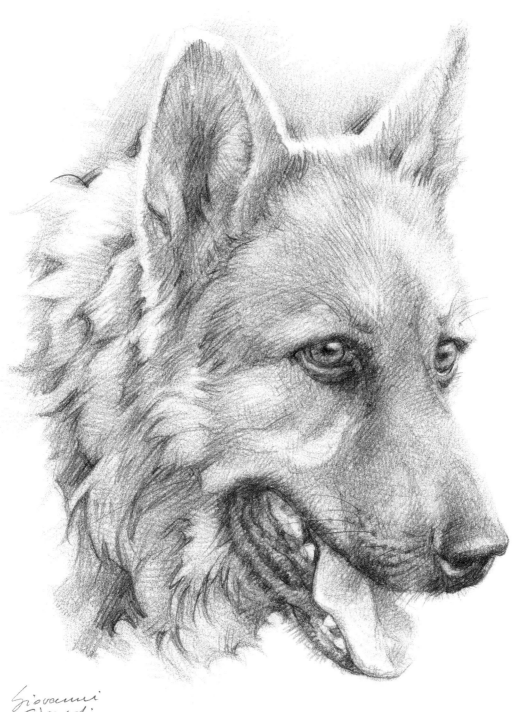

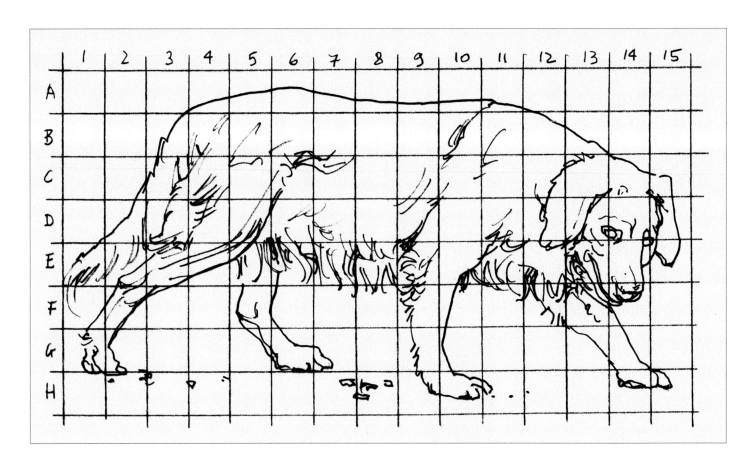

Step 1: Overall shape and size

Step 2: Structure and proportions

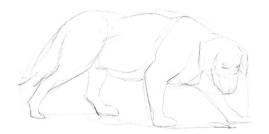

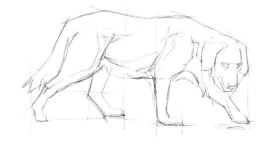

Step 3: Volume and shadows

Tonal study

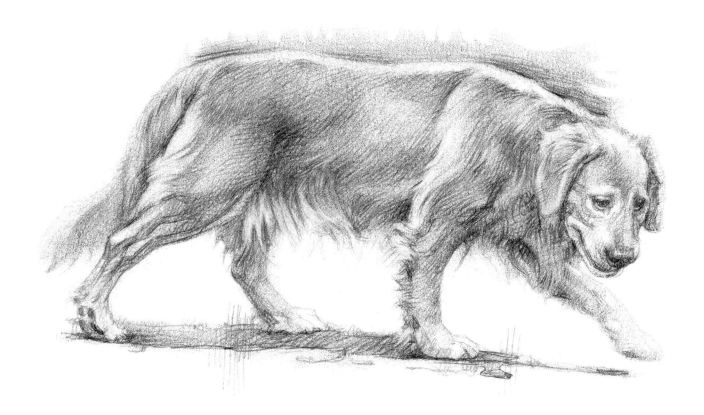

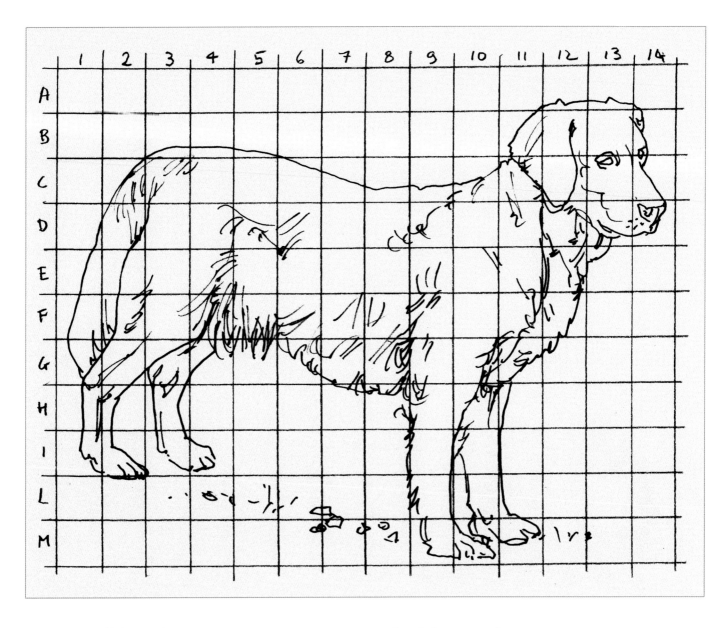

Step 1: Overall shape and size

Step 2: Structure and proportions

Step 3: Volume and shadows

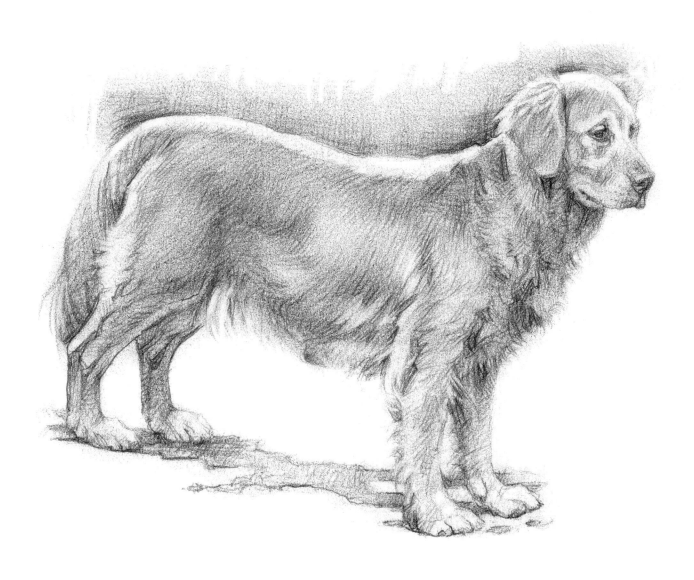

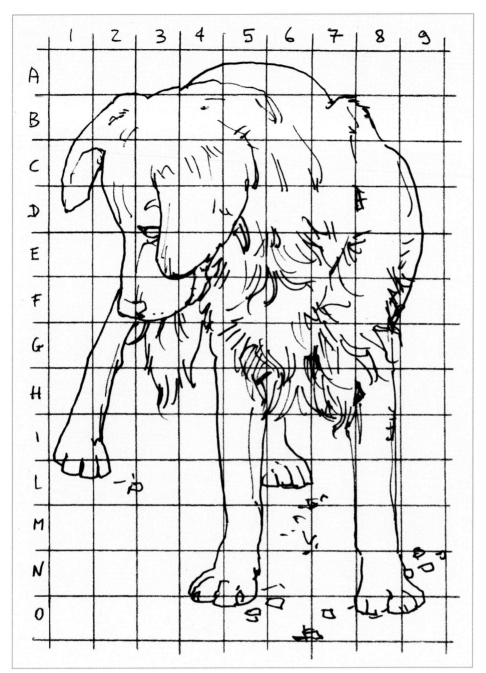

Step 1: Overall shape and size

Step 2: Structure and proportions

Step 3: Volume and shadows

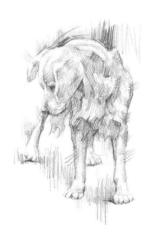

Tonal study

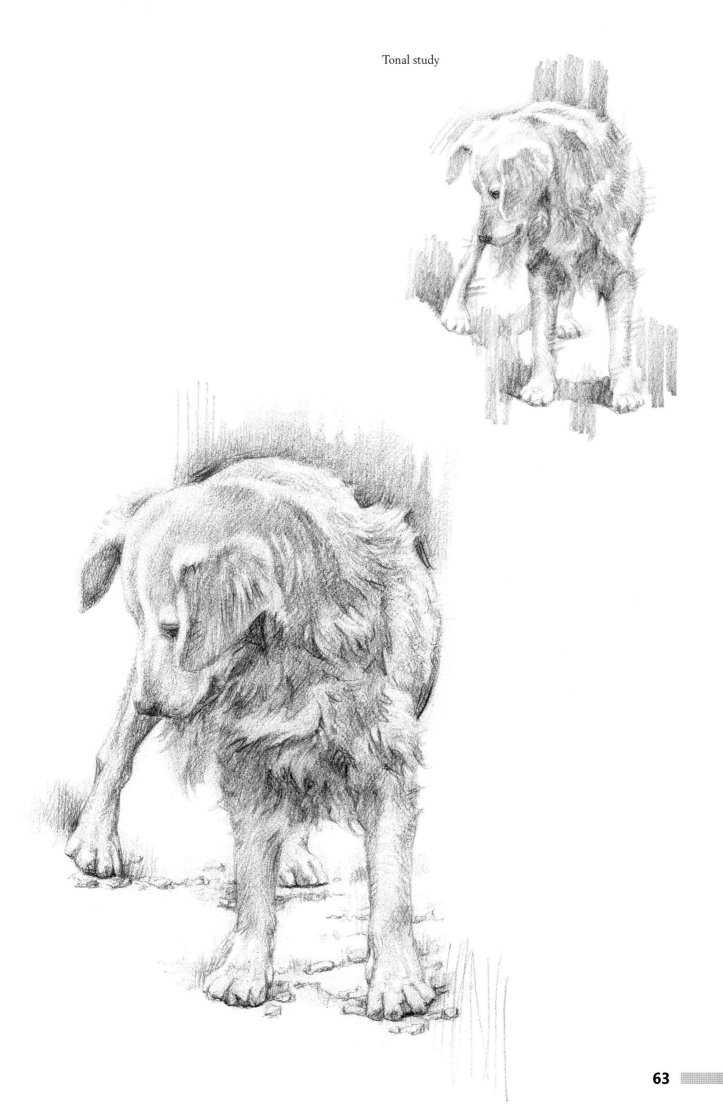

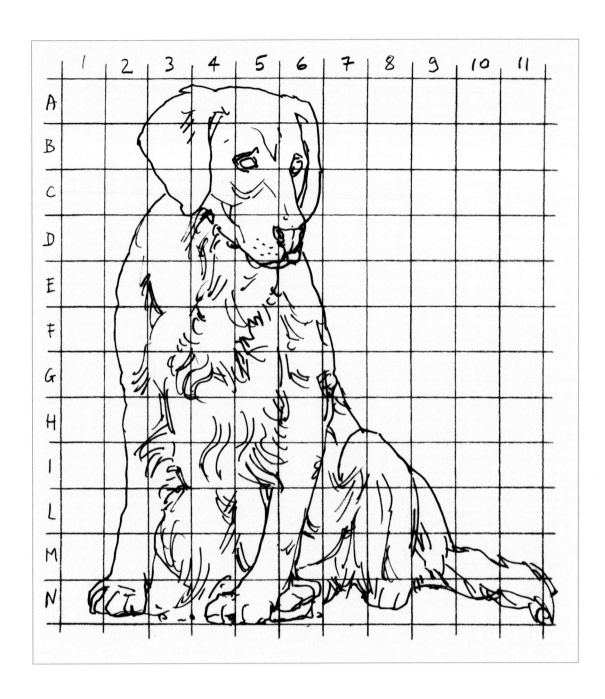

Step 1: Overall shape and size

Step 2: Structure and proportions

Step 3: Volume and shadows

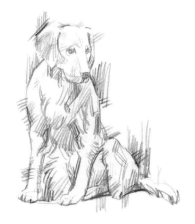

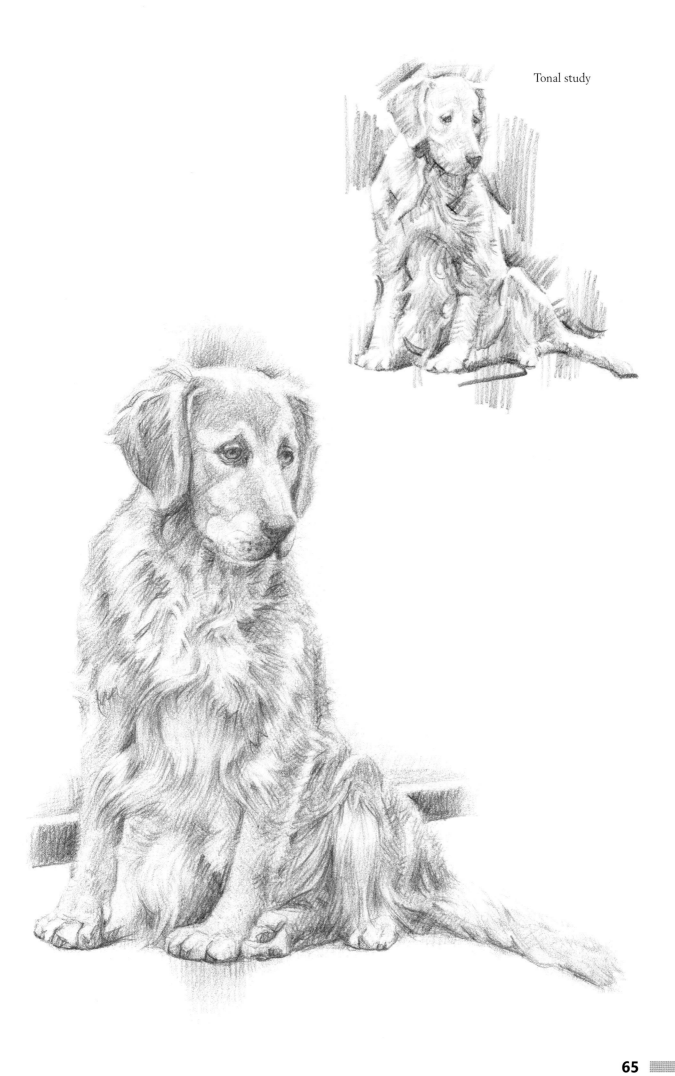

Tonal study

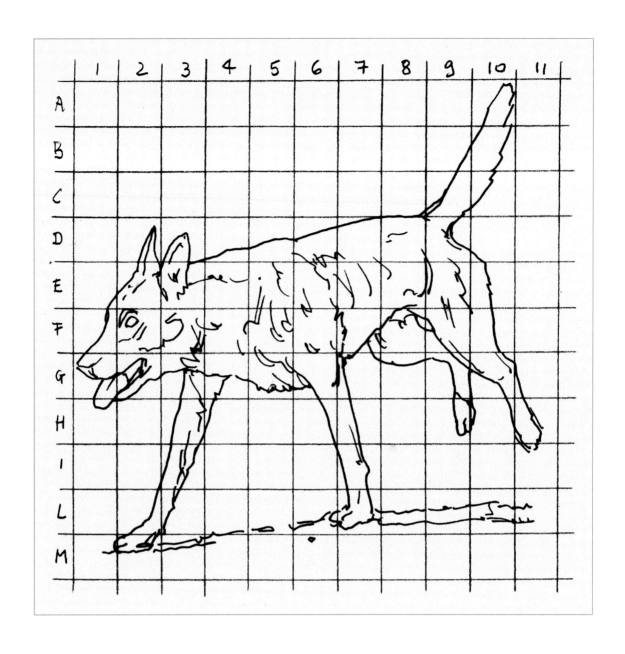

	1	2	3	4	5	6	7	8	9	10	11
A											
B											
C											
D											
E											
F											
G											
H											
I											
L											
M											

Step 1: Overall shape and size

Step 2: Structure and proportions

Step 3: Volume and shadows

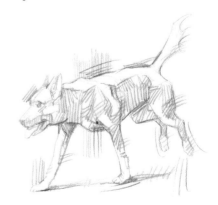

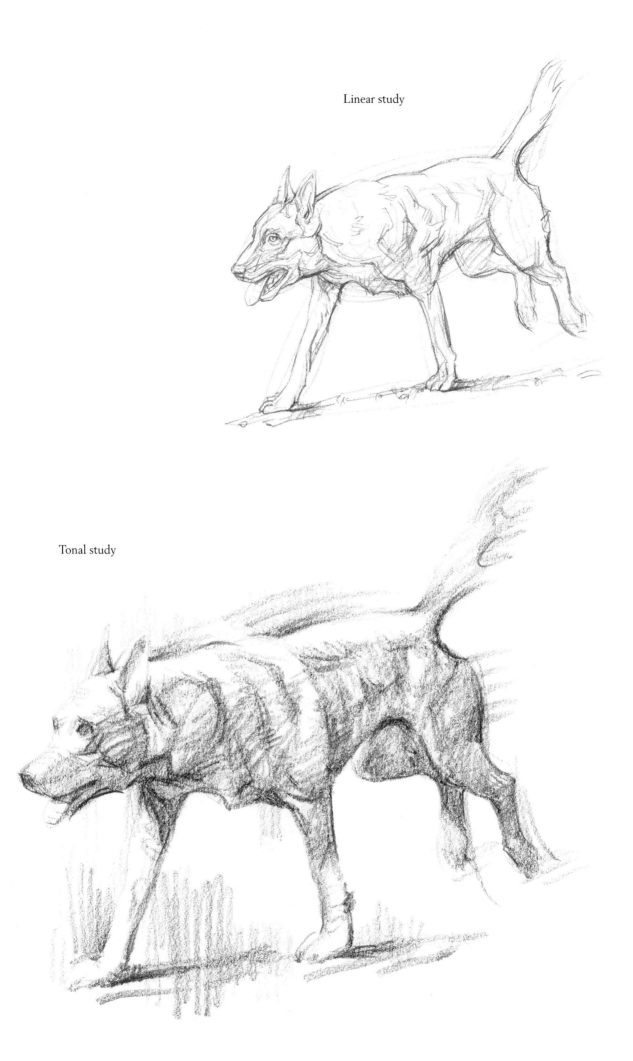

Linear study

Tonal study

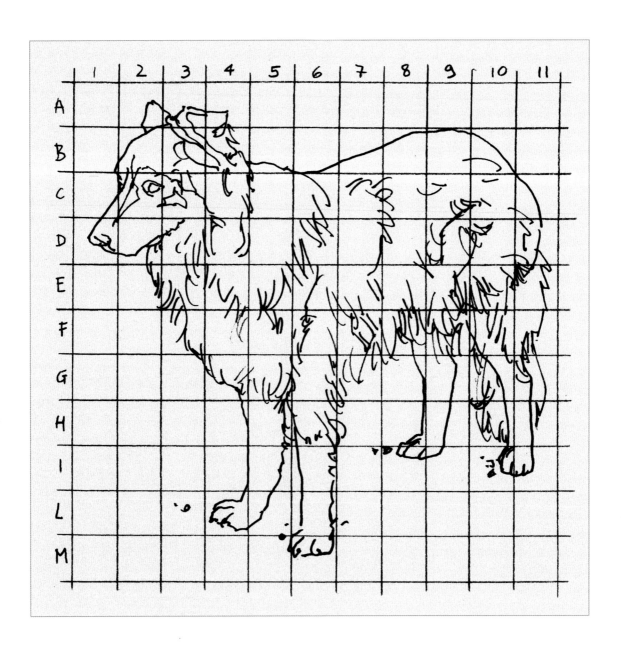

Step 1: Overall shape and size

Step 2: Structure and proportions

Step 3: Volume and shadows

Tonal study

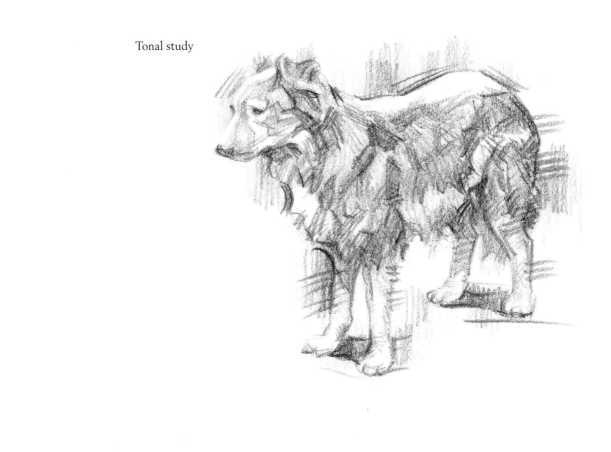

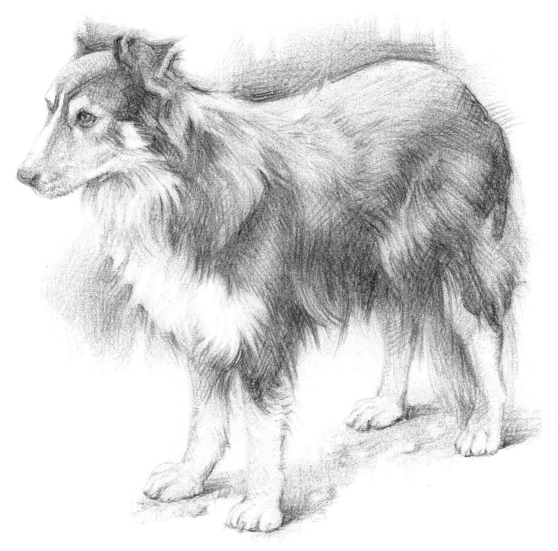

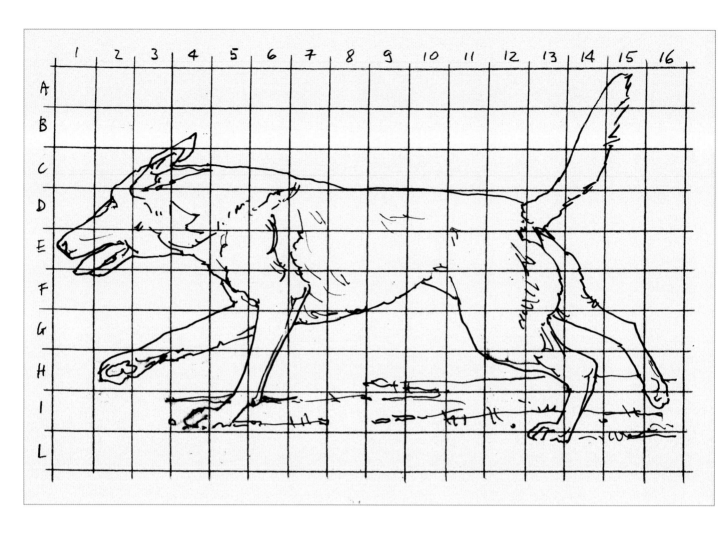

Step 1: Overall shape and size

Step 2: Structure and proportions

Step 3: Volume and shadows

Tonal study

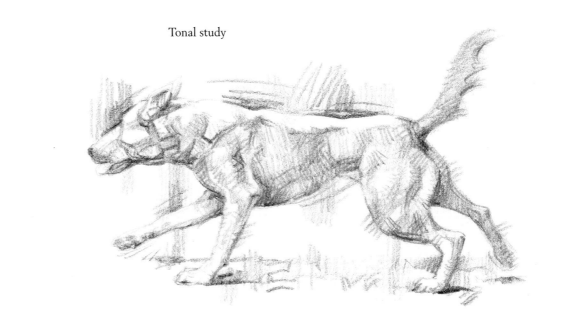

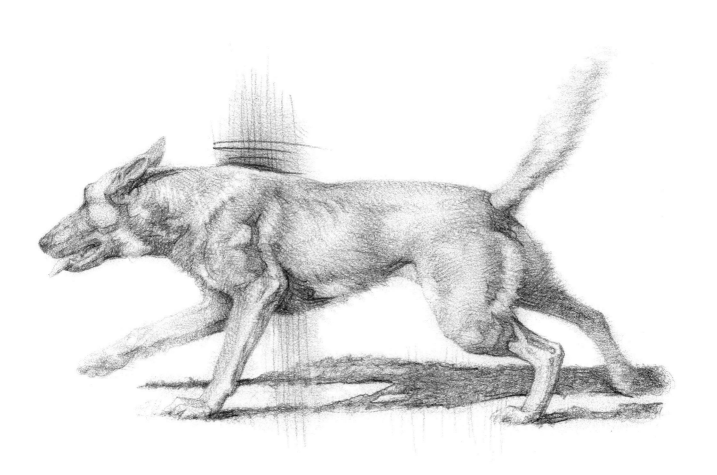

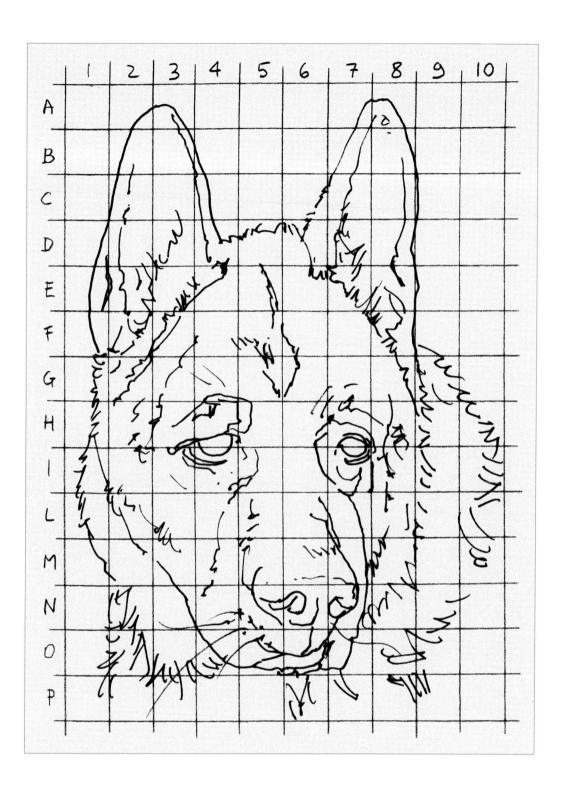

Step 1: Overall shape and size

Step 2: Structure and proportions

Step 3: Volume and shadows

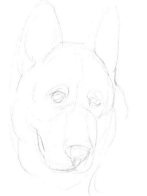

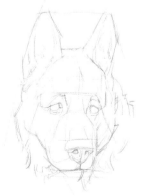

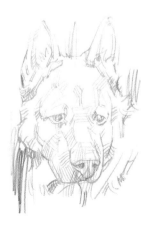

Tonal study

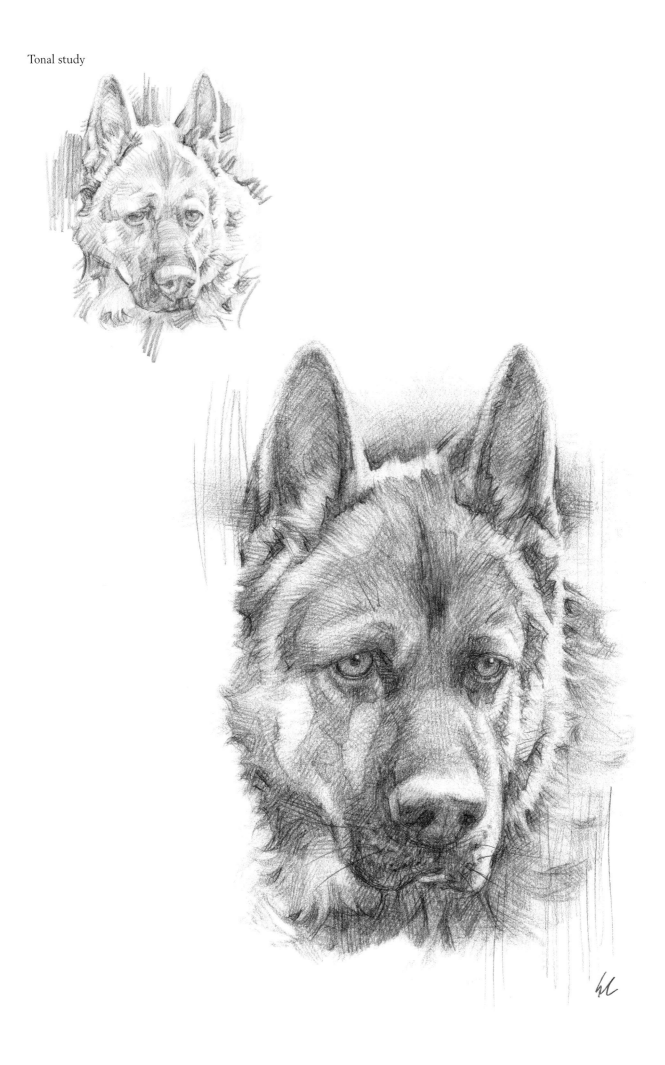

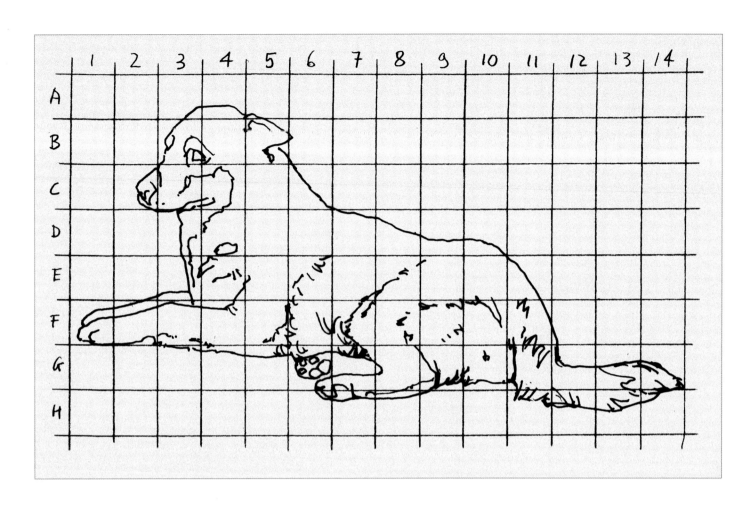

Step 1: Overall shape and size

Step 2: Structure and proportions

Step 3: Volume and shadows

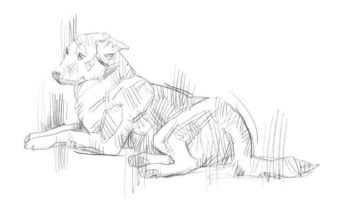

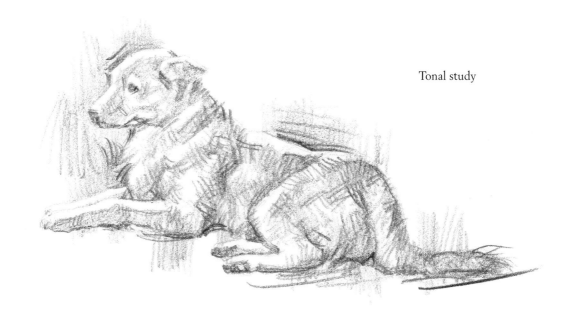

Tonal study

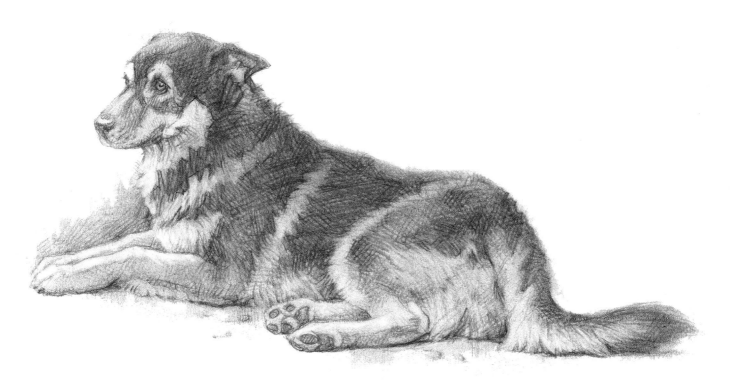

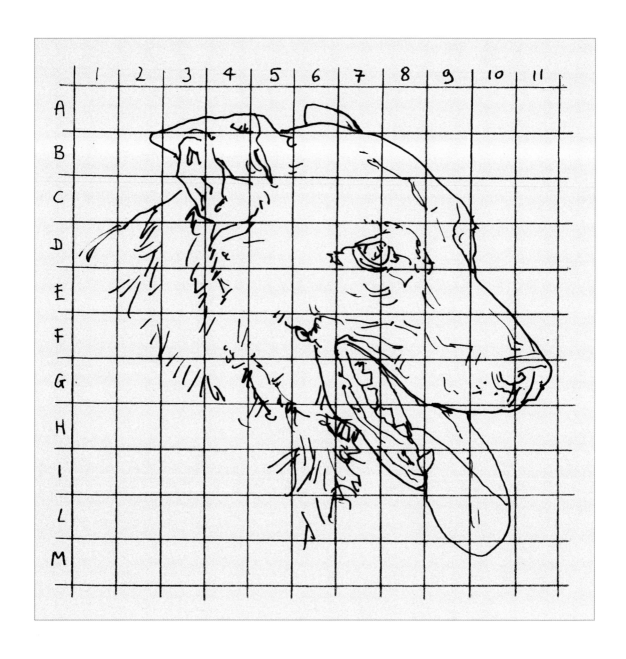

Step 1: Overall shape and size

Step 2: Structure and proportions

Step 3: Volume and shadows

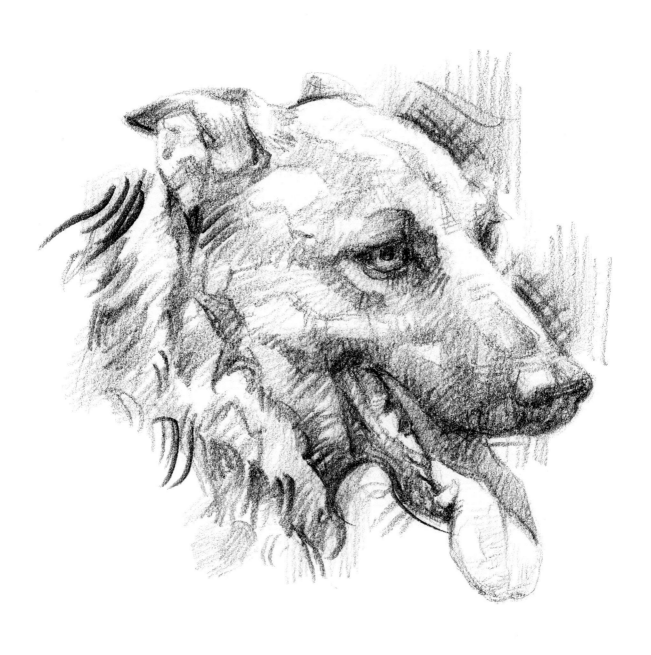

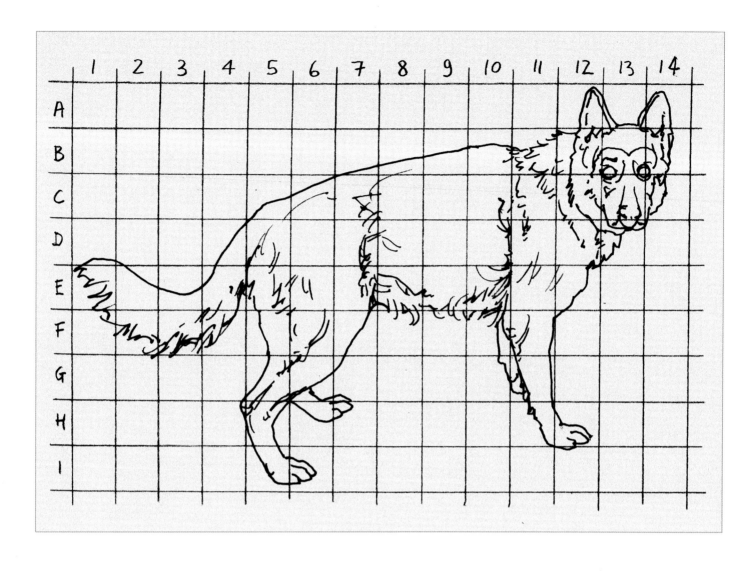

Step 1: Overall shape and size

Step 2: Structure and proportions

Step 3: Volume and shadows

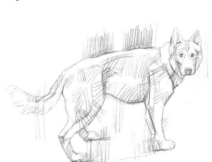

Tonal study

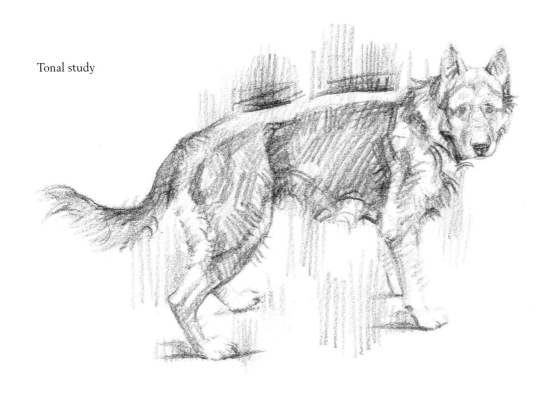

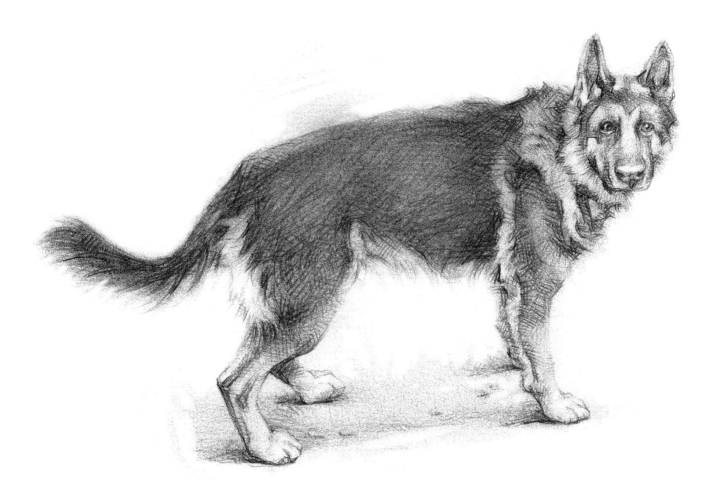

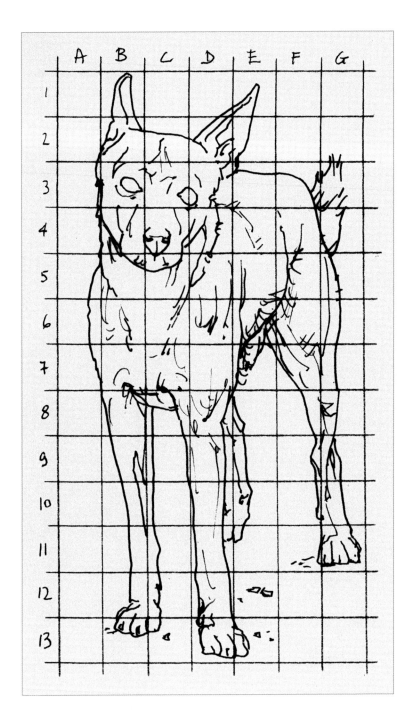

Step 1: Overall shape and size

Step 2: Structure and proportions

Step 3: Volume and shadows

Tonal study

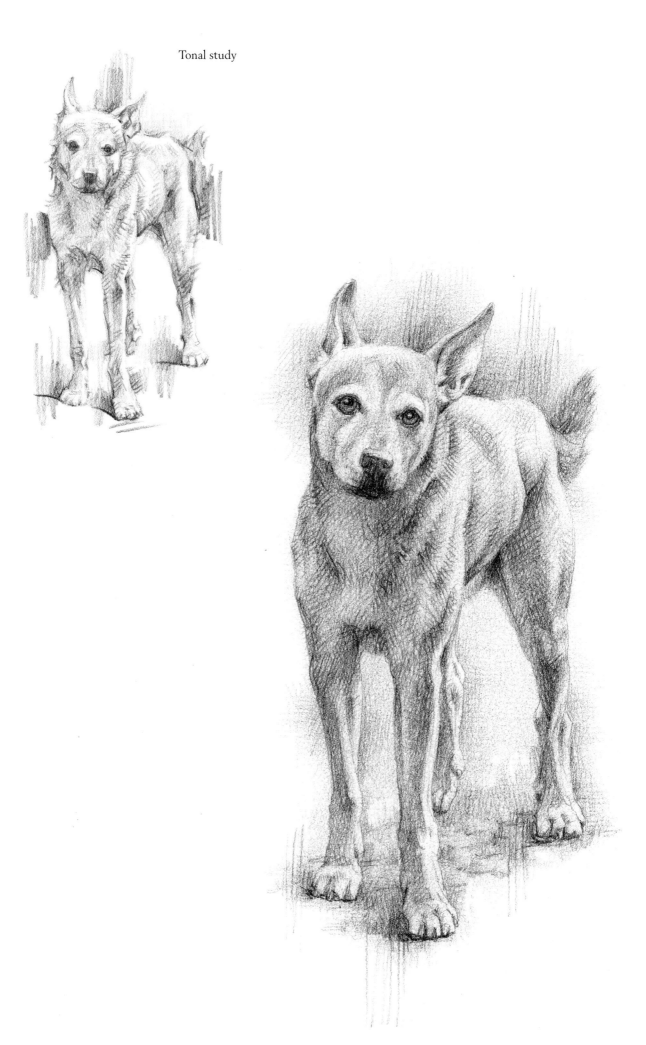

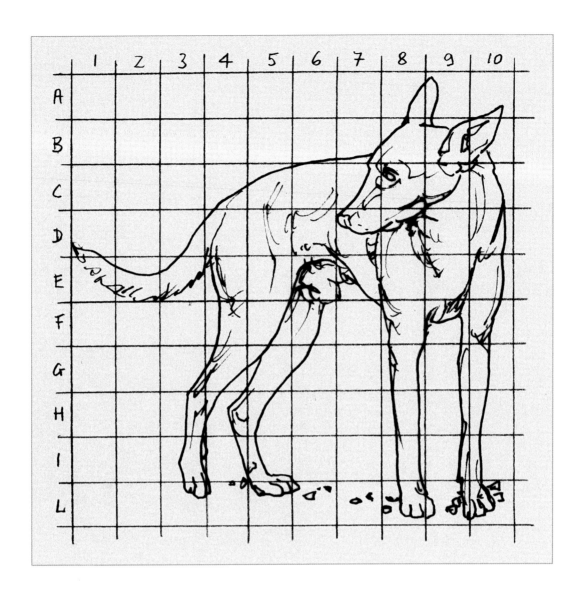

Step 1: Overall shape and size

Step 2: Structure and proportions

Step 3: Volume and shadows

Tonal study

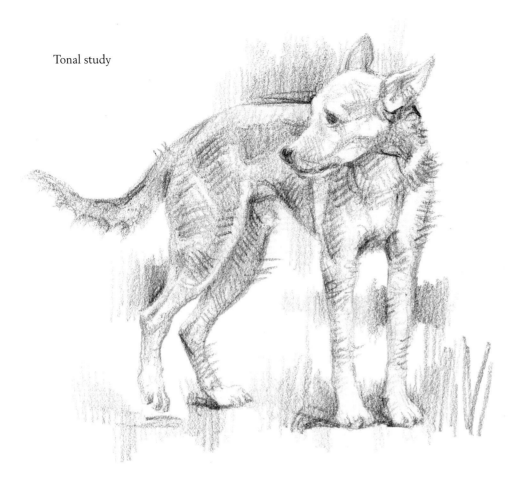

Linear study

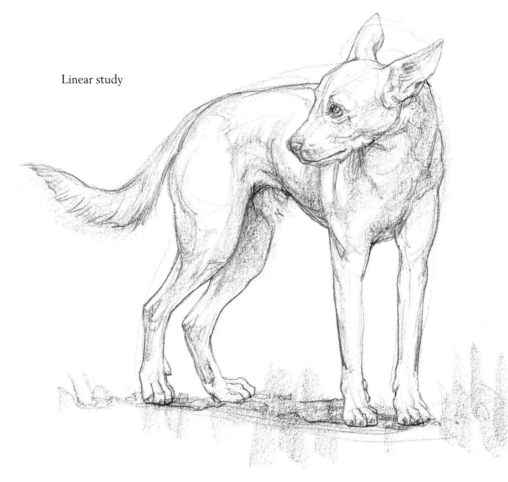

DRAWING
HORSES

*Some people in the world become teachers
without ever having been a pupil.*

Everything in the universe is in movement...

Don't just copy – interpret.
RUSSEL IREDELL

Klein, aber mein *(small, but mine)*.

INTRODUCTION

The oldest portrayals of horses can be found drawn on the walls of many prehistoric caves, and approximately date back to the Palaeolithic Age. They are pictures of wild horses. Since man tamed them around 5,000 years ago, he has used them as an engine of civilization – using them as a means of transport, for work or battle, and, of course, as a source of inspiration for art. One can see examples of this in the wonderful ancient interpretations in Egyptian, Mesopotamic, Greek-Roman and ancient Chinese art. Through taming, almost all human populations have tried to select particular qualities of horses according to their respective practical purposes, or to develop a large number of races and types, each with specific morphological characteristics and aptitudes.

To draw a horse, it is not always enough just to carefully observe it live, or to reproduce a horse faithfully from a photograph (which, while an essential aid, can also introduce error if the perspective is unusual). Many details of shape and structure can be found and interpreted correctly if there is some elementary 'scientific' knowledge of a horse's anatomy and physiology, and if the artist constantly frequents places where horses are likely to be seen, such as training or breeding stables. It is also recommended to the artist to understand horses' behaviour, to be able to move accordingly and safely when drawing them live and to get close to them. A rapid, summary sketch, carried out with the most efficient drawing techniques (linear and tonal – see page 92) and using common drawing tools (graphite, charcoal, etc.) is the most valuable way to study the forms of a horse – whether it is static or in movement. Rapid sketches are useful for several reasons: they provide effective preliminary 'notes' for a more elaborate drawing later; they help the artist to choose the most ideal view for drawing his or her subject; and they allow the artist to evaluate the composition before committing to a more detailed, time-consuming portrait (for example, it is often better to omit or blur the background behind the subject to bring them more into the fore).

A quick summary sketch almost always better expresses a kind of vitality and 'freshness' than a laborious study, and even more than a 'finished' drawing. For this reason, and to see the various procedures involved in the drawing of one subject, I have placed the relative tonal studies alongside the more elaborate horse drawings. The final, elaborate drawing can have value by itself, but it can also be a preparatory study for a painting or a sculpture: for instance, many horse lovers or owners often like having an 'artistic', personalized portrait made of their favourite horse.

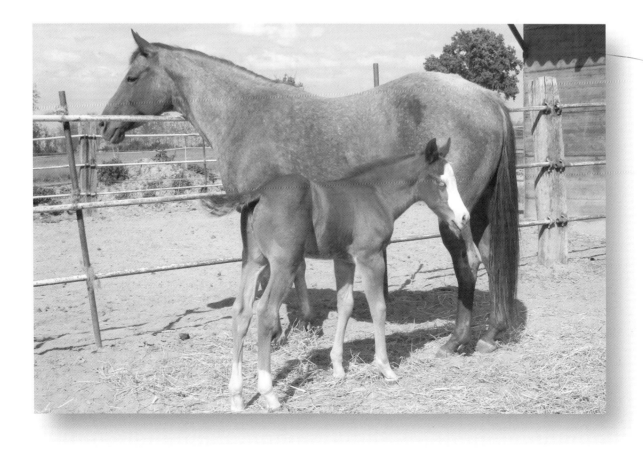

ANATOMY

A horse's body, like most mammals, comprises a skeleton that is the solid, 'passive' supporting structure (that permits locomotion through the bone joints), and an 'active' muscle element (musuclar system) that is necessary for carrying out the various movements (and often determines the external shapes, too).

BONES AND ARTICULAR COMPONENTS

The skeleton comprises an axial part (skull, spine, rib cage) that is attached to the appendicular part (the front and rear limbs). The rear limbs are articulated with the spine through the pelvis. Unlike humans, the front limbs do not have clavicle bones, but are connected to the torso by strong muscles only. To draw a horse correctly, whether static or moving, a basic knowledge of the skeleton is essential at least, as the proportions of a horse and the framework of its stance or action depend on it. The overall bone structure is already sufficient for suggesting the arrangement of the body in a space; however, a knowledge and the identification of the body's 'landmarks' (i.e. small areas where bones can be perceived just under the skin, such as the forehead, limb joints, withers, scapular rim and iliac crest) is useful for establishing or verifying the sizes and proportions of the various parts of the body.

Diagram of the bone structure (in a lateral projection):

1 – cranium and upper maxilla
2 – cervical vertebrae
3 – scapular cartilage
4 – thoracic vertebrae
5 – lumbar vertebrae
6 – sacrum
7 – caudal vertebrae
8 – ileum
9 – ischium
10 – femur
11 – fibula
12 – tibia
13 – calcaneus
14 – tarsals
15 – phalanges
16 – metatarsus
17 – patella
18 – ribs
19 – ulna
20 – phalanges
21– metacarpus
22 – carpals
23 – radius
24 – sternum
25 – humerus
26 – scapula
27 – mandible

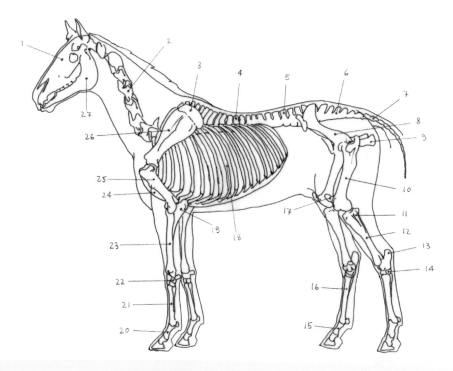

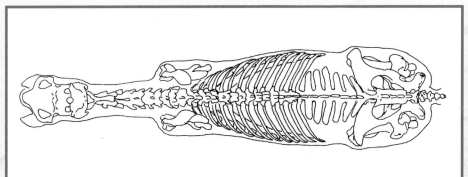

Bone structure in a typical horse's body, seen in a zenithal projection.

MUSCULAR COMPONENTS

If the skeleton is the 'bearing' support structure of the body, all the muscles (which are covered by fasciae, adipose tissue and skin, and are aided by tendons that connect them to bones) shape the external form of the horse's body. The skeletal muscles, of which there are many, vary in strength and are distributed across the body in overlapping layers, from the deepest muscles to the muscles that sit closest to the skin. The muscles in this last, top layer are the ones that influence the appearance of the body greatly, but it must not be overlooked that, together with the deep muscles, they contribute to defining the volumes of the different body regions, as well as the simple visual appearance.

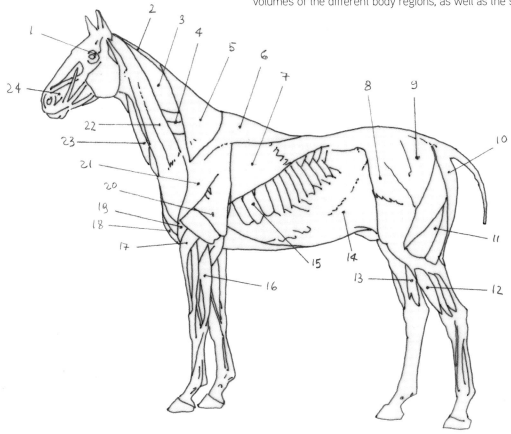

Diagram of the main superficial muscles (in a lateral projection):

1 – orbicularis oculi
2 – rhomboid
3 – splenium
4 – serratus anterior
5 – cervical trapezius
6 – thoracic trapezius
7 – latissimus dorsi
8 – tensor fasciae latae

9 – gluteus superficialis
10 – semitendinosus
11 – biceps femoris
12 – extensor digitalis longus
13 – flexor digitalis longus
14 – external oblique
15 – serratus
16 – extensor carpi ulnaris

17 – extensor carpi radialis
18 – pectoral
19 – brachialis
20 – triceps brachii
21 – deltoid
22 – brachiocephalicus
23 – sternocephalicus
24 – caninus

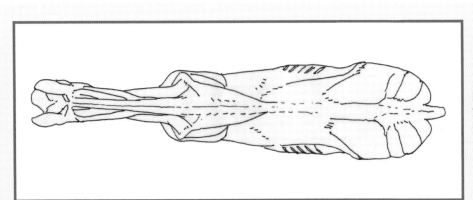

Muscular components in a typical horse's body, seen in a zenithal projection.

EXTERNAL MORPHOLOGY

The outer shapes of the horse can be appreciated more when the horse is static, is in an anatomical ('placed') position and is seen in a lateral projection (as seen below and on the previous pages). For descriptive purposes, or for easy reference, a horse's body can be divided into general, superficial regions where boundaries are established conventionally, and are suitably named using common words or equestrian terminology.

Main morphological features on a typical horse:

1 – forelock
2 – ear
3 – nape
4 – mane
5 – withers
6 – ridge
7 – loins (kidneys)
8 – hip
9 – rump
10 – tail
11 – buttock

12 – thigh
13 – leg
14 – hock
15 – cannon
16 – fetlock
17 – foot (hoof)
18 – chestnut
19 – stifle fold
20 – flank
21 – stomach
22 – ribs

23 – forearm
24 – elbow
25 – shoulder
26 – neck
27 – cheek
28 – lip
29 – nostril
30 – bridge of nose
31 – eye
32 – forehead

TYPICAL MORPHOLOGICAL CHARACTERISTICS

Ears

The auricle or pinna (outer ear) is covered in a very thin layer of skin and is supported by a lamina of elastic cartilage. It is shaped like a diagonally cut cone. The lateral edge is continuously convex, while the medial edge has an upper concave section and a convex lower section. The auricles are extremely mobile: they can be moved in pairs or individually, and can be turned in various directions. The length of the outer ear is more or less equivalent to the distance between the top of the head and the lateral corner of the eye.

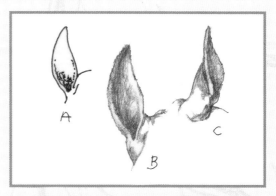

A – simplified diagram of a horse's right ear
B – frontal projection
C – lateral projection

Eyes

The eyeballs are rather large, and each eyeball is protected by two external eyelids and a 'third eyelid' positioned at the medial corner of the eye, next to the lacrimal caruncle. When the eye is 'open', the eyeball shows almost the entire iris, framed by the two outer eyelids that form an almost circular rim. Long eyelashes jut out from the eyelids, especially the upper one. The eyes are contained in eye sockets which are oriented towards the lateral plane, far from the head's median line. There is a characteristic depression (fossa) above the upper socket arch, near to the zygomatic arch.

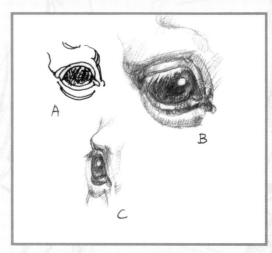

A – simplified diagram of a horse's right eye
B – lateral projection
C – frontal projection

Nostrils

The nostrils are external openings of the nasal cavities, located above the upper lip. Each nostril is a wide, oblique slot that is laterally convex, with a wide portion at the bottom that then narrows towards the top. The nostril is extremely mobile; it dilates when the horse breathes in deeply and during intense action, and contracts when breathing normally.

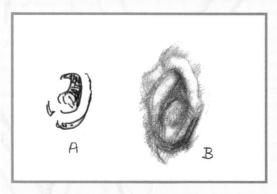

A – simplified diagram of a horse's left nostril
B – oblique projection

Mouth

The lips are the two muscle-membrane plica that surround and close the mouth opening, covering the horse's teeth. They are extremely mobile and have a few sparse tactile hairs, especially on the upper lip, which also has a slight vertical depression along its median line.

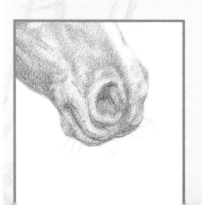

Hooves

The hoof is a horny formation of the epidermis. It has an outer wall, a part which touches the ground (sole) and a part that is embedded in the sole (frog), the ends of which splay and end at the heel in two lumps (heel bulbs). The outer wall is higher at the front and lower at the rear. From a frontal view the faces of the wall diverge towards the bottom, while from a side view they are almost parallel. The plantar face (sole) has an almost circular profile in the front limbs, unlike the rear limbs where it is more oval.

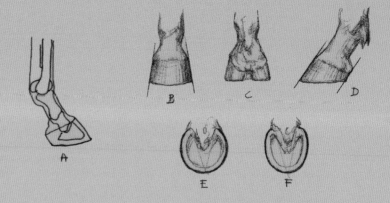

A – the external profile and the bone structure within it
B – anterior projection
C – posterior projection

D – lateral projection
E – plantar projection (front limb)
F – plantar projection (rear limb)

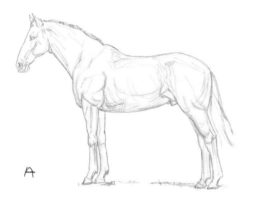

MORPHOLOGICAL DIFFERENCES IN SOME SPECIES

At first glance, all horses look similar. However, this is not actually the case: there are big morphological differences between the many horse breeds that exist and in the individual horses in them. By combining a good knowledge of basic horse anatomy and taking time to observe the horse in question, it is possible for the artist to create an authentic 'portrait' of the horse, capturing its particular shape, proportions and character.

The diagrams shown here should be enough to suggest an attentive and curious observation of each horse that the artist intends to draw.

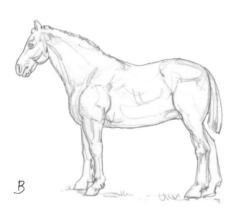

A – **'Race' horse:** longilineal (long-limbed and slender) in shape; wide, has a streamlined head; a long, slim neck; a horizontal back; long, slim limbs; prominent withers.

B – **'Cart' horse:** brevilineal (broad and short-limbed); has a solid, wide head; a concave spine; a wide, rounded rump; a thick neck; short, robust limbs.

C – **'Saddle' horse:** it has intermediate proportional ratios and shape, compared to those of the two previous types. The Quarter horse is representative of this type and is now also widespread outside the great Northern American plains. It has a normolineal conformation although is somewhat sturdy looking, with strong muscles but good agility; has a short, wide head; a short back; average length limbs. Many of the horses that I have drawn in this chapter belong to this breed.

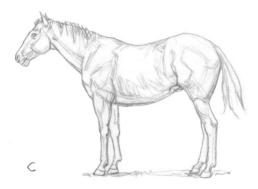

PROPORTIONS AND PERSPECTIVE

PROPORTIONS

The horse has been studied in all its aspects for hundreds of years, including from an aesthetic point of view – both for the purpose of portrayal (for example, in paintings and sculptures), and for a morphological appreciation of function or state of health. Thus, several different measurements and proportional ratios have been taken, but generally, it suffices for the artist to 'imagine' the horse's body in a square, in a lateral projection, where the side is equivalent to the height of the withers.

The same measurement extends horizontally, from the sternum to the ischial tuberosity. The horse's head can be divided into three sections of the same size, corresponding to the distance between its eyes. It should be noted that these measurements provide an approximate proportional reference for the artist, but when possible a horse's stature should be considered and observed live.

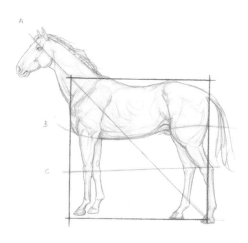

A – the diagonal of the square is also useful for evaluating the direction of the axes of the neck and the head.

B, C – the two lines highlight the profile of the stomach (more accentuated at the front) and the different level of the knee joints (in the front limb) and the hock (in the rear limb).

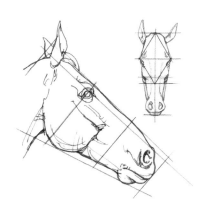

PERSPECTIVE

Like all three-dimensional objects, a horse's body is located in a space and in an environment. An oblique linear perspective can be useful when placing a horse in a space correctly in relation to other figures and animals, or with other surrounding elements, to evaluate the foreshortening of the individual body parts, and to outline the extension and direction of the projected shadows. An oblique linear perspective requires that the subject (the horse's body) is placed in relation to the horizon (which is always at the observer's eye level) and two vanishing points at varying distances on the horizon, with which the imaginary oblique lines tangential to the body converge.

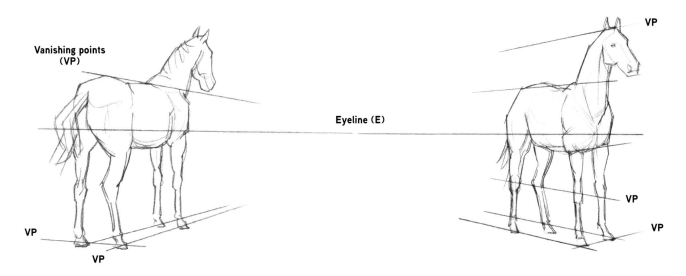

Vanishing points (VP)

Eyeline (E)

VP

APPROACHES TO DRAWING

BASIC DRAWING TECHNIQUES

There are various tools used for drawing. The traditional and most commonly used ones are graphite, charcoal, pen and ink. The way in which the drawing is made can vary even more, and depends on each artist's style and the aim of his or her work (for example, scientific or documentary analysis, or a personal aesthetic expression). There are, of course, differences in conception and execution, even in the event of wishing to draw a rapid sketch or an elaborate, in-depth study. In this chapter (and throughout this book), it will suffice to look at two ways of proceeding that can be integrated into the drawing to varying degrees either independently, or in conjunction with each other.

Linear drawing

This method concentrates on the structure of the body overall or its individual parts. It suggests the volumes and defines the ratios by modulating or adjusting only the lines, which can be of varying thicknesses and repeated to suggest some *chiaroscuro* (highlights and shading) effects. Suitable tools may be an ink pen, a hard graphite (H or HB) stick and a ballpoint pen.

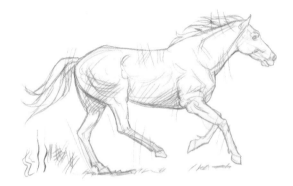

Tonal drawing

The tonal approach, on the other hand, concentrates on modulating tones and emphasizing the *chiaroscuro* effects. Lines establishing structure and shape give way to the contrasts and relationships of adjacent tones, as these alone are enough to hint at the volume of the body. Suitable tools are the ones that leave soft lines which can easily be blurred with a finger, rag or putty eraser: charcoal, soft graphite (2B, 4B or 6B) sticks, watercolours in a monochrome palette, for example.

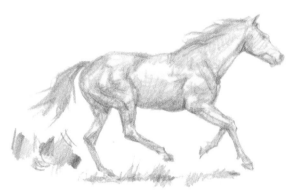

STRUCTURAL SIMPLIFICATION DIAGRAMS

The shapes of a horse are rather complex to draw, especially when the animal is moving or in an unusual position. In these cases, simplifying the structural lines of the larger volumetric 'masses' is essential for effective portrayal, to lend vitality to the drawing and its subject. For example, it is useful to practise drawing (also from memory or imagination) a number of similar diagrams to the ones suggested here.

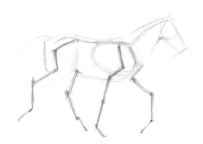

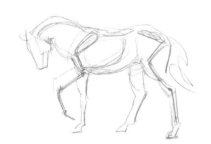

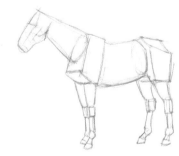

Indication of a skeleton in a 'transparent' body shape, intended to establish the structure of the horse and the main axes of rotation (for example, the spine and limbs).

Identification of the superficial 'planes', and the 'geometrization' of the body shapes, likened to flat or solid geometric shapes (for example, a square, cube, circle or sphere.

Indication of the main volumetric masses and their mutual relationships.

THE GRID METHOD

Of the many 'mechanical' procedures – which includes photocopying, projection, photographic and digital zooming – that can be used to reproduce a flat reference picture (whether drawing or photograph), that of using a grid is the simplest and oldest. While providing great precision for transferring the outlines of an image's basic structure, it also allows full freedom for the artist to develop the drawing further. The procedure is simple and intuitive, and can be summarized as described below.

Step 1 – A number of parallel lines (horizontal and vertical) are traced directly (or onto tracing paper) onto the reference image (or a photocopy) to form a grid of squares which vary in size, depending on the degree of precision with which one wishes to transfer the image.

Step 2 – Lightly drawn pencil lines are used to produce the same grid on the drawing surface (paper, canvas, etc.). Changing the distance between the lines creates larger or smaller squares.

Step 3 – The main outlines and shapes within each square on the reference image are transferred to the corresponding square on the drawing surface's grid, until the whole outline of the subject has been traced. Before working on the transferred image and applying more free-hand procedures, it is advisable to rub out the grid lines.

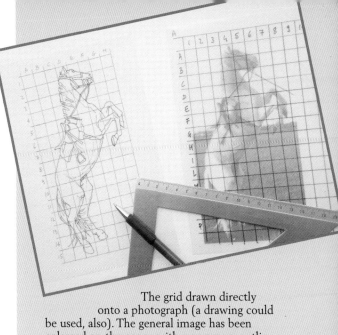

The grid drawn directly onto a photograph (a drawing could be used, also). The general image has been enlarged on the paper, with a summary outline made of the horse and its main shapes. The numerical and alphabetical axes at the sides of the grid are useful to the artist for finding particular squares.

PRACTICAL CONSIDERATIONS

Where to find horses Horses are rarely used for general travel and work nowadays, but they can be still easily viewed live by visiting a stud farm, riding stables, racetracks and country fairs, to name a few. Images of horses can be found in books or magazines and in footage (horse races, polo matches or rodeos etc.), or in classic Western or historical films.

Understanding horses There is no need to fear horses, but it is necessary to be careful when approaching them as every horse has its own particular nature and personality. A horse has a very refined sense perception, so can grasp even the smallest changes in the surrounding environment. Many clues to its intentions and mood can be found in its eyes (wide eyes suggest nervousness or fear), by observing whether its nostrils are flared, and also by looking at its ears and how they move. For example, if the ears are long and lowered backwards, the horse is expressing aggressiveness; if the ears are straight and stretched forwards, it's attentive; if the ears are rotating, it's nervous; if the ears are turned out to the side, it's tranquil.

How to behave with horses Avoid loud, sudden noises or brusque movements, and do not stop or walk close to their rear legs and tail, as they may suddenly kick or evacuate. It is preferable to work (standing or sitting) to the side, allowing one to pay attention to both the drawing and any signs of the horse's restlessness. The best place for viewing the horse and ensuring its tranquillity is when the horse is left free in a small paddock.

When to observe horses All horses have a marked tendency to graze for a long time, and thus assume rather monotonous postures. They are, however, more lively and inclined to run or jump immediately after being released from their stable enclosure into the free space of a meadow or a paddock. In the cold winter season, horses' hair becomes denser and thicker, and consequently their coat makes the superficial muscles less defined. In the summer season, the heat makes the horse (and the artist) more idle and wanting to seek refuge in the shade. Therefore, it is clear that the most suitable, comfortable periods for drawing free horses live are during the spring and autumn seasons.

Photographing horses Although a rapidly drawn sketch should be made of the horse initially, enough to express the basic shape and essence of the horse, a photograph is essential for capturing the movement of the horse accurately. The photograph must be taken from a certain distance or using a zoom lens, in order to reduce distortions in perspective proportions. It is worth noting that, even with these considerations, awkward perspective and minor proportional deformations will be present to some degree, and must be rectified in the drawing. The shooting time for the photograph can influence the result of the image. For example, an excessively rapid shutter speed can fix the horse's action, but can also 'freeze' it in an unnatural appearance, while a longer shutter speed can leave some parts of the body blurred or 'moving'. The latter is an effect that can be attractive in the drawing, albeit if applied with moderation.

HOW TO FOLLOW THE GALLERY

The drawings printed in this section (from page 94 to page 159) are intended to give ideas and elements for practice, in order to be able to observe and study proportions and shapes of a static or moving horse. The graphic style that I have used in drawing them is somewhat 'neutral', and involves a *chiaroscuro* with soft transitions. The reasoning for this was to provide as objective a portrayal of the subject as possible, leaving the artist with a general drawing to use as a starting point so that he or she could elaborate on it with his or her own interpretation, according to the styles and techniques that are the most suitable and fitting for his or her own aesthetic awareness and sensitivity.

Each horse is accompanied by rapid preliminary studies, or 'steps' – these are drawings of the outlines, shapes and tones I observed, carried out in a short time with a soft lead pencil, in a much more liberal style than the one then applied to the more elaborate, contemplated drawing (see the drawing below). These preliminary studies serve almost as 'visual notes', to aid in the making of the final, elaborate drawing. For example, in step 1, the overall size of the horse, the space it takes up on the sheet, together with a suggestion of its action are indicated, using a few light lines; in step 2 the supporting structure of the horse, its general volume and the direction of its main axes are established; in step 3, key shadows for modelling the volume are introduced, while modulating the *chiaroscuro* tones.

Most of the more elaborate drawings in this section of the book were drawn using graphite (HB and B) on paper (15 x 21cm/6 x 11in). The tonal studies that accompany almost all the portraits were drawn using softer graphite (4B and 6B) sticks on larger sheets of paper (21 x 28 cm /8¼ x 11in, or US letter).

The grid suggested for each figure can be used as an initial guide to reproduce the basic outline of the horse's body (after having also traced it on to the drawing surface, at the desired size). After this summary indication of the overall dimensions, the next developmental stages concern checking proportions, identifying the constructive planes and establishing tonal effects. The grid can be drawn directly onto the reference image that is to be reproduced, be it a photograph or drawing. I prefer to use tracing paper and then use this to draw only the most summary body parts on it, just enough to begin the next drawing stage.

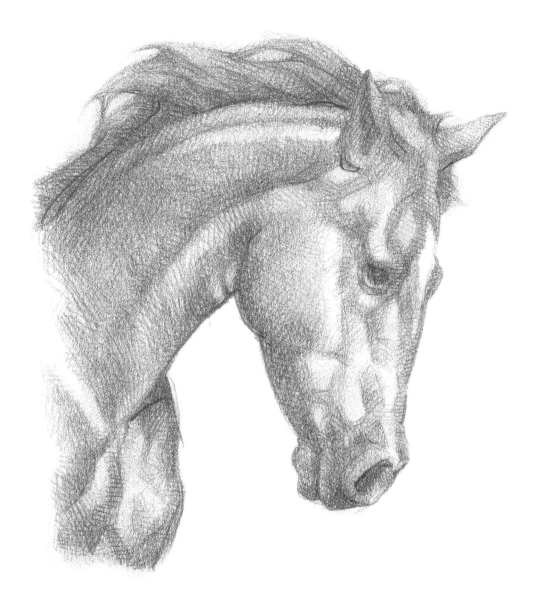

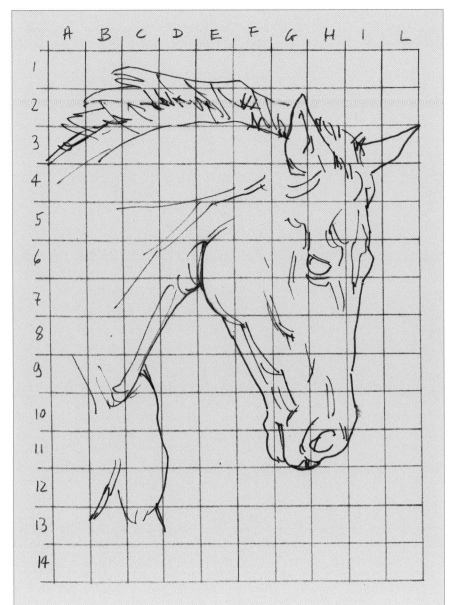

Step 1: Overall shape and size

Step 2: Structure and proportions

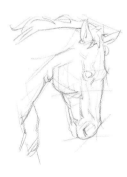

Step 3: Volume and shadows

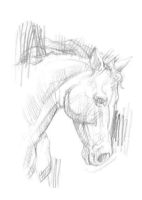

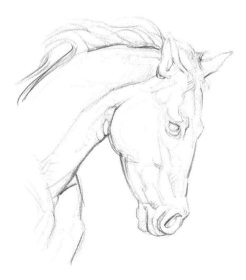

Linear study

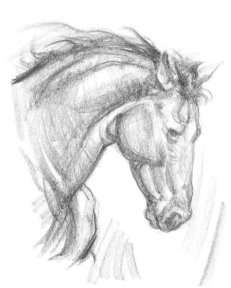

Tonal study

Step 1: Overall shape and size Step 2: Structure and proportions Step 3: Volume and shadows

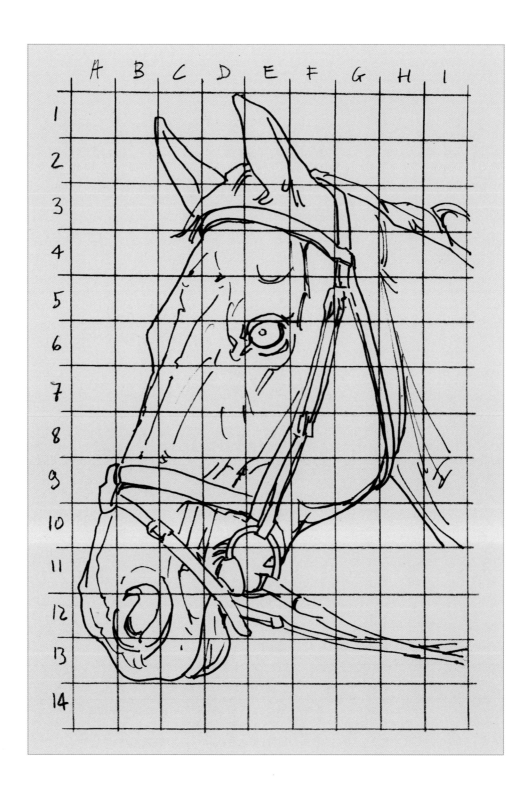

Tonal study

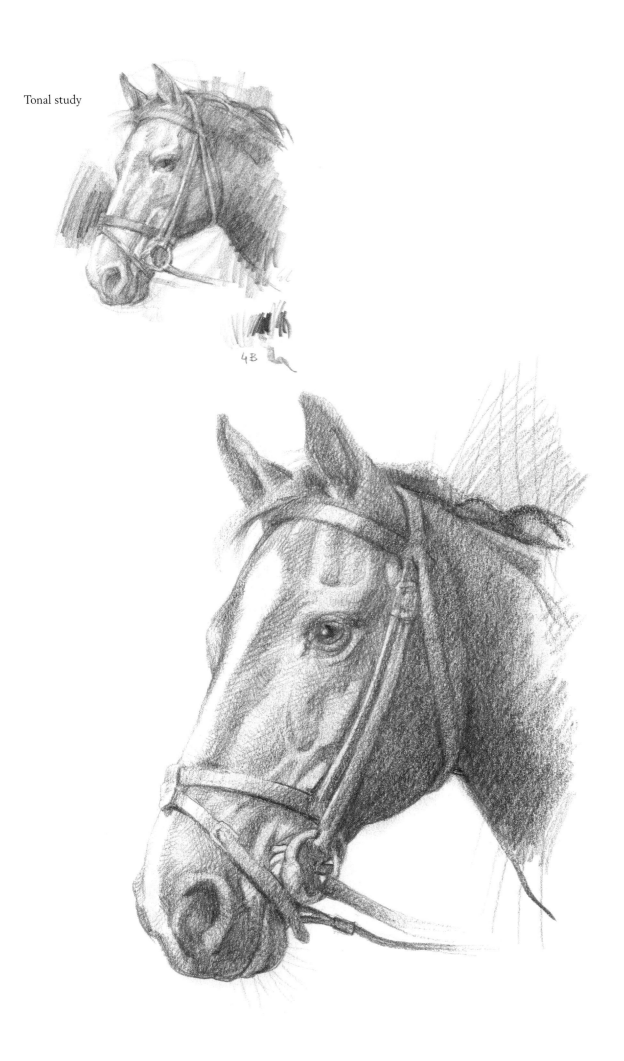

4B

Step 1: Overall shape and size Step 2: Structure and proportions Step 3: Volume and shadows

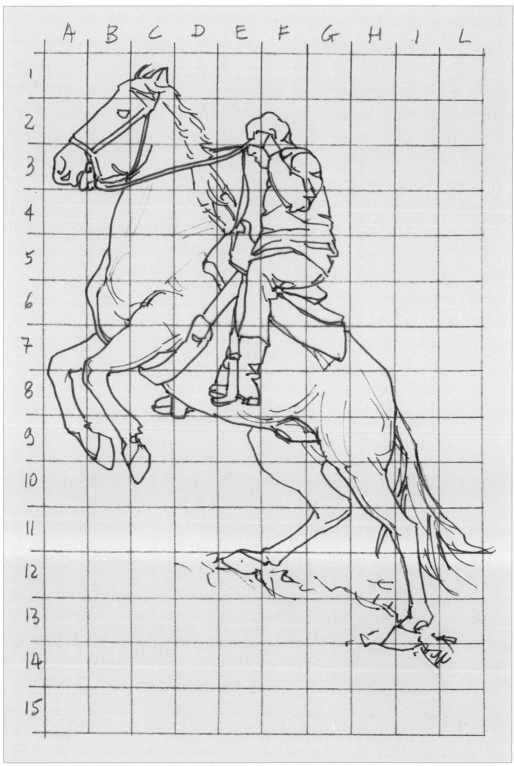

Tonal study

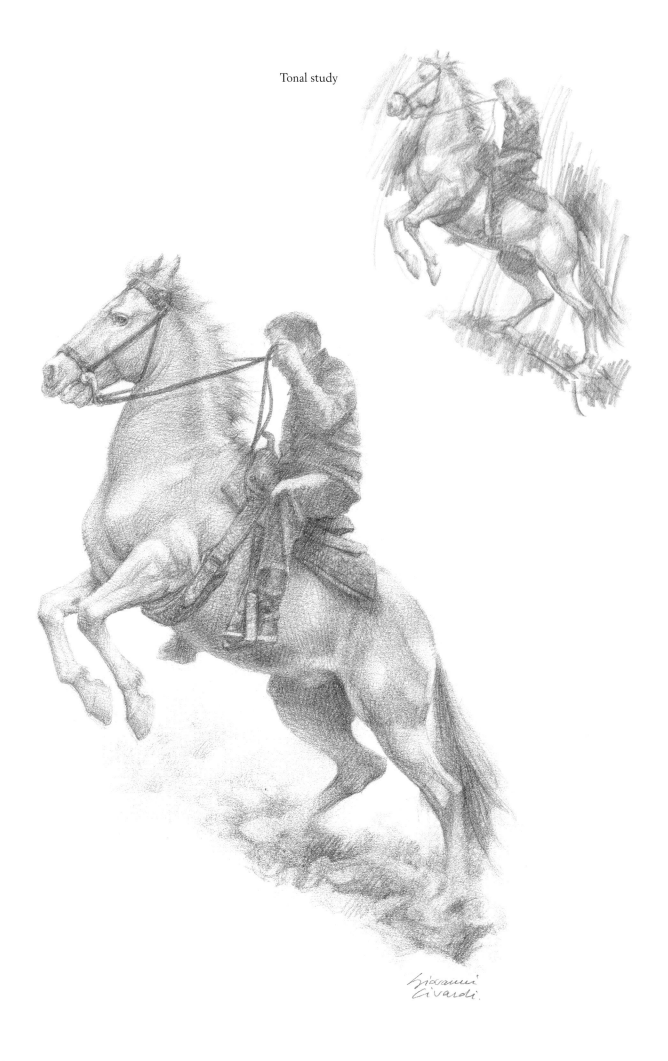

Step 1: Overall shape and size

Step 2: Structure and proportions

Step 3: Volume and shadows

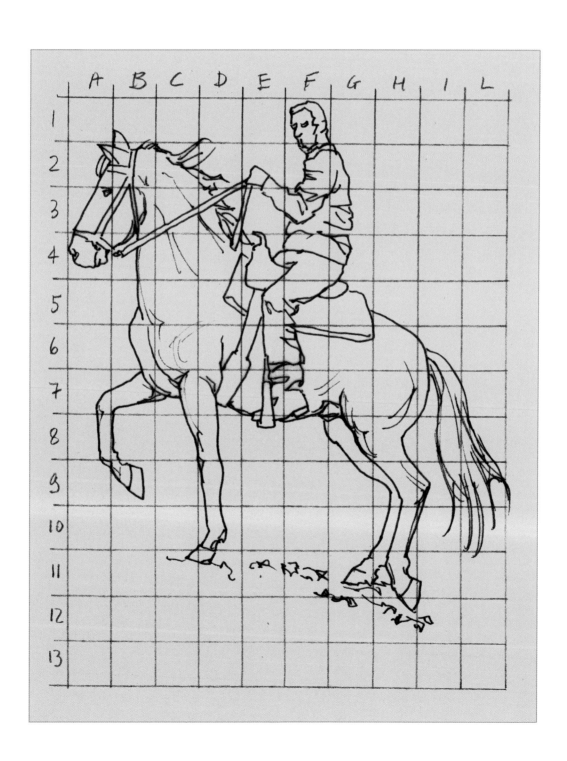

Tonal study

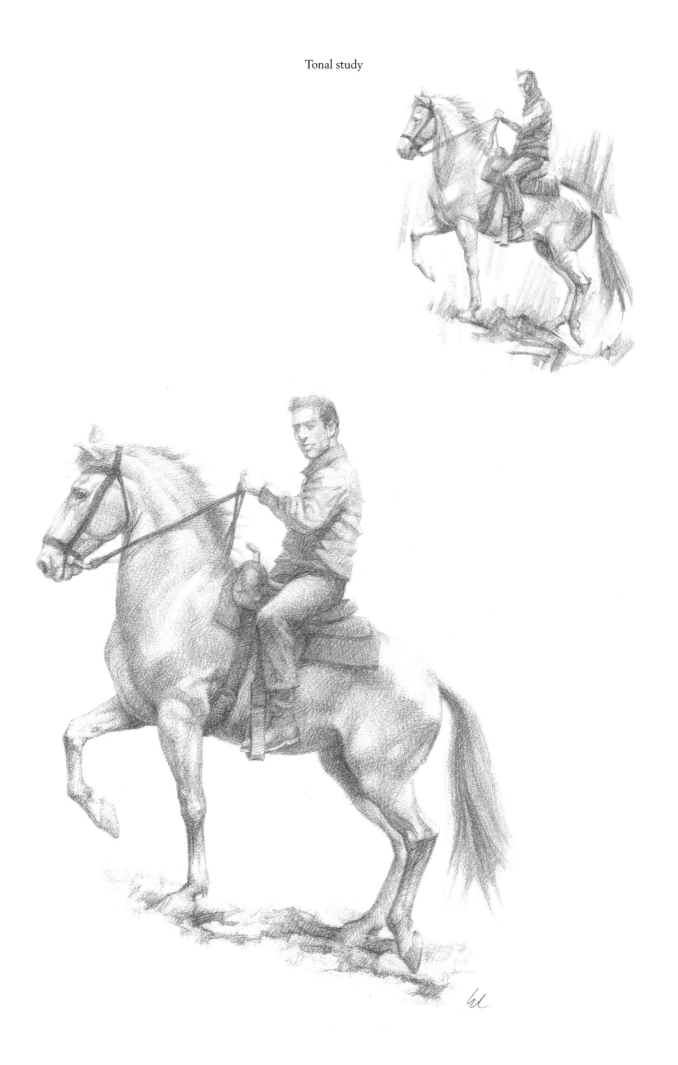

Step 1: Overall shape and size

Step 2: Structure and proportions

Step 3: Volume and shadows

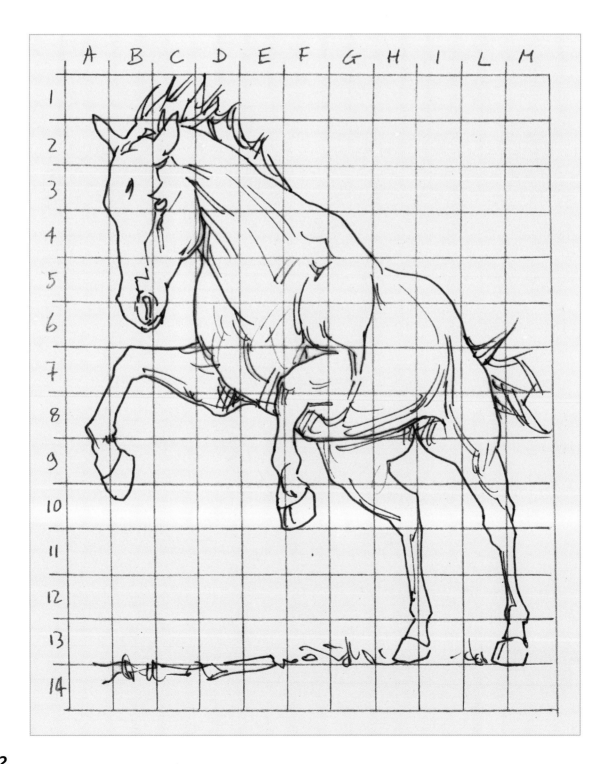

Tonal study

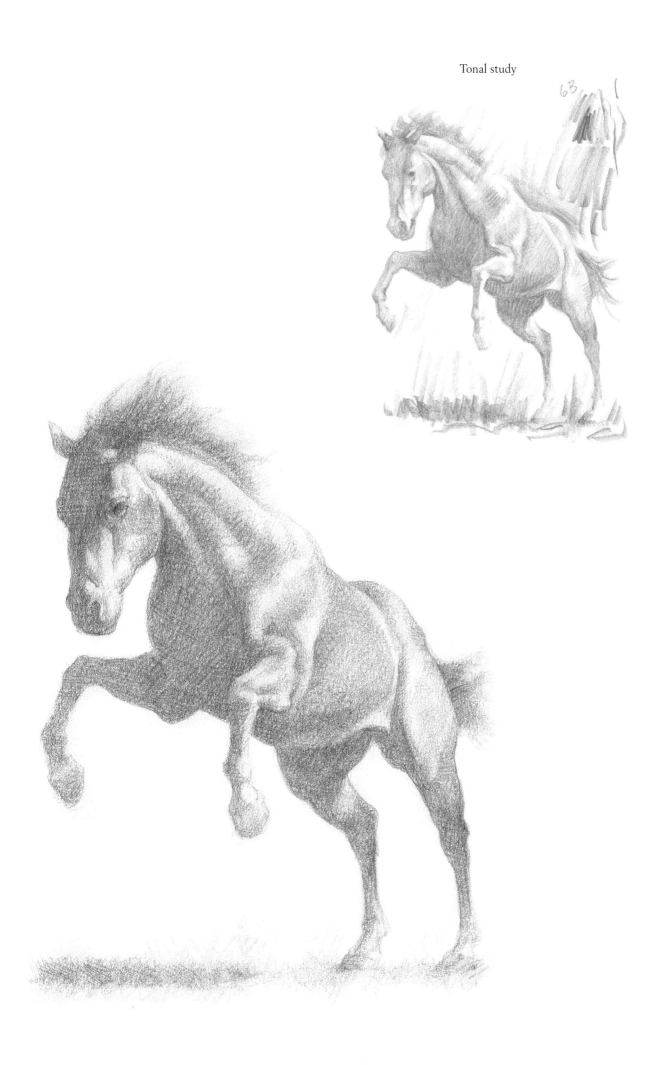

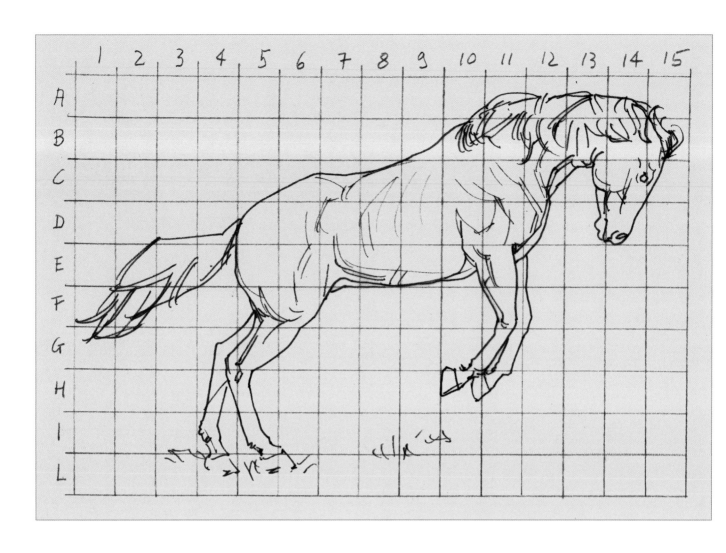

Step 1: Overall shape and size

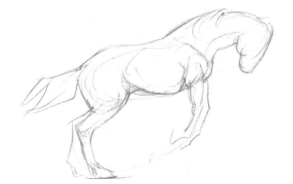

Step 2: Structure and proportions

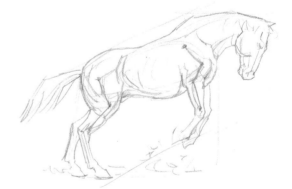

Step 3: Volume and shadows

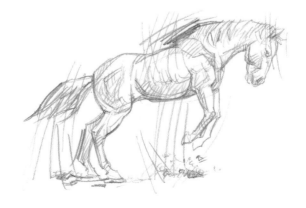

Tonal study

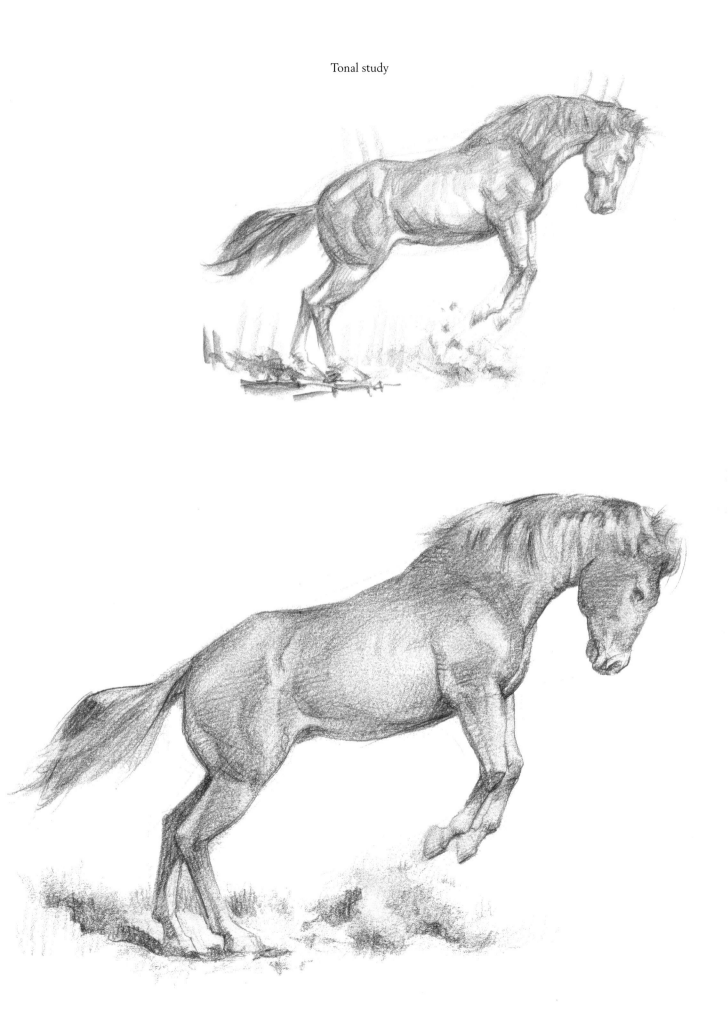

Step 1: Overall shape and size

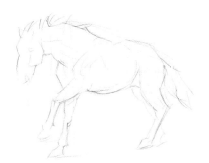

Step 2: Structure and proportions

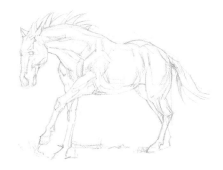

Step 3: Volume and shadows

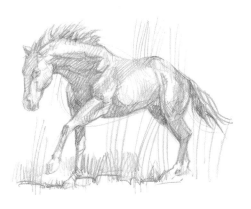

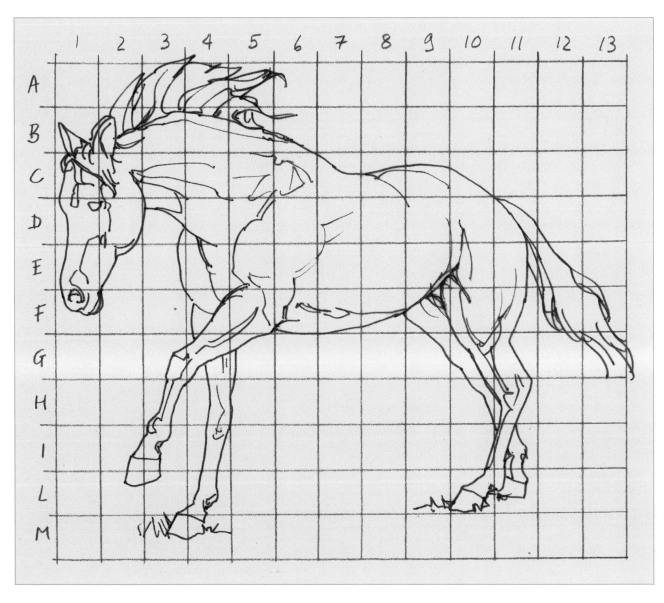

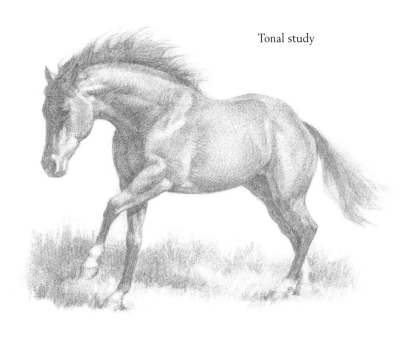

Tonal study

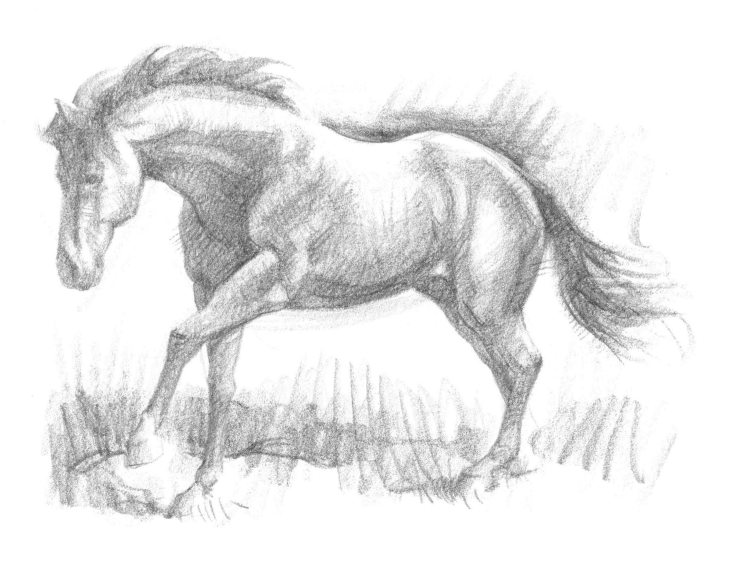

Step 1: Overall shape and size

Step 2: Structure and proportions

Step 3: Volume and shadows

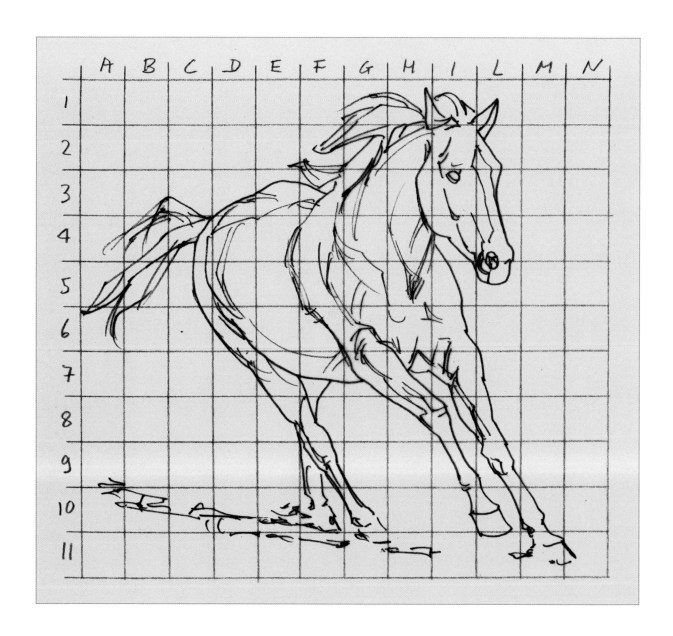

Tonal study

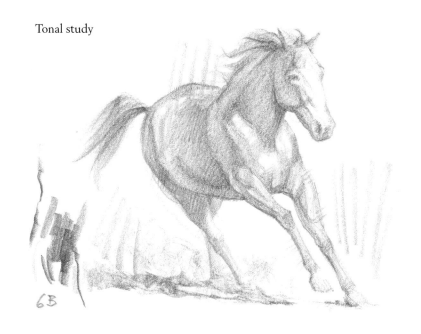

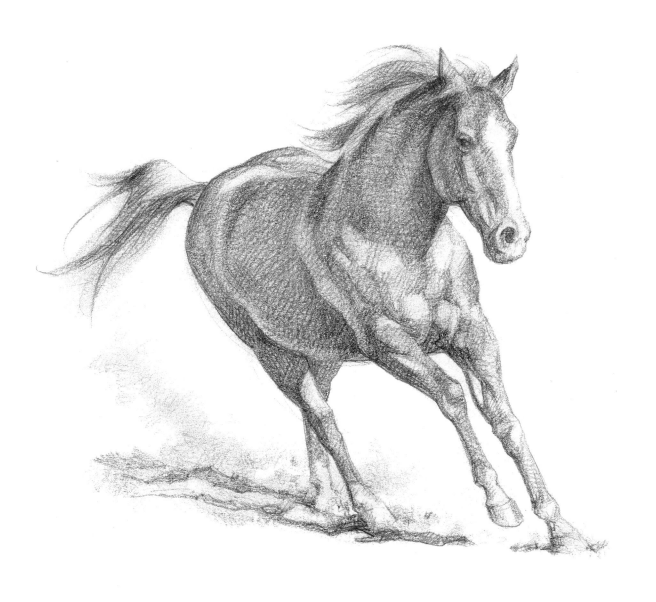

Step 1: Overall shape and size Step 2: Structure and proportions Step 3: Volume and shadows

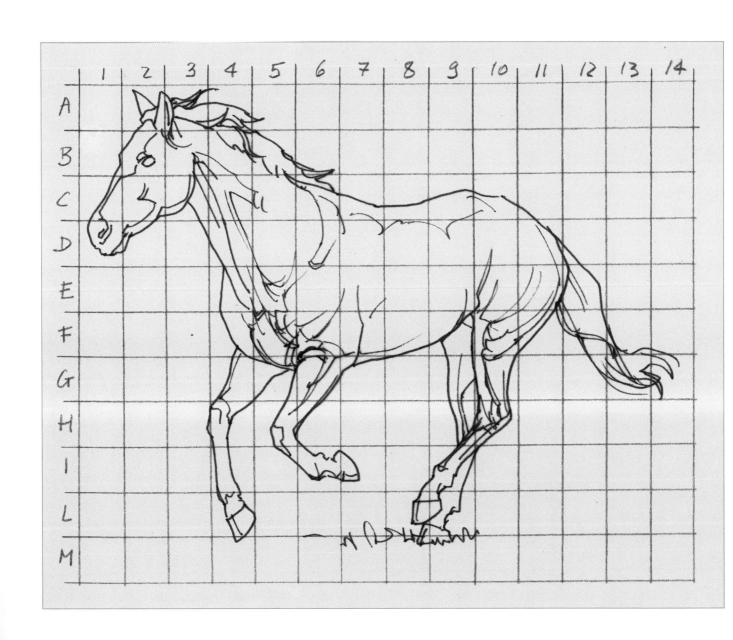

Tonal study

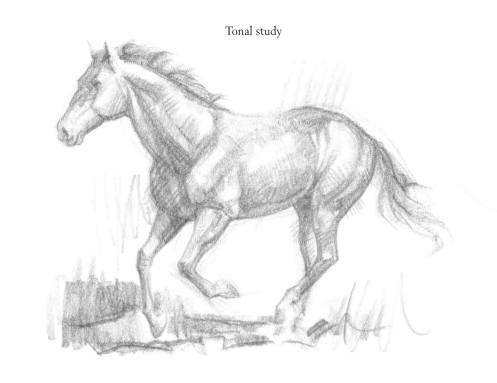

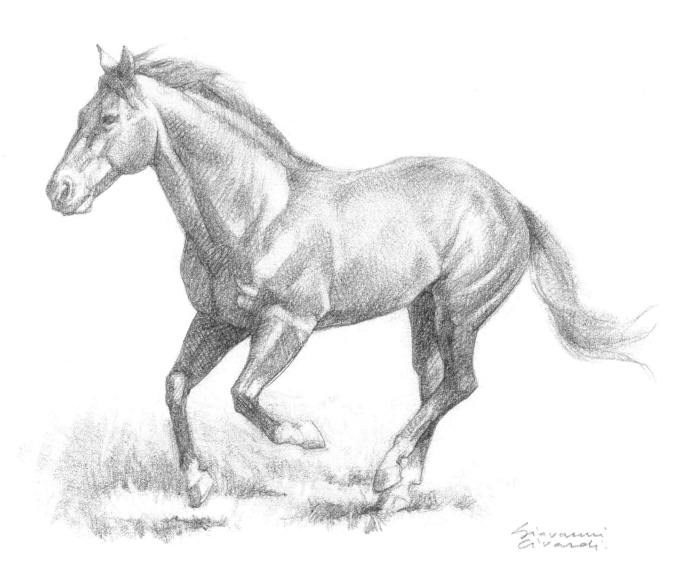

Step 1: Overall shape and size

Step 2: Structure and proportions

Step 3: Volume and shadows

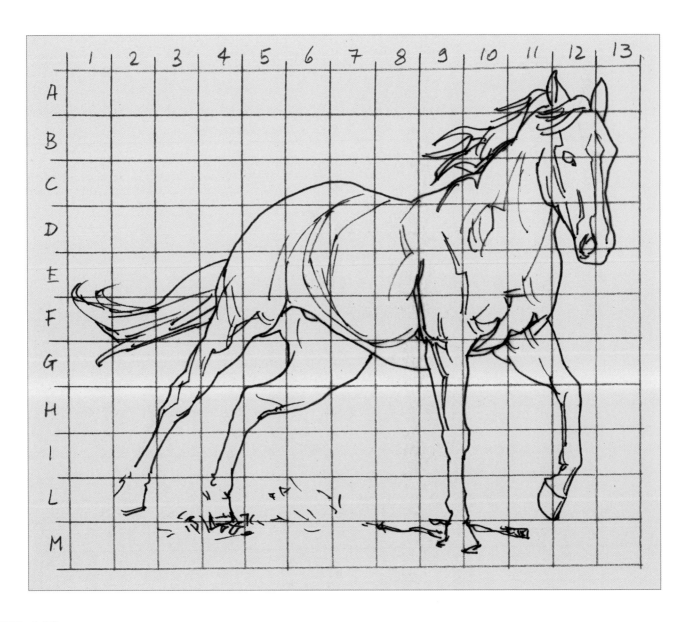

Linear study

Tonal study

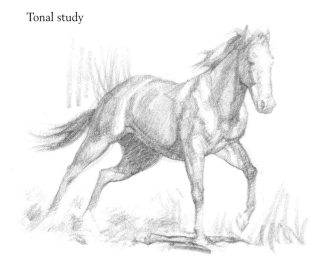

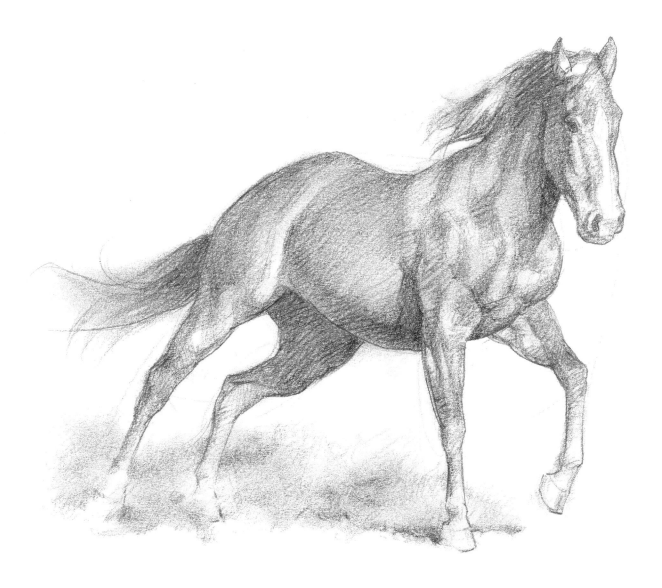

Step 1: Overall shape and size

Step 2: Structure and proportions

Step 3: Volume and shadows

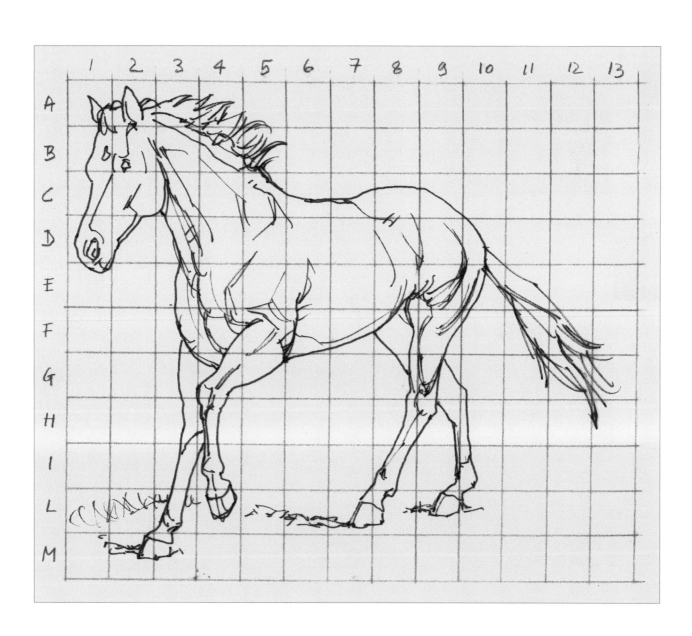

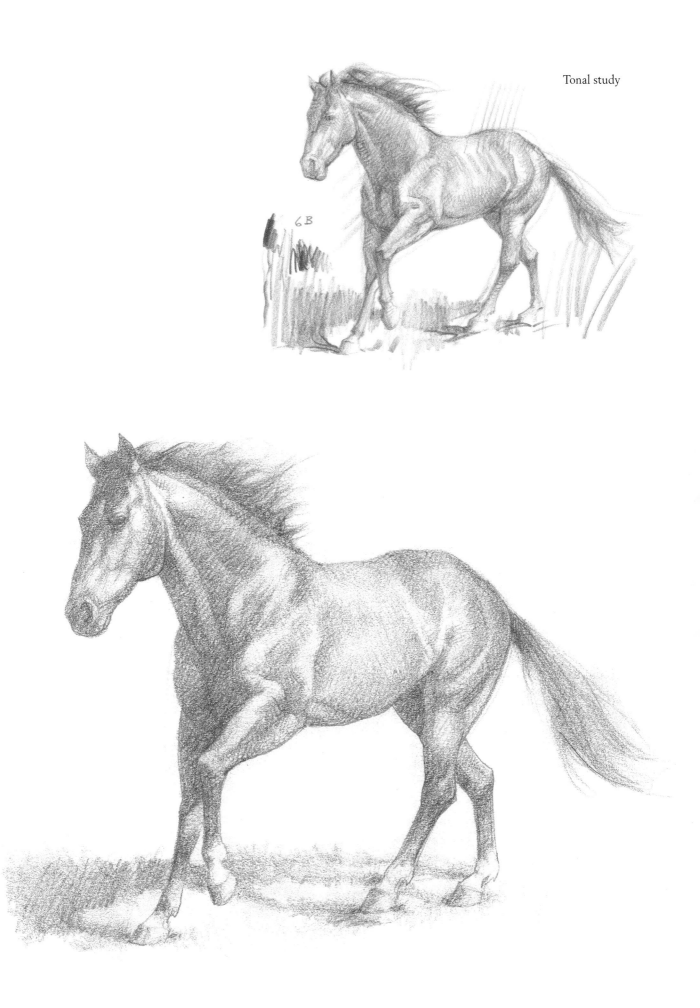

Tonal study

6 B

Step 1: Overall shape and size

Step 2: Structure and proportions

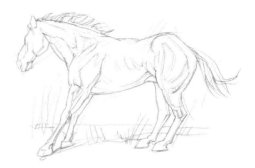

Step 3: Volume and shadows

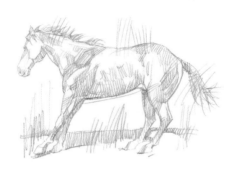

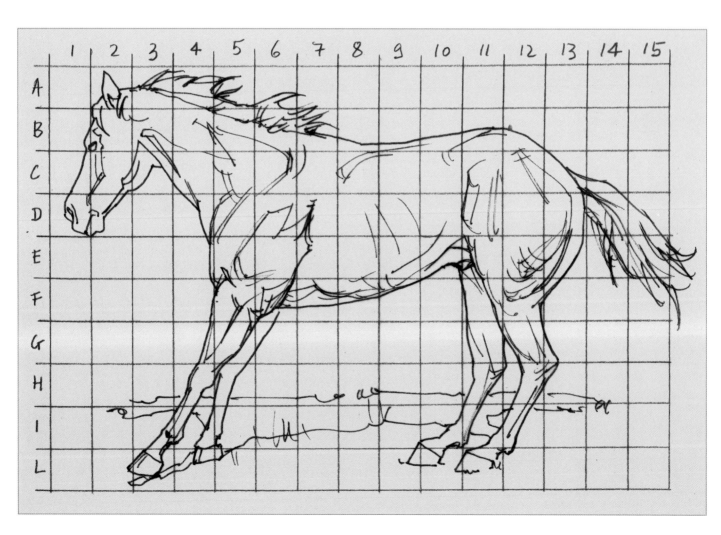

Tonal study

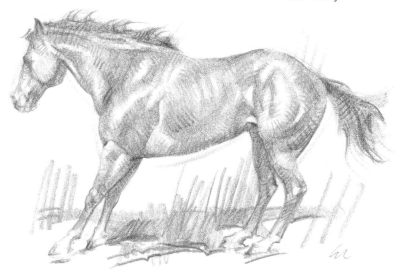

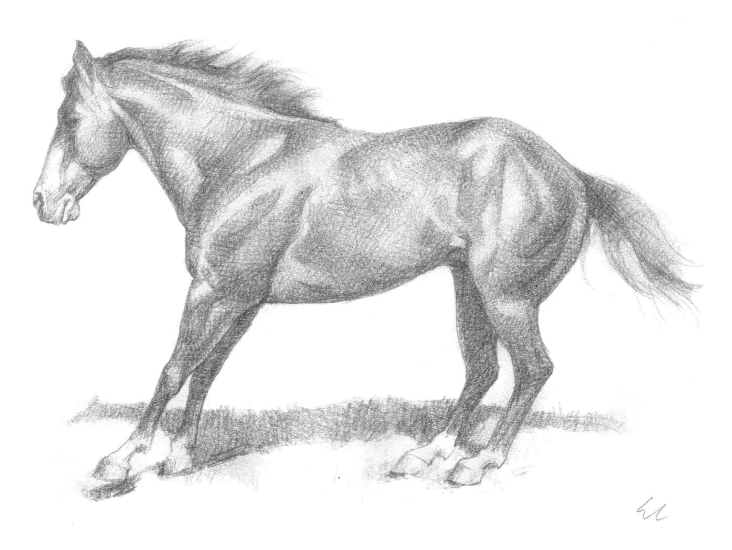

Step 1: Overall shape and size

Step 2: Structure and proportions

Step 3: Volume and shadows

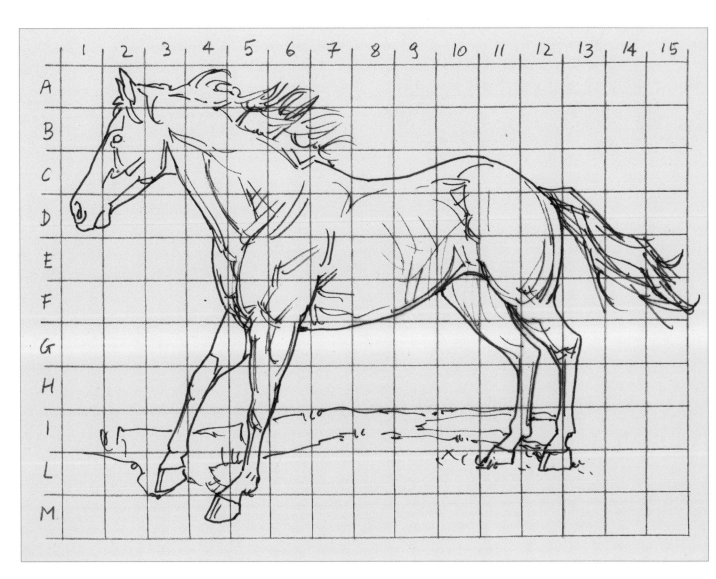

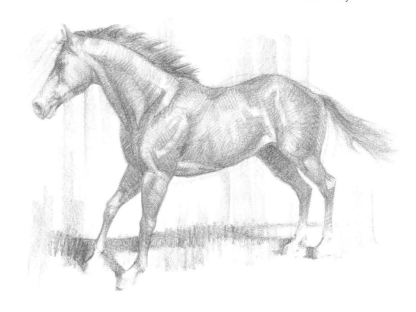

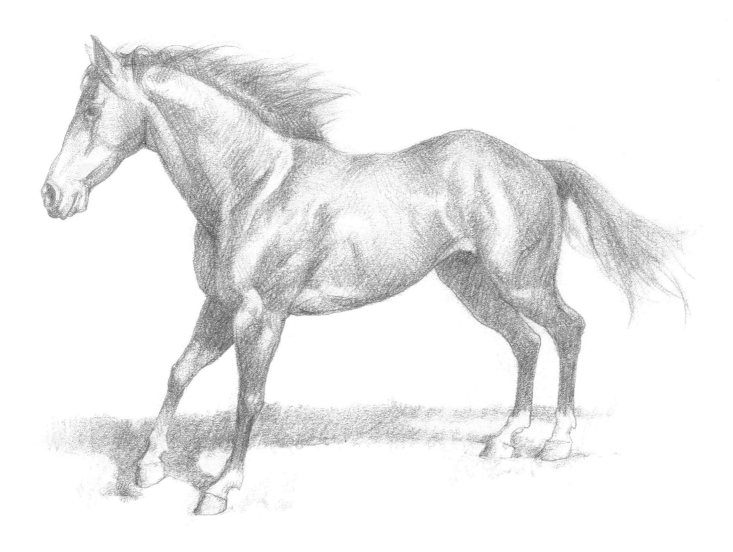

Step 1: Overall shape and size

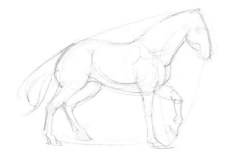

Step 2: Structure and proportions

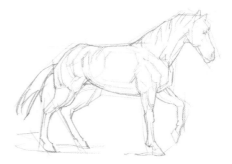

Step 3: Volume and shadows

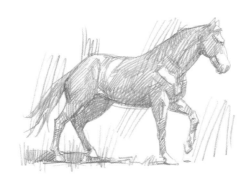

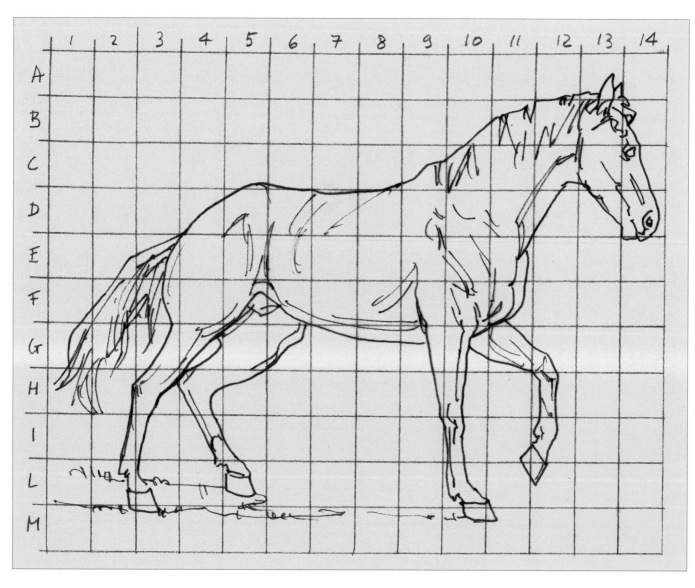

Tonal study

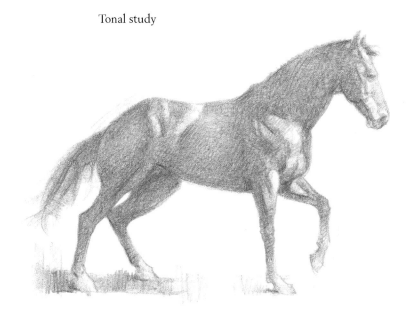

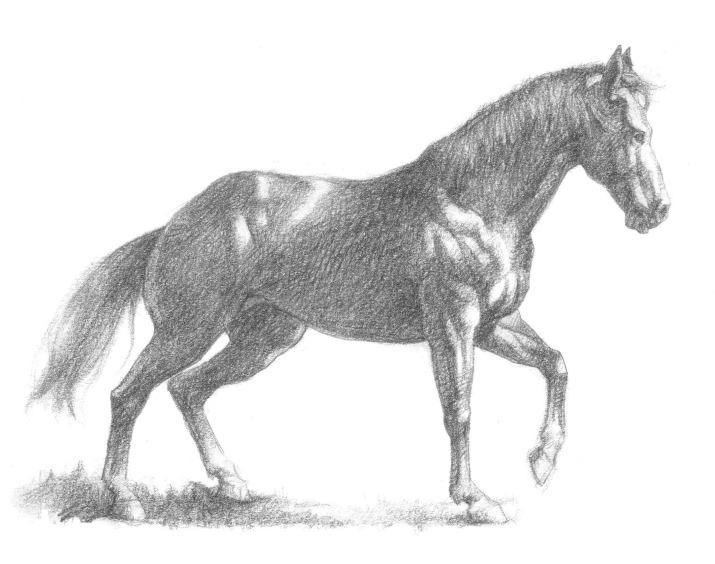

Step 1: Overall shape and size

Step 2: Structure and proportions

Step 3: Volume and shadows

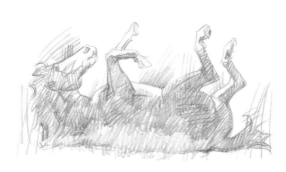

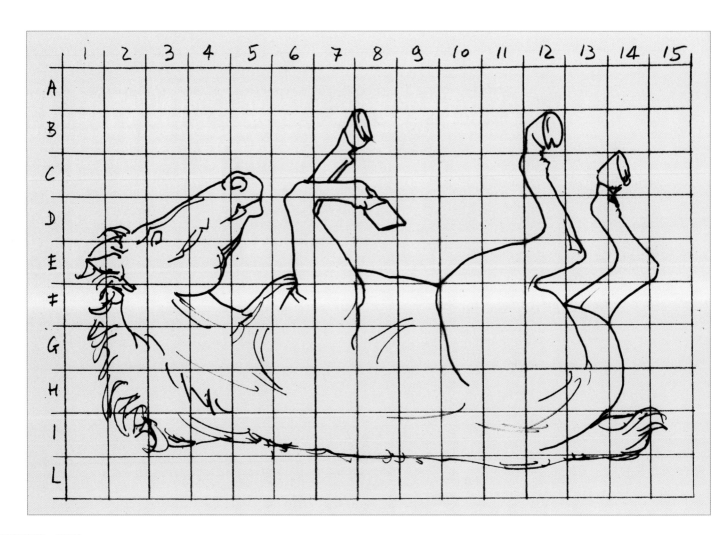

Tonal study

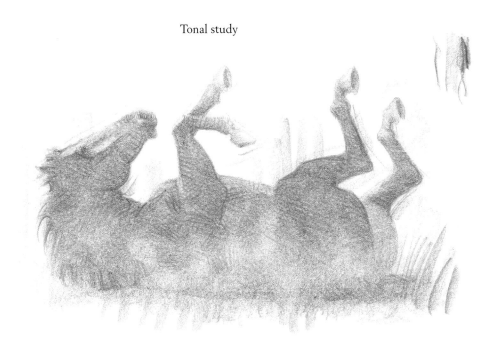

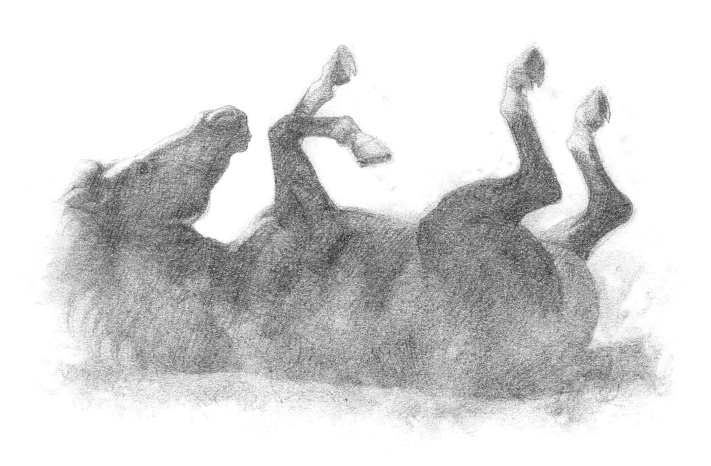

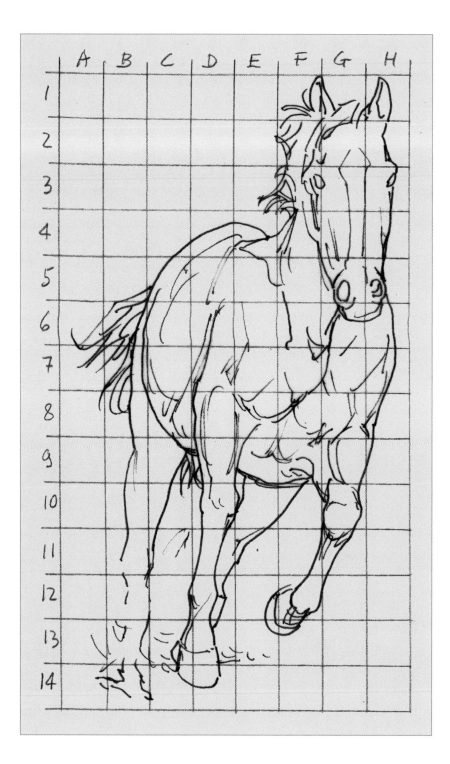

Step 1: Overall shape and size

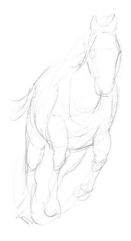

Step 2: Structure and proportions

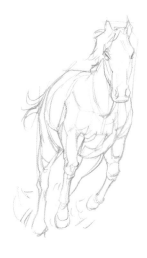

Step 3: Volume and shadows

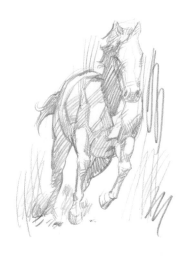

Tonal study

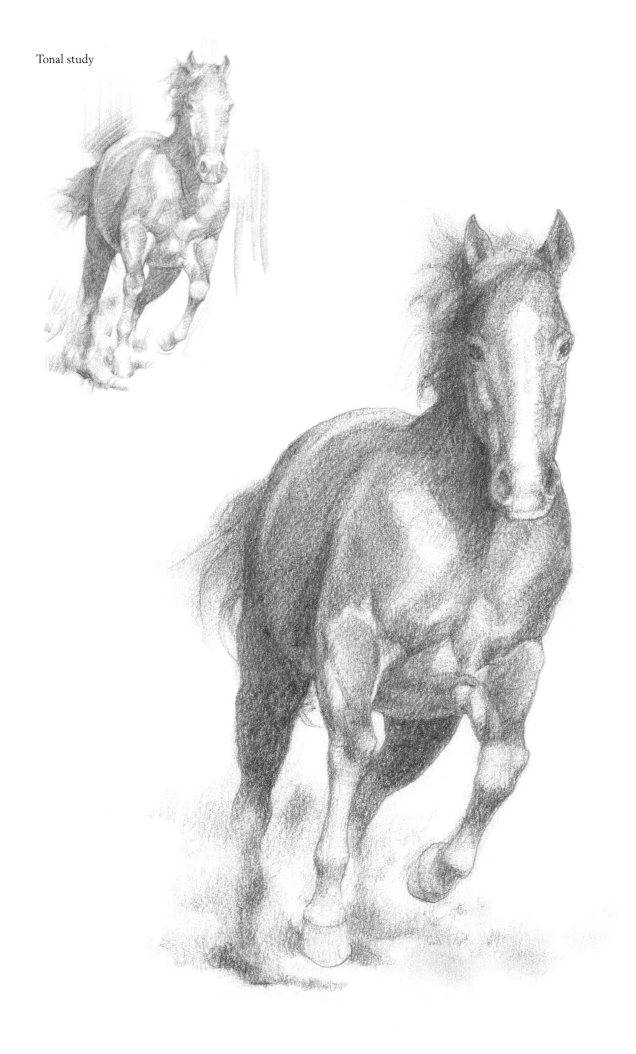

Step 1: Overall shape and size

Step 2: Structure and proportions

Step 3: Volume and shadows

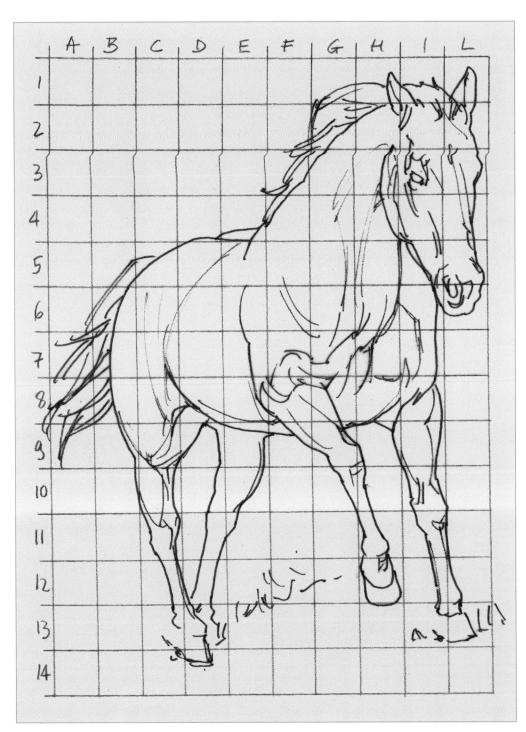

Tonal study

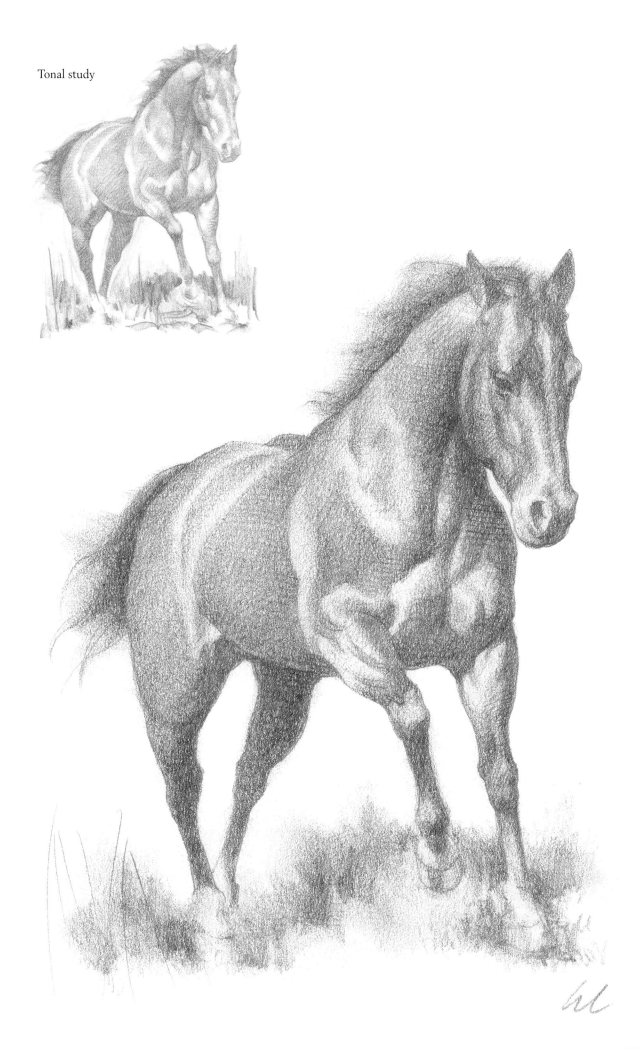

Step 1: Overall shape and size Step 2: Structure and proportions Step 3: Volume and shadows

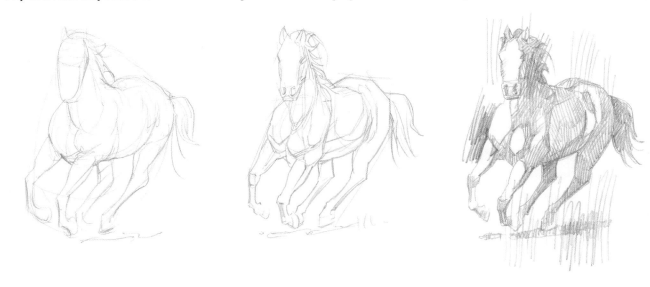

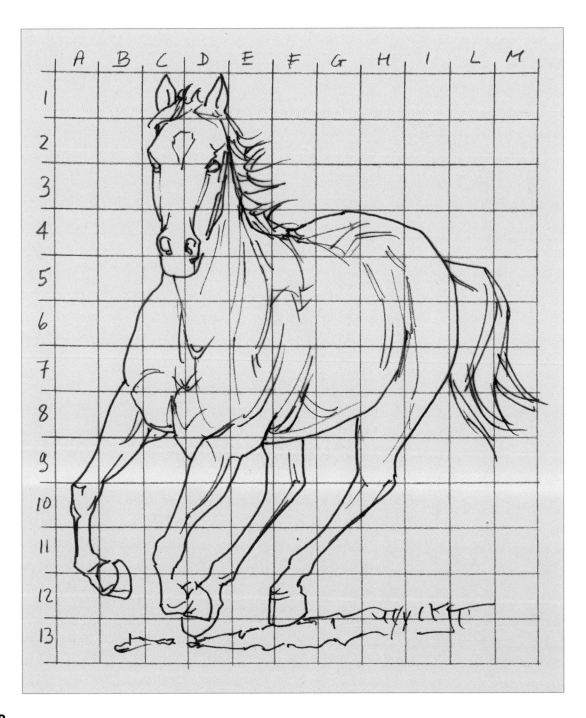

Tonal study

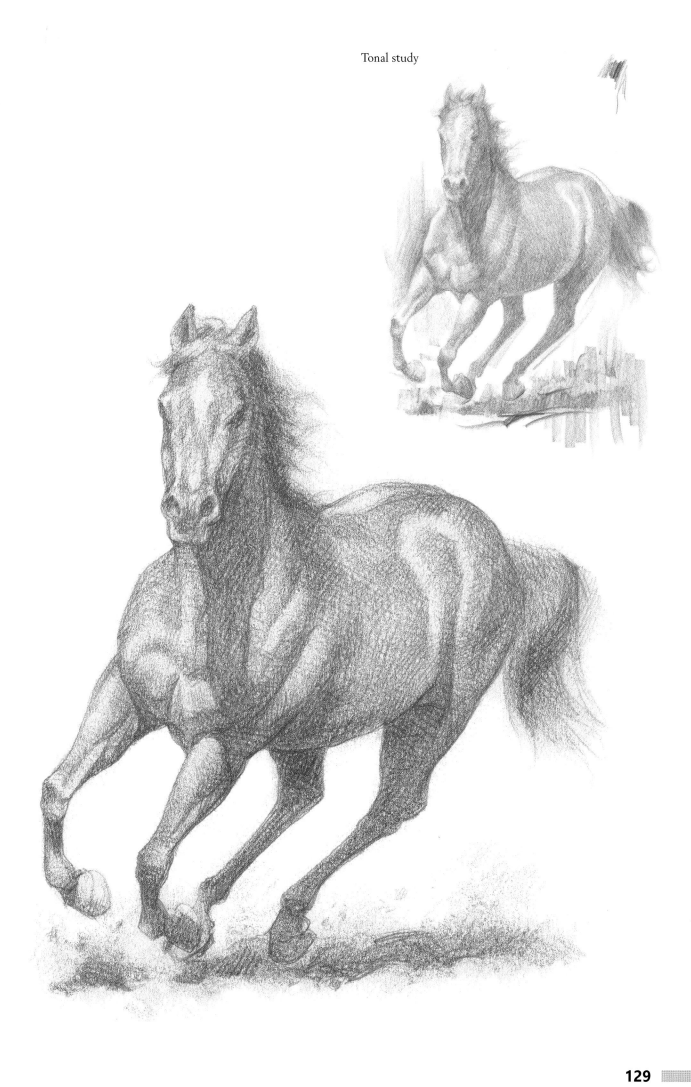

Step 1: Overall shape and size Step 2: Structure and proportions Step 3: Volume and shadows

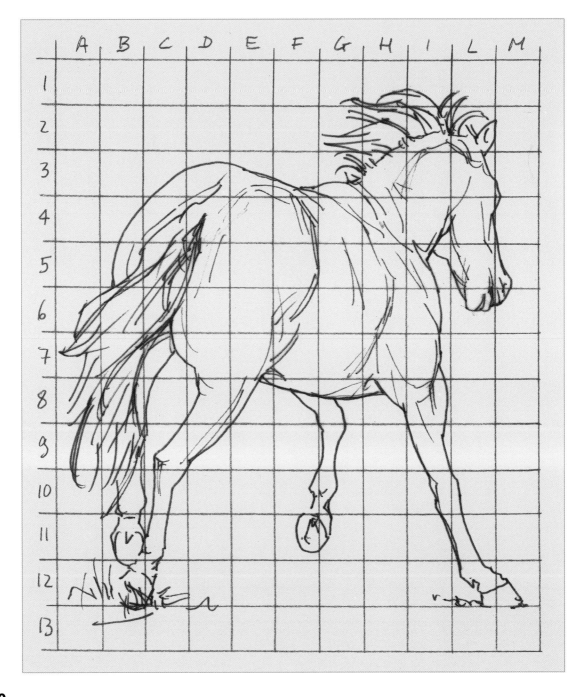

Tonal study

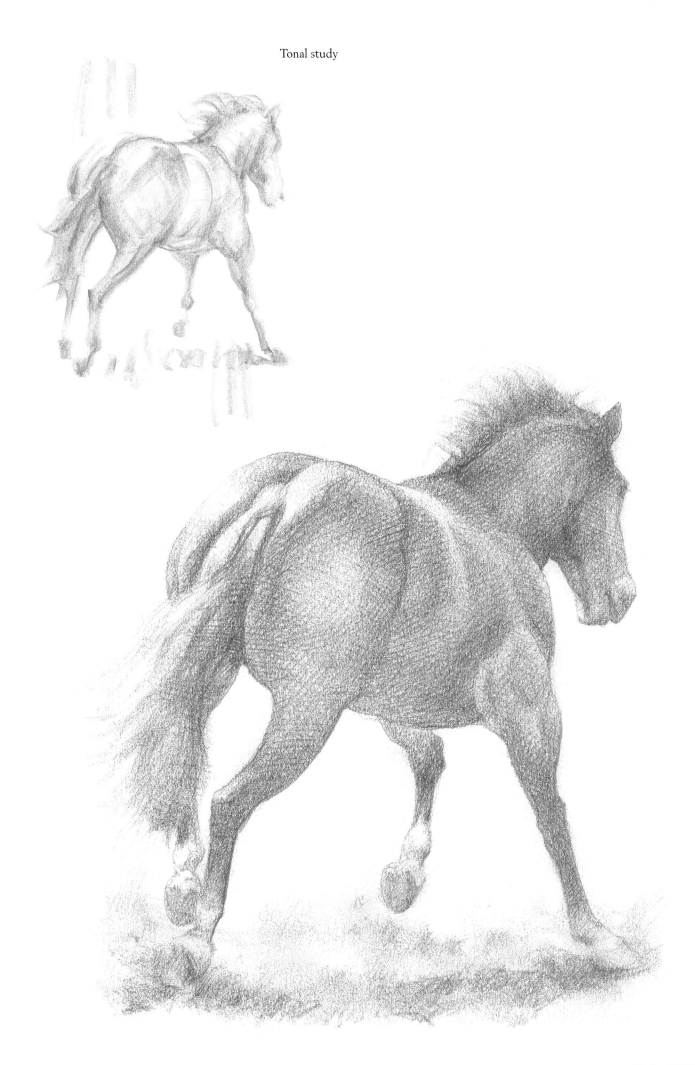

Step 1: Overall shape and size

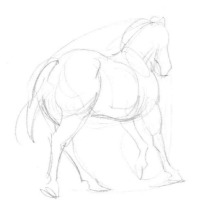

Step 2: Structure and proportions

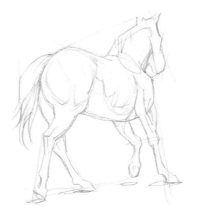

Step 3: Volume and shadows

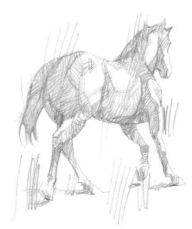

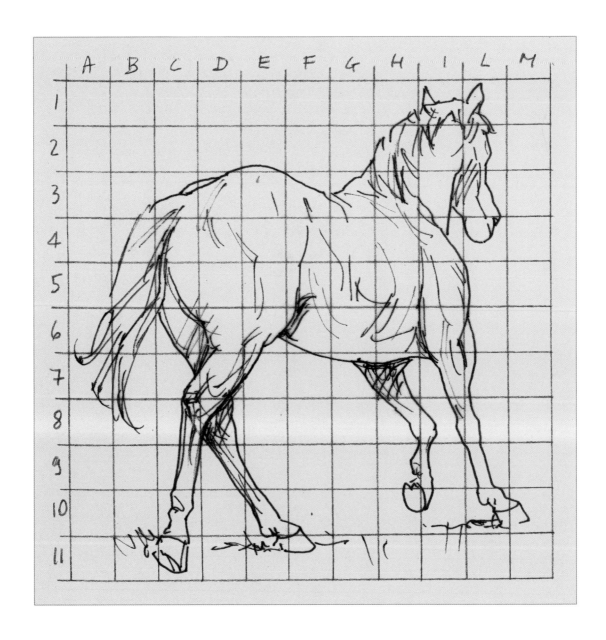

Tonal study

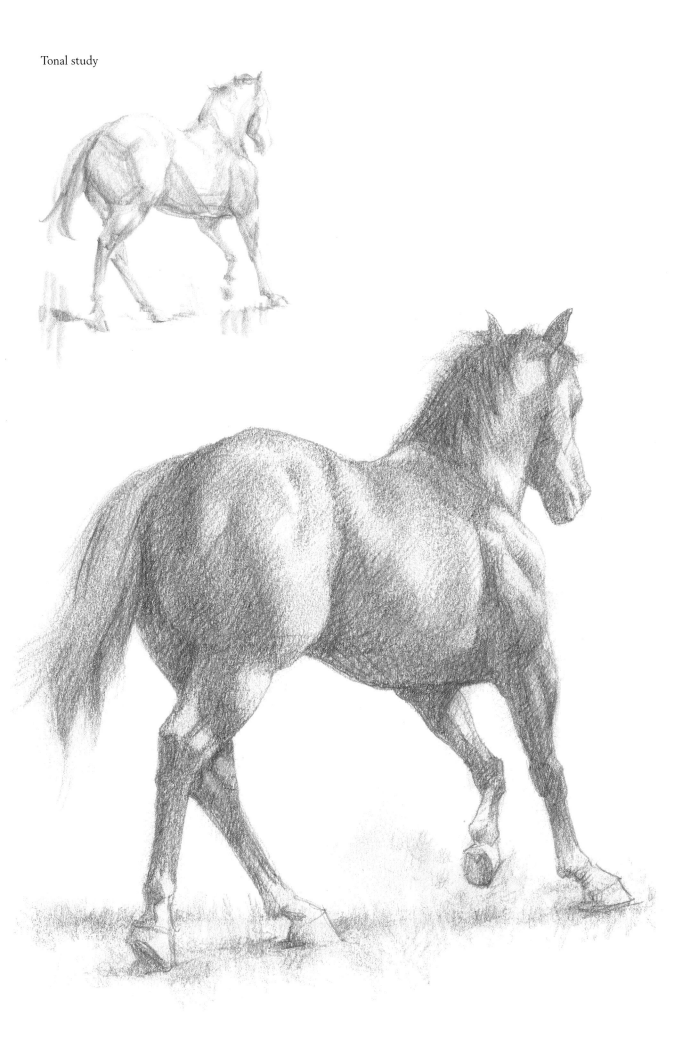

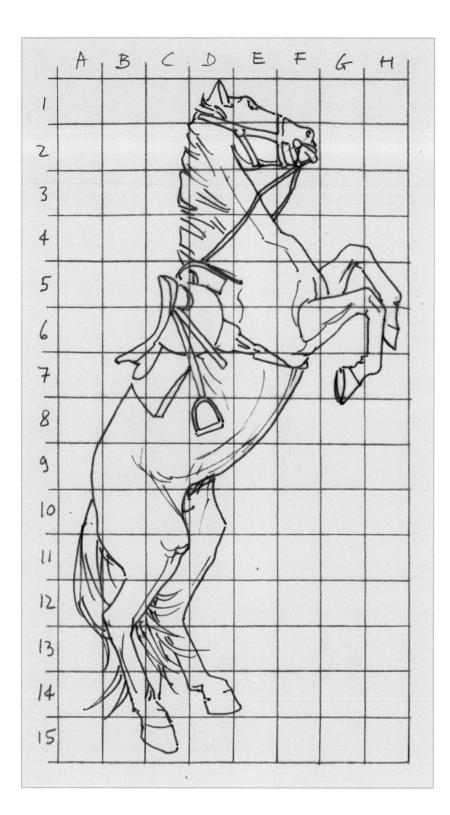

Step 1: Overall shape and size

Step 2: Structure and proportions

Step 3: Volume and shadows

Tonal study

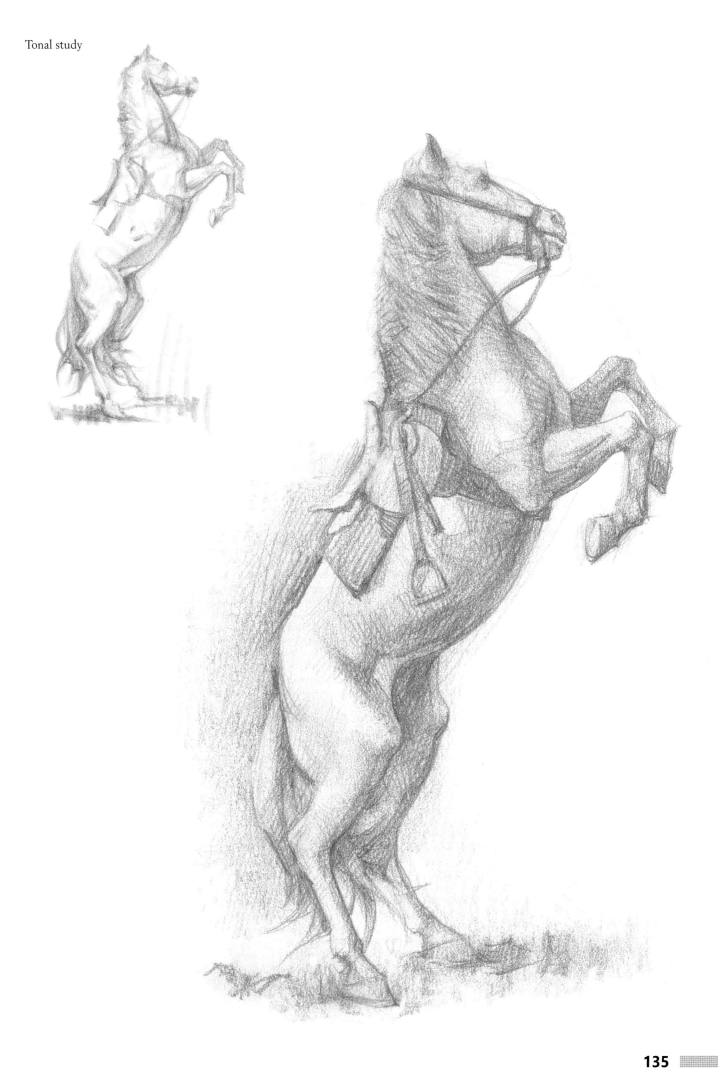

Step 1: Overall shape and size

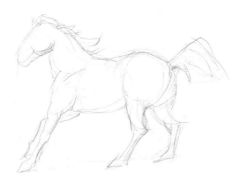

Step 2: Structure and proportions

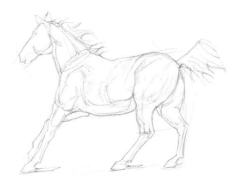

Step 3: Volume and shadows

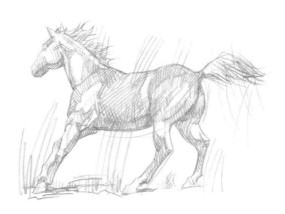

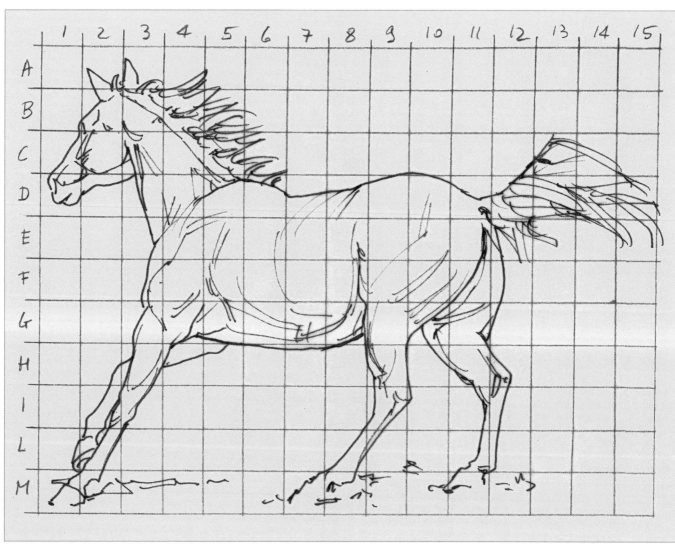

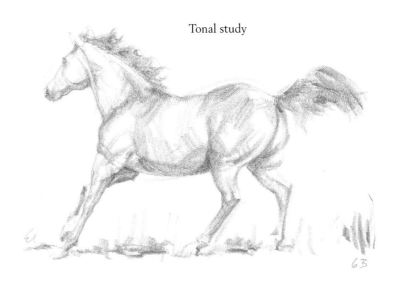

Tonal study

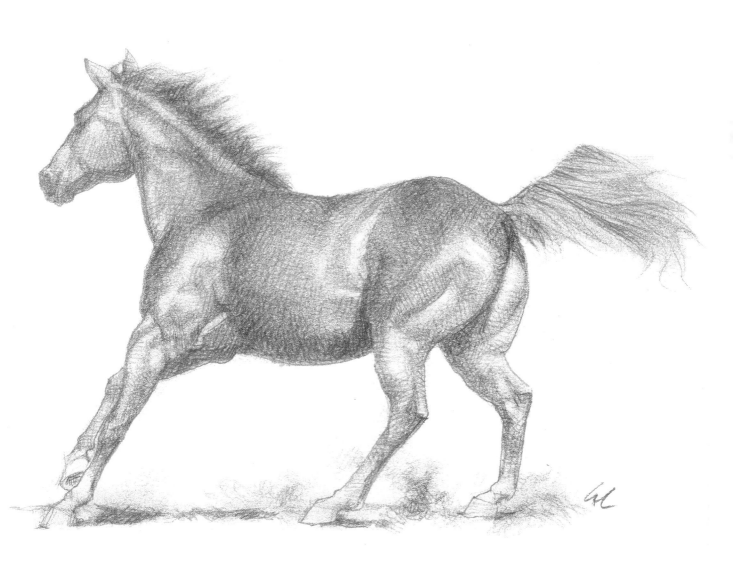

Step 1: Overall shape and size

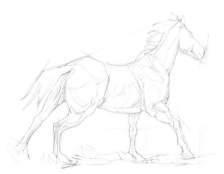

Step 2: Structure and proportions

Step 3: Volume and shadows

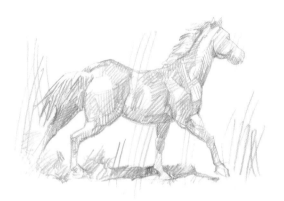

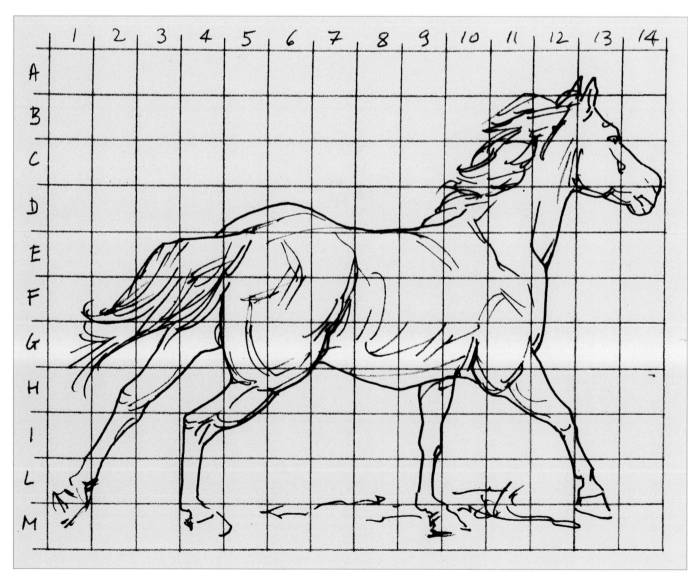

Linear study

Tonal study

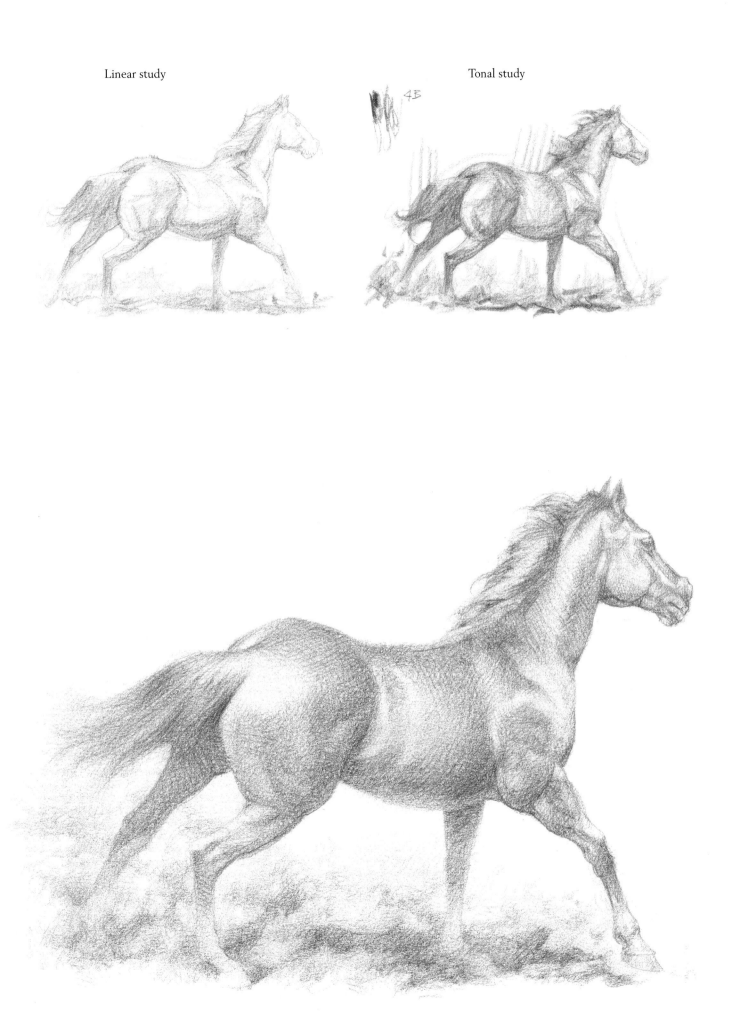

Step 1: Overall shape and size

Step 2: Structure and proportions

Step 3: Volume and shadows

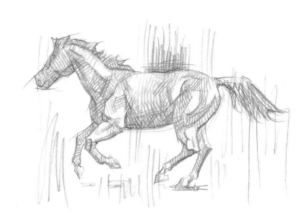

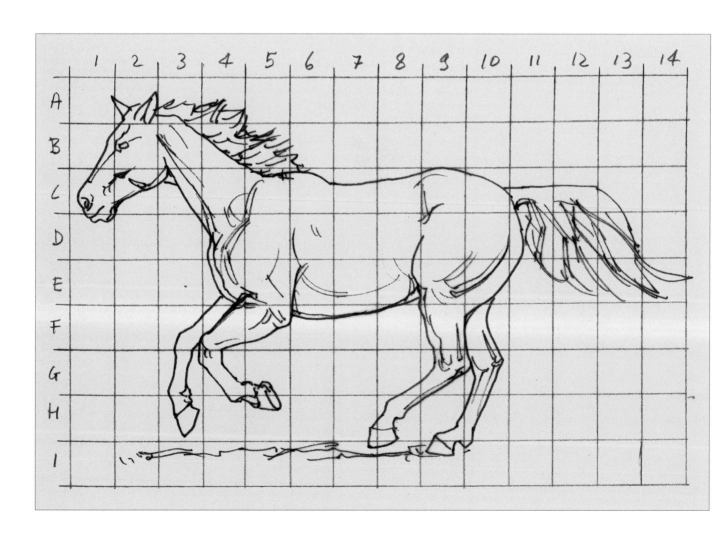

Tonal study

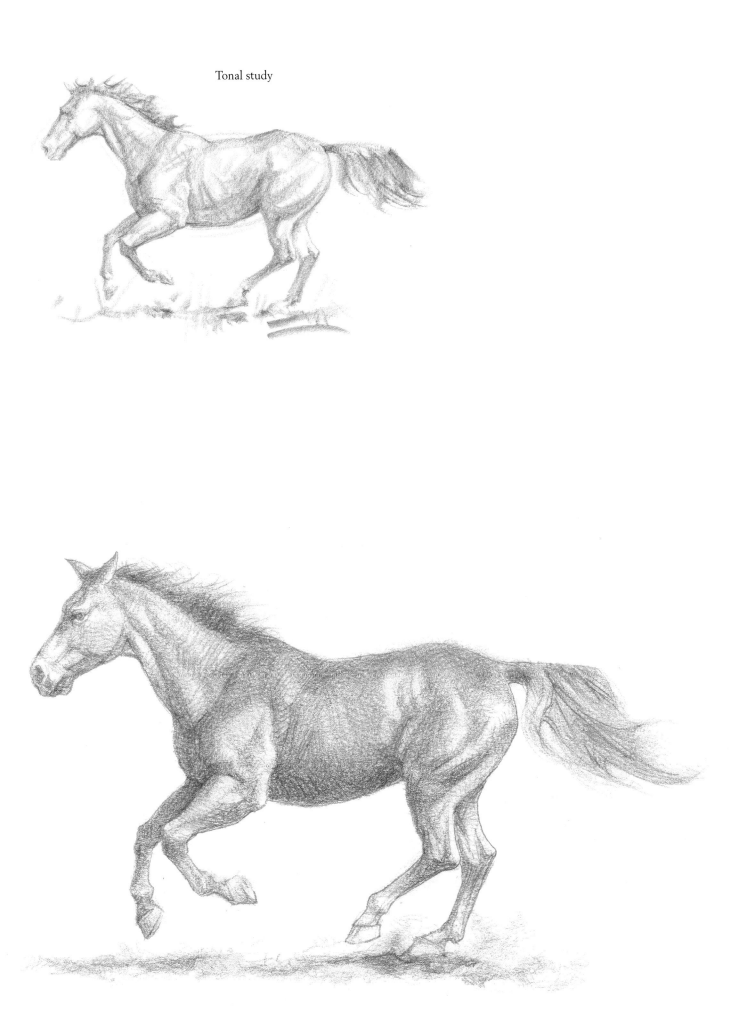

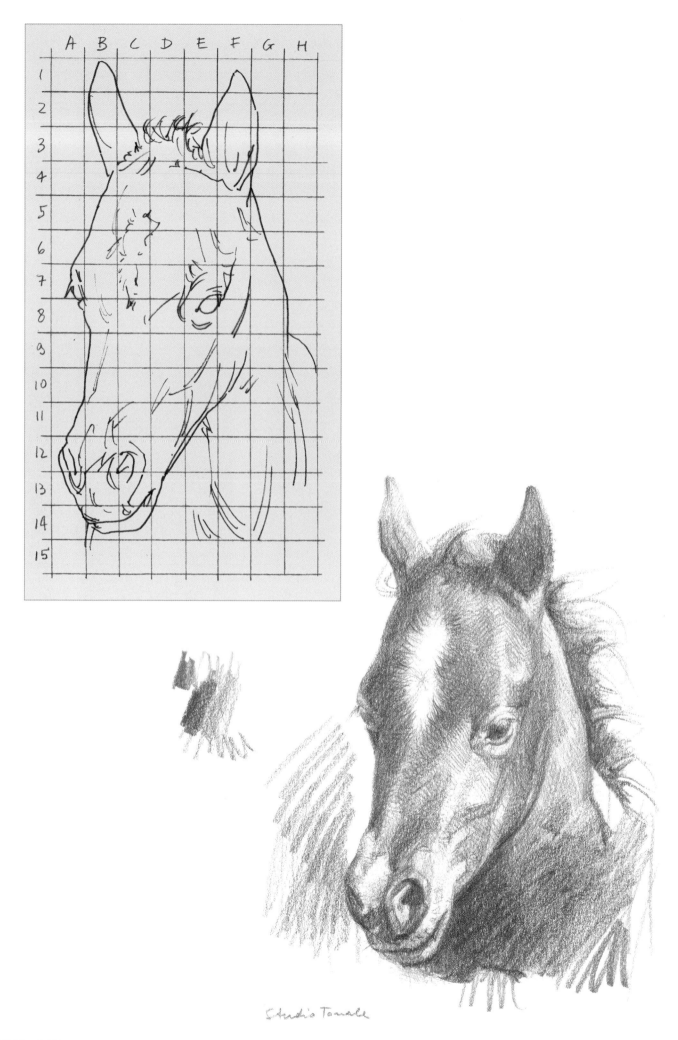

Studio Tonale

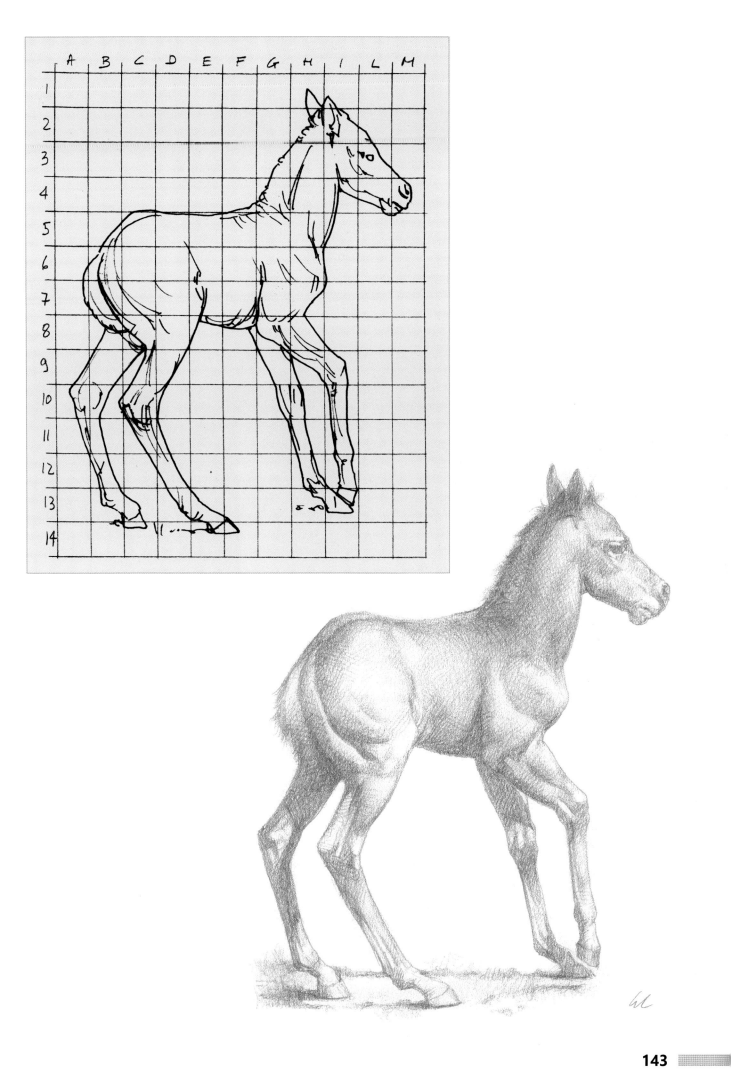

Step 1: Overall shape and size

Step 2: Structure and proportions

Step 3: Volume and shadows

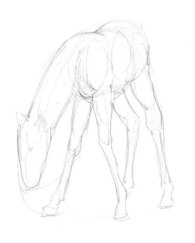
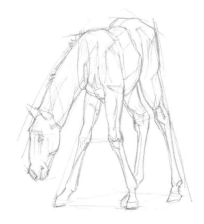
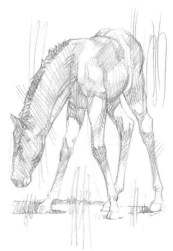

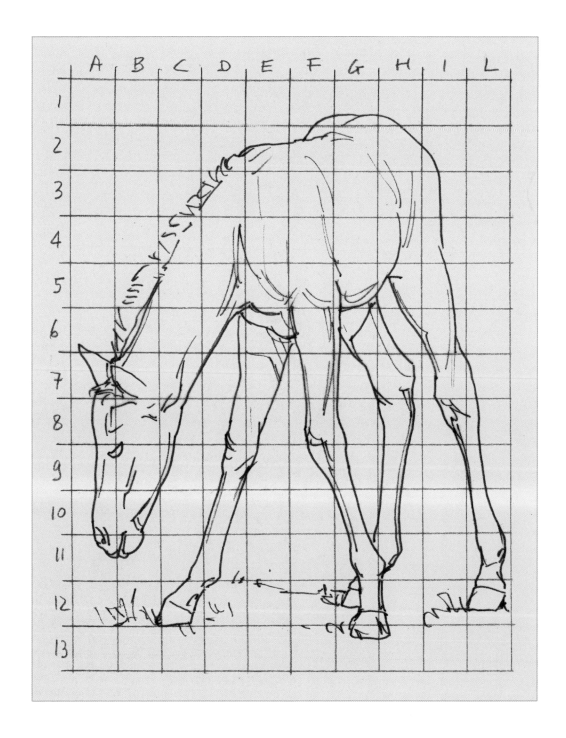

Tonal study

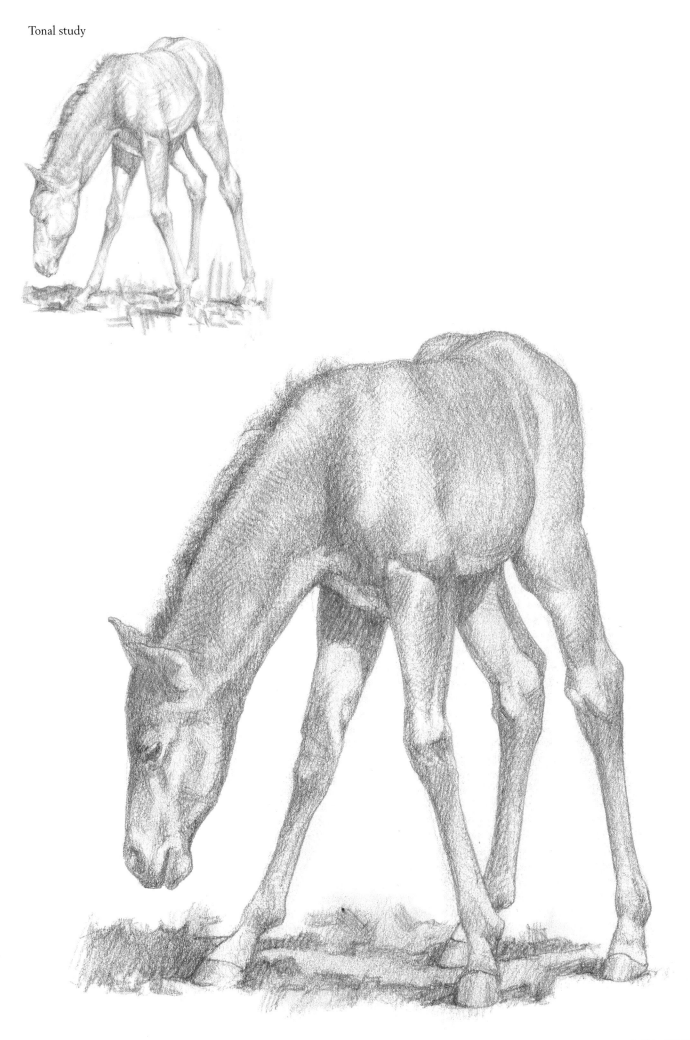

Step 1: Overall shape and size

Step 2: Structure and proportions

Step 3: Volume and shadows

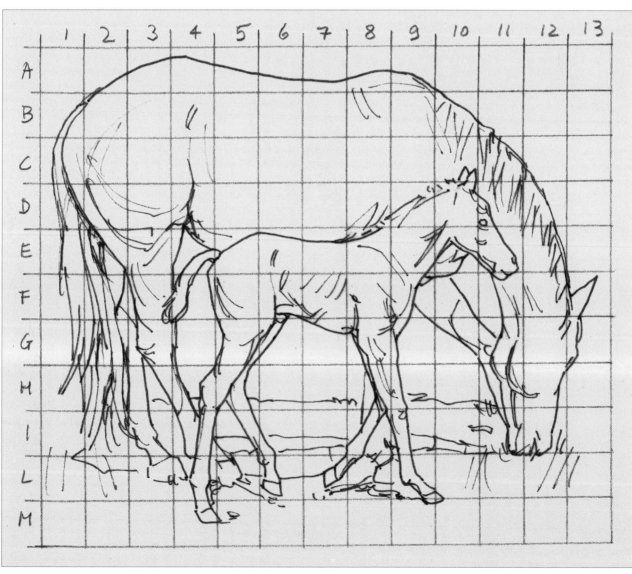

Tonal study

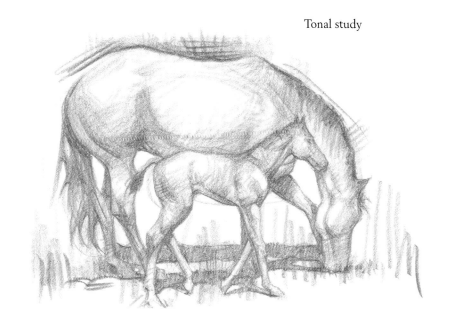

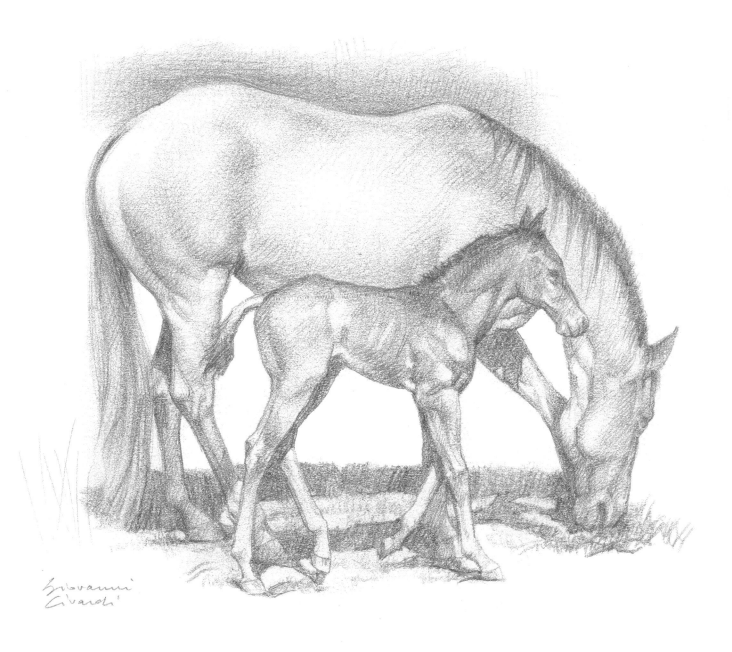

Step 1: Overall shape and size

Step 2: Structure and proportions

Step 3: Volume and shadows

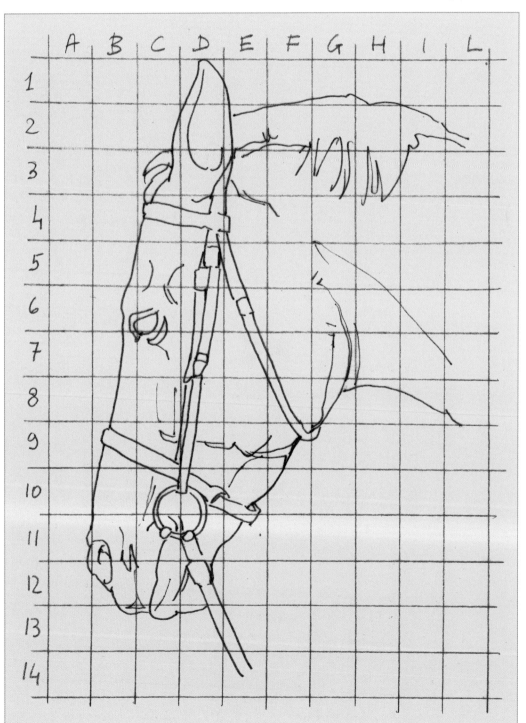

Tonal study

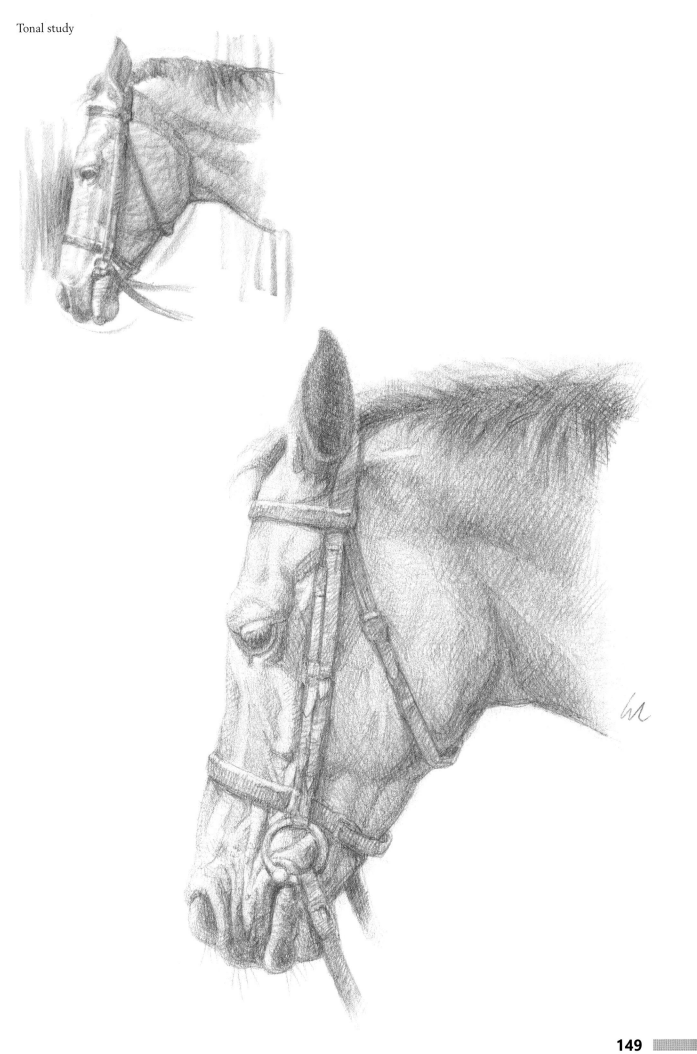

Step 1: Overall shape and size

Step 2: Structure and proportions

Step 3: Volume and shadows

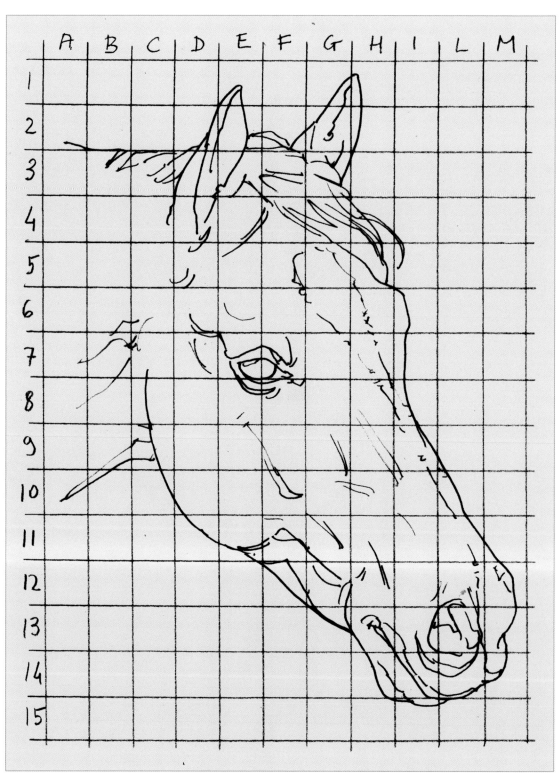

Tonal study

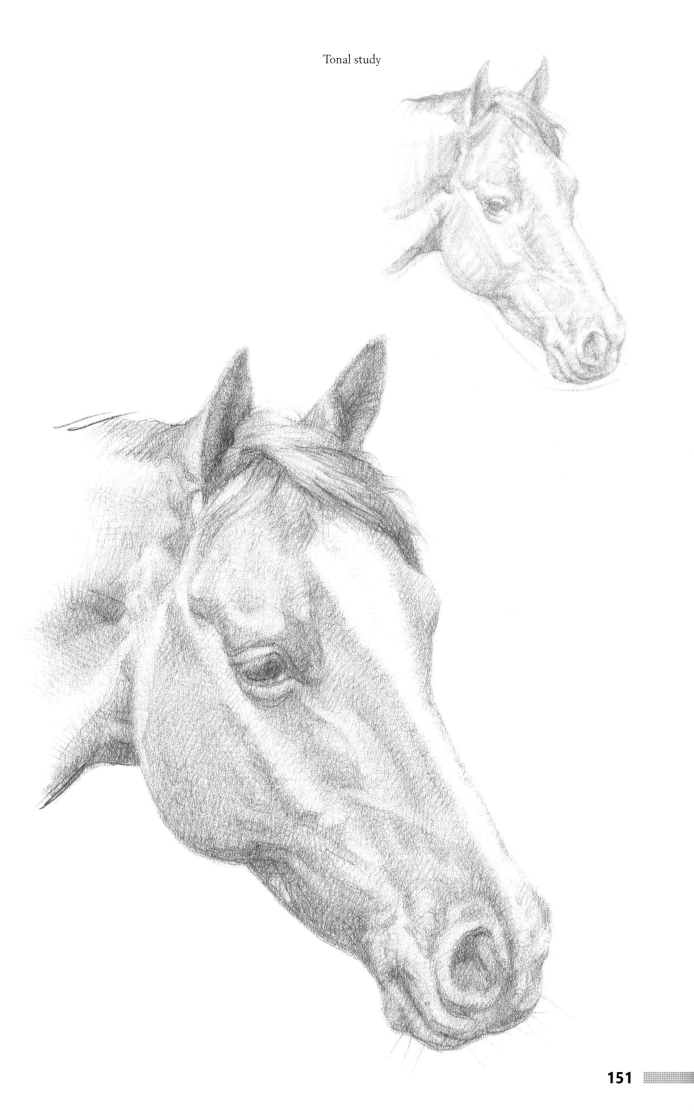

Step 1: Overall shape and size Step 2: Structure and proportions Step 3: Volume and shadows

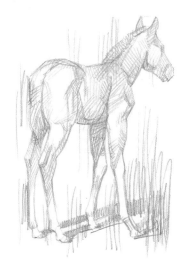

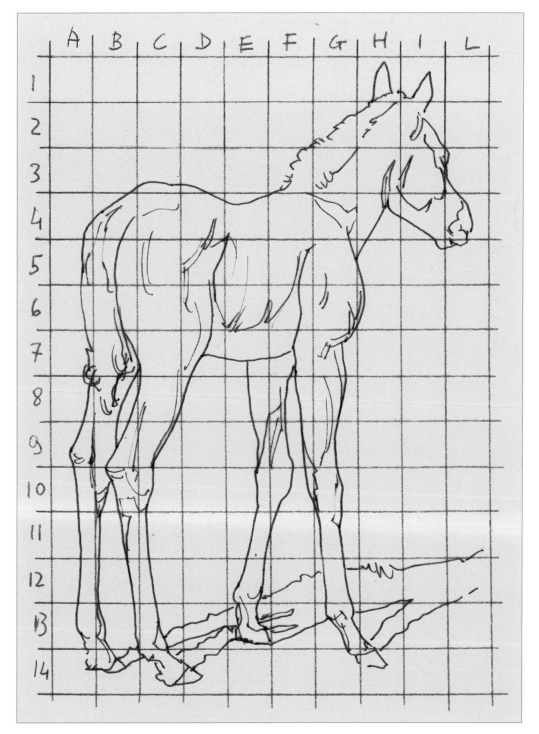

Tonal study

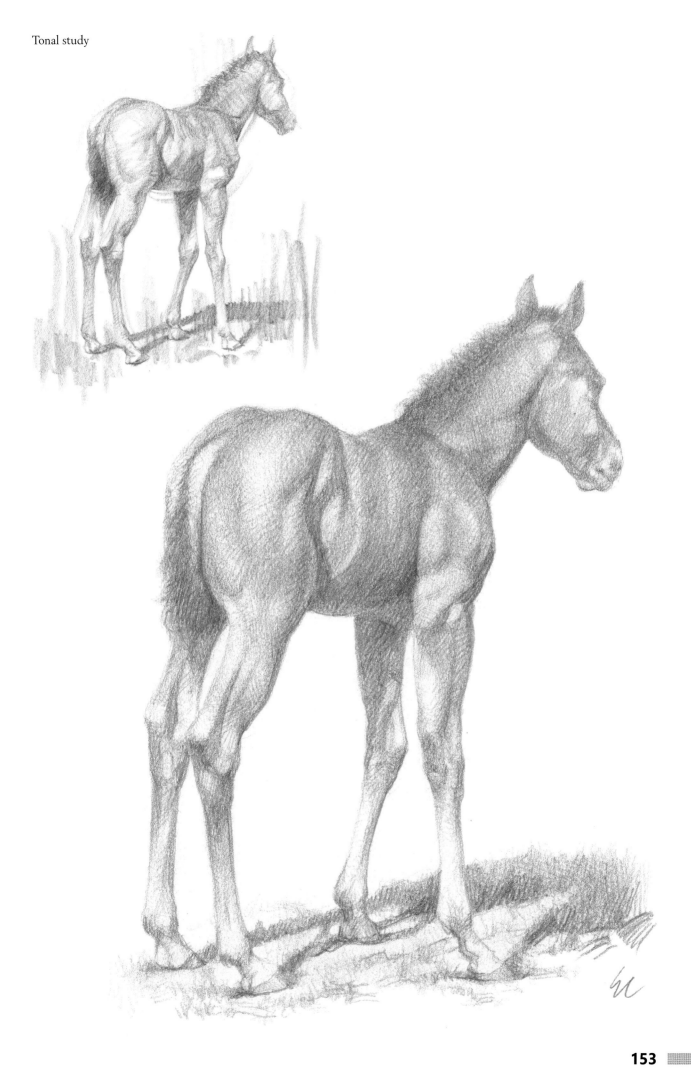

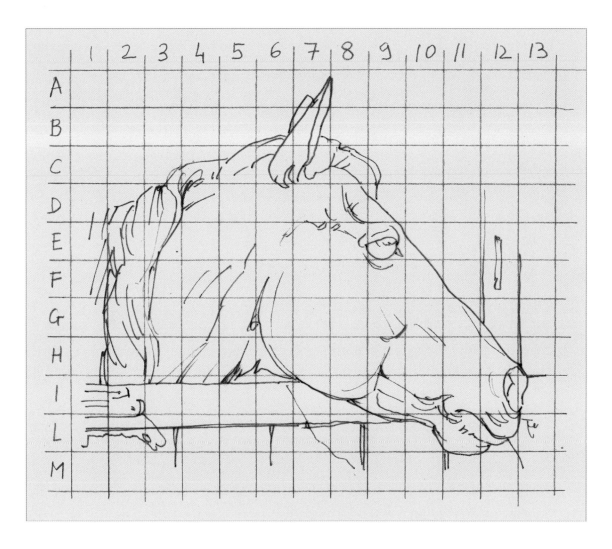

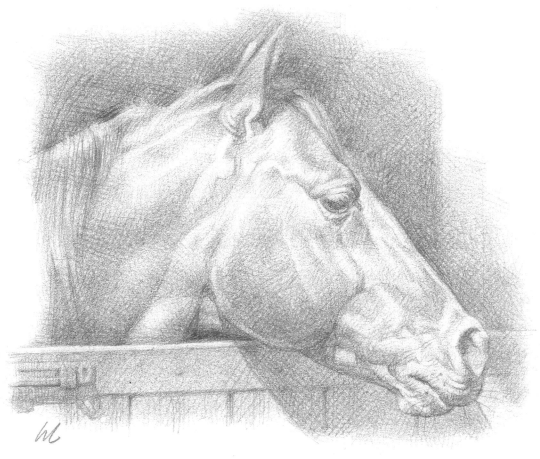

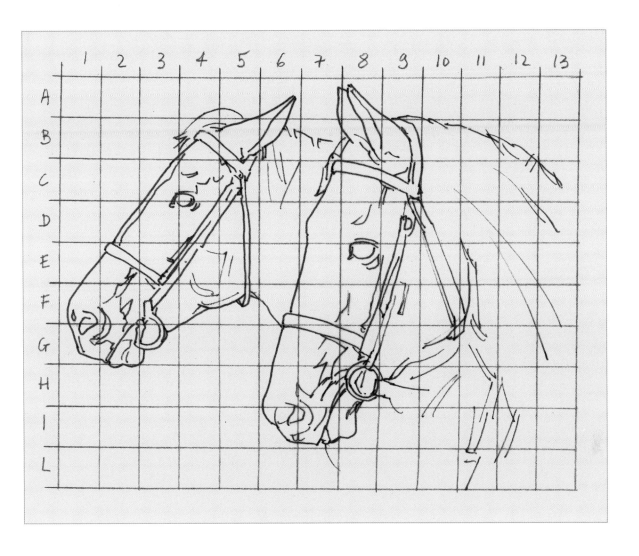

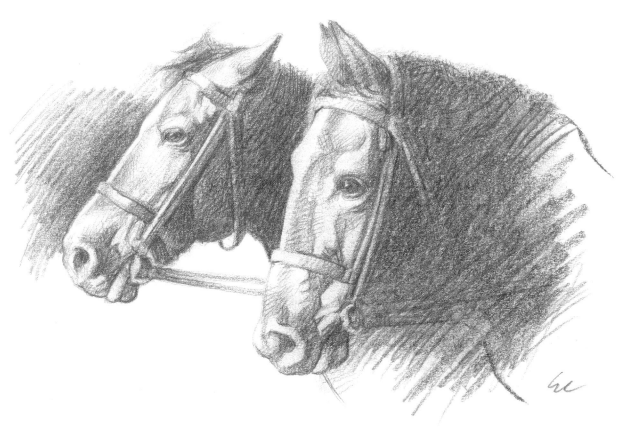

Step 1: Overall shape and size

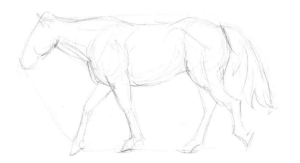

Step 2: Structure and proportions

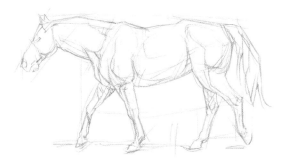

Step 3: Volume and shadows

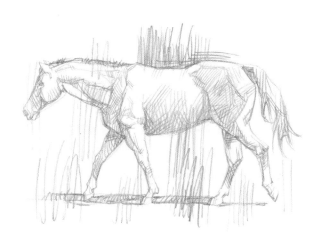

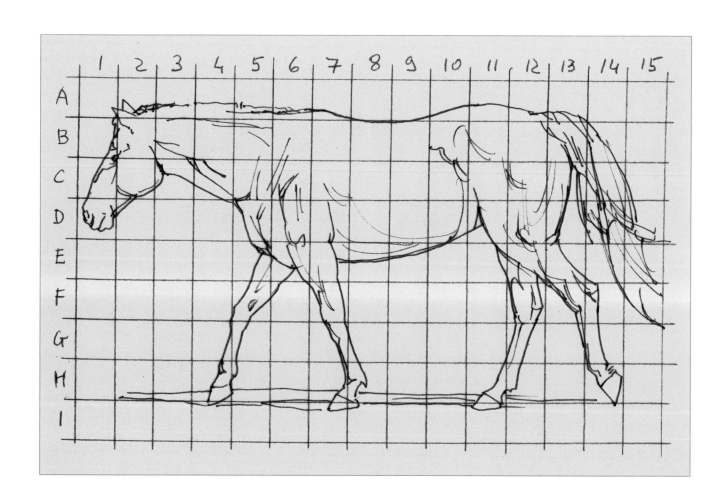

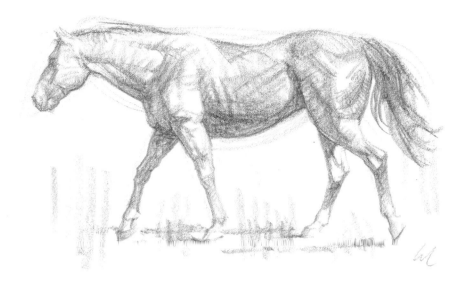

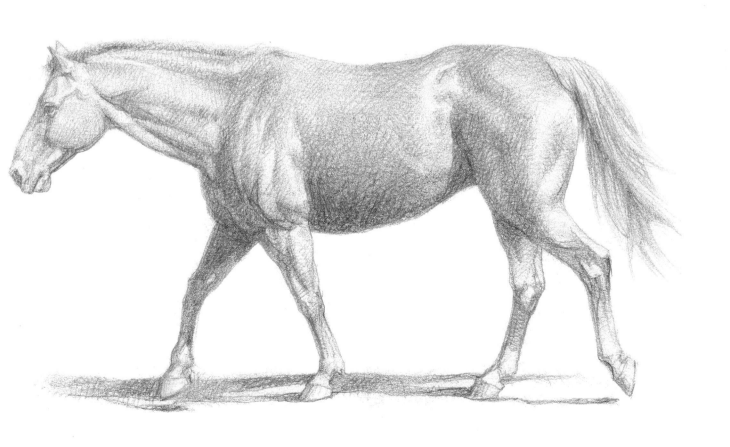

Step 1: Overall shape and size

Step 2: Structure and proportions

Step 3: Volume and shadows

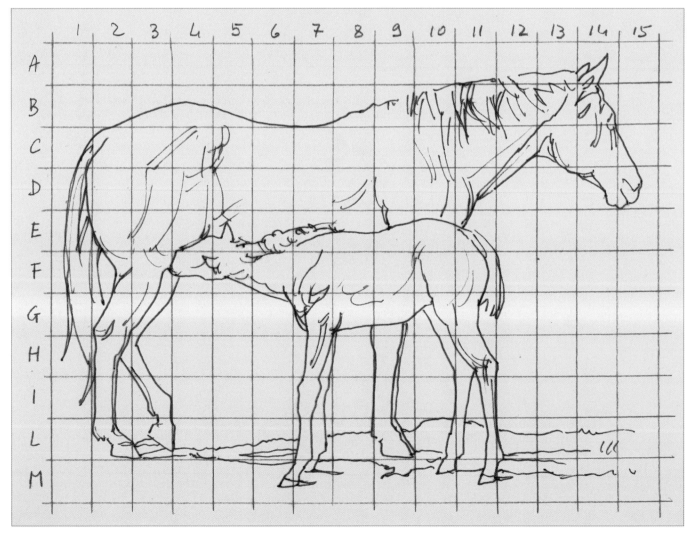

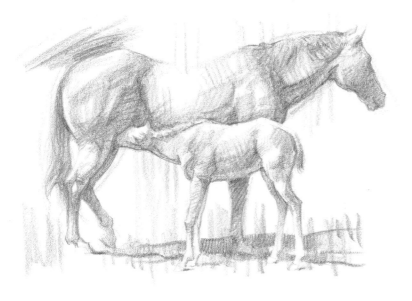

Tonal study

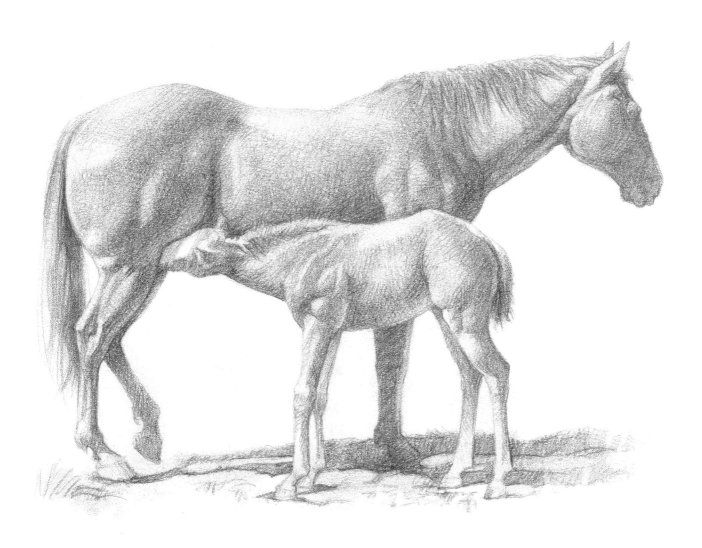

HORSE AND MAN

Man has had an extremely close relationship with horses due to the countless practical ways in which they have worked together: for example, through hunting, competitions, transportation and trekking. Therefore, it is useful to consider the ratios of a 'generic' horse (one of 'average' conformation) with an adult human being of 'average' height. The diagrams and photographs reproduced on these pages highlight these ratios; however, it must be noted that these sizes are references only, and the artist should observe the size of the horse in front of him or her, given the large variety of horse breeds.

People's use of horses has led to the need to apply a harness and tack, which makes it easier to ride and drive the horses. The following drawings show only some types of saddle, each adapted to specific functions (racing, walking etc.), and the elements that make up the bridle (bit, headstall, reins, and so on). Whatever the type of saddle, it is placed on the horse's back, right behind the withers, and is kept in place by a large strap that binds it to the front part of the stomach. The stirrups hang to the sides, supported by straps.

Diagrams of the average proportional ratios between an adult man and a horse.

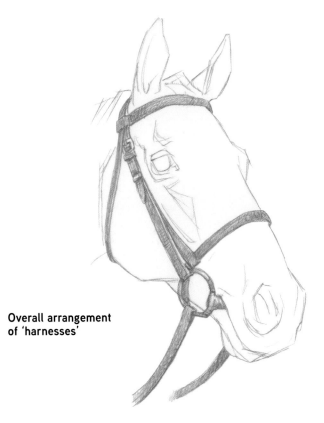

Overall arrangement of 'harnesses'

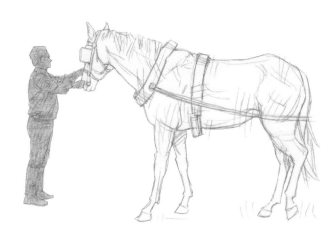

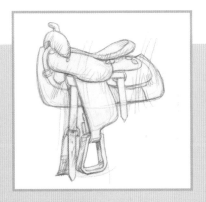

Western saddle

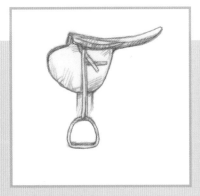

Racing saddle

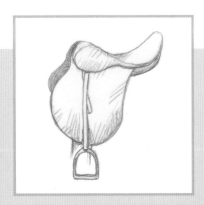

Hunting or walking saddle

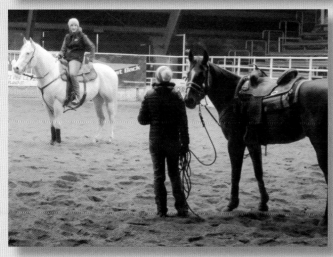 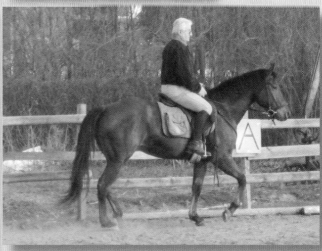

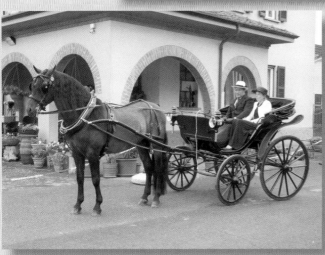 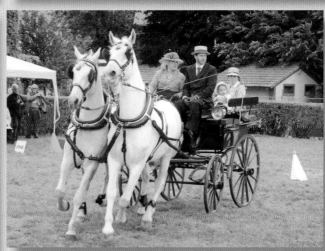

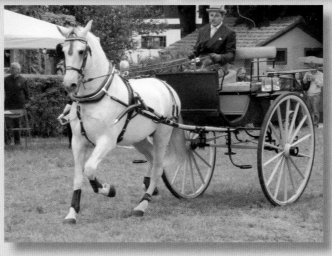

The photographs here show some correct ways to position a saddle, to mount a horse and to drive a carriage or a trap.

DRAWING
CATS

Dedicated to my mother Anselma Marchi, my father Lino Civardi, and to Vanessa.

Lux cordis, lumen mentis *(light hearted, bright mind).*

Loss is the deepest source of permanence.

INTRODUCTION

Some animals were considered to be divine incarnations by the Ancient Egyptians. When a 'sacred' animal died, its body was embalmed and buried with dignity and veneration. These animals included cats, visible icons of the goddess Bastet, the protector of the sky and the home. Populations from ancient times, both in the East and the West, kept cats on their farms as they were useful animals, and they also adopted the symbolic and religious quality of the cat: it was a protector of grain stores, custodian of sacred books, inspirer of light or shadows, bringer of good and evil, keeper of the family home and a heraldic symbol. The cat, therefore, became a widespread subject of artistic portrayal, especially in Eastern art and arts portraying nature. As well as being esteemed for its practical use, the cat has always been admired for its elegant posture, its agility, its independent spirit and its enigmatic, fixed gaze that reveals almost nothing at all.

In this book, I have chosen to look at the general 'feline form' of the cat, so to speak, which means that I have not concerned myself with overly characterizing each 'model' in my drawings with information about breed, type of coat or other distinguishing elements. I have prioritized searching for simple positions or actions, sometimes static, other times as variations of the same stance. Nevertheless, it is important to note that each cat has its own features that identify it and give it its own 'character': this can be portrayed in the drawing. Human beings, in all their variety, belong to the same species; similarly, domestic cats also all belong to one species with variations (rather a lot of them) known as 'breeds'.

A cat's superficial anatomy and morphology are hidden, to varying degrees, by its fur (which is dense, soft and of varying length) – even more so if it has stripes and markings on its fur that serve as camouflage. Therefore, it is important to carefully observe the overall shape of a cat, its proportions, appearance and the direction of its fur and stripes, and then combine all this with basic anatomical knowledge. The drawing of an animal can comprise a detailed, elaborate work, or be a simpler study summarizing its forms or its movements (that perhaps could be developed at a later point with the help of photographs). The portrait also could concentrate solely on the body, either isolating it from its environment and background or showing it in its usual habitat.

The cat is a fascinating animal, and drawing one also means having many opportunities to carry out real 'portraits', perhaps commissioned by admirers or breeders. It is not to be overlooked that knowing the forms of the cat is an excellent preliminary training for drawing other members of the *Felidae* family, which are less easy to approach!

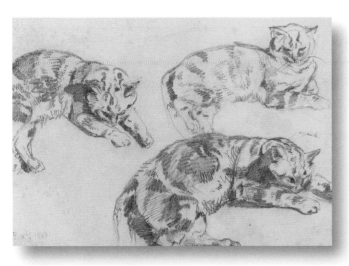

Above: *Trois études de chats allongés.* Eugène Delacroix. 1843. Graphite pencil, 24.7 x 38.1cm (9¾ x 15in). Courtesy of Musée Delacroix, Paris.

ANATOMY

To portray any animal convincingly, it is necessary to know its anatomical structure – at least summarily – especially the locomotor apparatus. This is extremely useful for the artist as it is almost always difficult to recognize the skeletal conformation within many species of animals' bodies with certainty, that are often hidden by strong muscles, which in turn are hidden by their fur. A cat's fur, which can be of varying thickness and length, is also marked by stripes, markings and features that are intended to act as camouflage.

Cats are carnivorous mammals that belong to the *Felidae* family. They are hunters of smaller animals, which are their prey. Their agile, flexible bodies make them able to attack their prey suddenly and silently, holding it with their protracted claws and grasping it with their short, powerful jaws.

The body of a cat is, in fact, suited to short, rapid, lightning movements. The flexibility and elasticity of its skeleton and joints allows it to bend itself almost entirely in two, or curl up, stretch out or turn around completely.

The anatomical conformation of the cat highlights some characteristic aspects. For example: its snout is short and the head seems small in relation to its long body; its small clavicle allows the front limbs to move in almost all directions; its powerful muscles in the rear limbs (which are longer and stronger than the front ones) makes it possible for the cat to execute long, sudden jumps; and the flexibility of the tail helps to keep the cat's balance when running and to straighten the body when it is falling.

BONES AND ARTICULAR COMPONENTS

The skeleton is divided into two sections: the axial part (head, spine, rib cage) and the appendicular part (front and rear limbs), connected to each other by the pelvic girdle and shoulder girdle. The bones are connected by joints that either allow varying degrees or restrictions of movement, depending on their conformation.

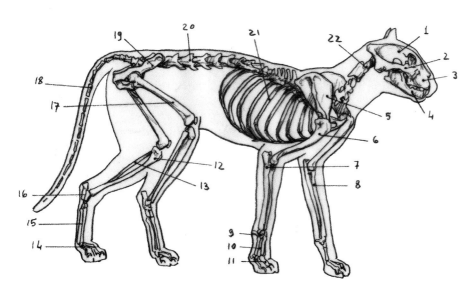

Diagram of the bone structure (in a lateral projection):

1 – cranium
2 – zygomaticus
3 – maxilla
4 – mandible
5 – scapula
6 – humerus
7 – ulna
8 – radius
9 – carpus
10 – metacarpus
11 – phalanges
12 – tibia
13 – fibula
14 – phalanges
15 – metatarsus
16 – tarsus
17 – femur
18 – coccygeal vertebrae
19 – pelvis (ileum)
20 – lumbar vertebrae
21 – ribs
22 – cervical vertebrae

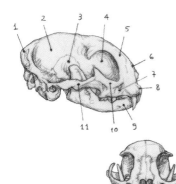

Main bones of the skull, in a lateral projection (top left) and frontal projection (bottom left):

1 – occipital
2 – parietal
3 – temporal
4 – orbital cavity
5 – frontal
6 – nasalis
7 – maxilla
8 – premaxilla
9 – mandible
10 – zygomaticus
11 – zygomatic arch

Diagram of the relations between the cranium's surface and the thickness of soft tissues (layers of muscle, skin etc.).

MUSCULAR COMPONENTS

The muscles in the locomotor system vary in shape (some flat, some tapered) and are voluntary muscles, each comprising a contractile centre (striated muscles) and tendons that are attached to the bones. There are also several thin, superficial, cutaneous muscles (especially on the head, neck and back), that act on the skin. A cat's typical agility and rapidity comes from its especially powerful muscles located in the lumbar-dorsal region and rear limbs (for jumping and climbing), and on its shoulders and neck (for grabbing its prey and holding on to it firmly).

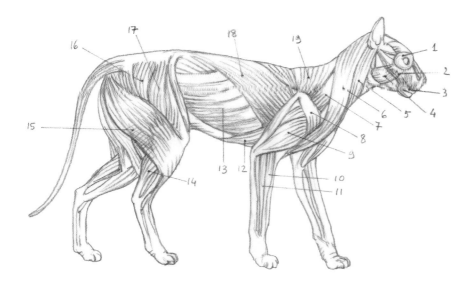

Diagram of the superficial muscle layer (in a lateral projection):

1 – orbicularis oculi
2 – zygomaticus
3 – orbicularis oris
4 – masseter
5 – sternocephalic
6 – brachycephalic
7 – omotransversarius
8 – deltoid
9 – triceps
10 – extensor carpi radialis
11 – extensor digitorum lateralis
12 – pectoralis profundus
13 – external oblique
14 – triceps surae
15 – biceps femoris
16 – gluteus
17 – tensor fasciae latae
18 – latissimus dorsi
19 – trapezium

Diagram of the main muscles in the head (in a lateral projection):

1 – temporalis and frontoscutularis
2 – orbicularis oculi
3 – nasalis
4 – levator nasolabialis
5 – levator labii superioris
6 – orbicularis oris
7 – zygomaticus
8 – masseter
9 – sternohyoid
10 – parotidoauricularis
11 – brachiocephalicus
12 – cervicoauricularis

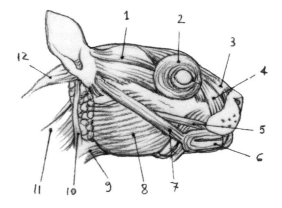

A cat's body in a zenithal projection. This particular cat is extremely slim and streamlined in relation to its length.

Its width at the shoulders and waist, for example, is almost the same width as the head.

EXTERNAL MORPHOLOGY

When observing the forms that make up your chosen cat's body, it is first necessary to recognize what makes it similar to other cats, then to look for the individual differences.

Unlike a human body, where the anatomical structure can be seen more clearly, and helps the artist to easily determine the general external form of the body and proportions, generally animals – cats in particular – have an outer appearance that is decidedly influenced by the abundance of fur and their camouflage markings. A cat's fur and its markings relate to the breed they belong to, and seasonal and environmental adjustments – for example, its fur becomes thicker in cold seasons, and tends to be thick if it's a breed that habitually lives in colder climates. Furthermore, cats have delicate proportions and sizes (on average, they are 30cm / 11¾in tall at the withers), and their rounded, soft forms make it difficult to see key anatomical points of reference, which are a useful drawing aid when establishing a cat's overall form and its proportions. These include the shape of the head (which is almost spherical, but with a tendency to be oval or wedge-shaped depending on the breed); the short neck; the angles of the limbs or the shoulder blade; and the pelvis. Compared with an adult cat, a kitten has some interesting, differing details. For example: the head and outer ears appear to be large in comparison with the body; the eyes are big while the mouth and nose are tiny and dainty; the neck is very short; and the paws are short, with large, stubby digits.

Studying a domestic cat is an excellent exercise if you wish to draw other, wilder felines (lion, tiger, leopard, etc.). Below is a summary of the main features on a typical domestic cat.

Drawing of the main topographical regions and direction of growth of hair on head and body.

Under its long hair, which forms the coat, there is a layer of thick, short hairs which act as thermal protection. A cat's coat is shed and replaced each season, in spring and autumn, and they can have a number of different designs on them (markings). For example, a tabby cat (i.e. the rather common grey cat with black stripes) is divided into two large groups: the tiger-striped one, with a coat with narrow vertical stripes; and the marbled one, with circular stripes. Both groups have ring-shaped stripes on their tails.

1 – neck	7 – hock	12 – finger pads
2 – withers	(metatarsal)	13 – shoulder
3 – ridge	8 – knee	14 – whiskers
4 – loins	9 – stomach	15 – snout
5 – tail	10 – elbow	
6 – thigh	11 – spur	

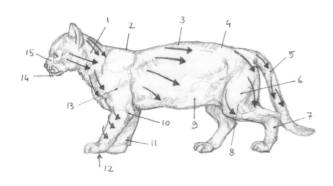

A cat's facial hair and markings.

Tactile hairs can be found growing in a few areas on the head: above the eyes, on the cheeks, sides of the nose and on the upper lip ('moustache' or whiskers). These are long, thick, off-white hairs. In some cases, they can be drawn with a thin graphite mark, but in other cases it is more effective to show their position through 'negative' work (i.e. using the tip of a putty rubber that has been well sharpened to erase areas of the drawing where the hairs lie). On the front of a tabby cat, the marks and stripes are arranged in a characteristic design that looks like the letter 'M'.

Cat profiles.

There are several breeds of domestic cats each with its own morphological, proportional, attitudinal and chromatic characteristics – for example the length and colour of their fur (long-haired cats, short-haired cats, etc.), or the marks and patterns on their coats. These are the so-called 'pedigree' cats, as they have a documented genealogical line. The largest population is perhaps that of the common cat with no pedigree, known as a 'stray' or 'moggy', born from random couplings.

TYPICAL MORPHOLOGICAL CHARACTERISTICS

Eyes

Predatory carnivores, including cats, have their eyes facing forwards: this limits the width of their visual field, but makes the judgement of distances more precise when pursuing and attacking prey. Their eyeballs are almost spherical, and in cats they protrude and seem to be rather large in relation to the head (on average, its eyeball is approximately 2cm / ¾in in diameter). There are two eyelids touching the eyeball, one upper and one lower, that form a protective barrier for the eye and help with lubrication. The upper eyelid is usually much more mobile and extended than the lower one. There is also a third eyelid (or semi-lunar fold, the nictitating membrane), at the inner corner of the eye. This becomes more evident if the cat is ill or is suffering. Each corner of the eye is at a different level: the medial one, at the bridge of the nose, is slightly lower than the lateral one. Overall, the open eye seems almost circular, slightly almond shaped and shows only the cornea, iris and pupil. From a frontal view, the distance between the medial corners (lacrimal caruncle) of each eye is about one and a half times that of the width of the eye. Cats' eyes are sensitive to light. As the pupil is elliptical (and not round), it is reduced to a vertical slit in strong light, whereas in the dark it dilates as far as possible, becoming almost circular in shape. The colour of a cat's irises can vary greatly, from grey-blue to brown-yellow, and in some breeds or individuals the two irises can differ from each other in colour and/or intensity.

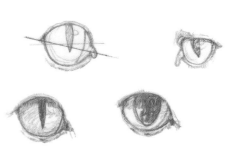

Drawings of cat's right eye, in a frontal projection.

Ears

In cats, the auricle (outer ear) is almost always erect, vertical, is triangular and ends with a slightly rounded tip. The ear has a flexible cartilaginous structure that is almost semi-circular at the base and then becomes flat in the free part (pinna). From a profile view, the outer ear, positioned on top of the head, appears to be thin and pointed. The cartilage is covered with a thin layer of skin, with hairs of varying density and length growing on the inner surface, while on the outer surface it is covered in fur. On the lateral edge of the auricle, just inside the ear, there is small fold of skin that breaks up the regular profile. The dimensions of the outer ears do not differ greatly between breeds; however, the presence of the fur that grows around the base of the ears and on their inner surface can vary between cats. There are several specific muscles in the outer ear that allow the ear to be mobile in all directions, to locate the origin of sounds and to manifest its current state of mood.

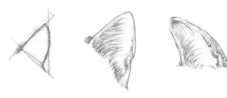

Drawings of both ears, in a frontal projection.

Nose

The tip of the cat's nose has two nostrils that are shaped like commas which taper out to the sides. These are separated by a fleshy pad that varies in shape and size, depending on the species. Generally, this nose pad is small and triangular, and has a light vertical median groove (the philtrum) that continues to the upper lip, which separates the two adipose pads where the whiskers grow. There tend to be 30 whiskers growing on these pads, which are long, hard, tactile hairs arranged in three or four parallel lines. A cat's nose is generally pinkish in colour, but some variations can be related to breed and the colour of their fur. For example: a wild cat's nose is reddish; a ginger or black cat's nose is black and a white cat's nose is pink. Sometimes, especially in cats with a dappled coat, there is a mixture of colours between the two nostrils, one pink and the other black. On the lip to the side of the nose there is a slight fatty pad where more tactile hairs grow.

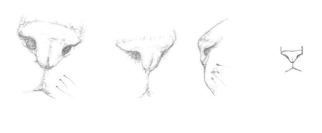

A slight mound between the bridge of the nose and forehead characterizes the head's profile and highlights how short the snout is.

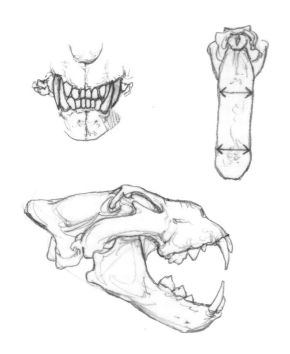

Mouth, teeth and tongue

When drawing a cat with an open mouth (a rather rare event that can only be done with the help of photographs), it is necessary to highlight the correct form and position of the exposed teeth and also the visible part of the tongue. A cat's mouth is not only for gripping and crushing food, but is also used for touch and for exploring the environment. Their lips are extremely mobile and of different lengths: the lower lip is shorter and less developed than the upper one, the latter partly overlaps and hiding the former. Both the upper and lower jaws are short and strong, activated by powerful chewing muscles used for the vertical occlusion movement. An adult cat has 30 permanent teeth: 12 small incisors (three each side and on each jaw); four very sharp canines (one on each side and on both jaws); 10 small, sharp premolars (three on each side on the upper jaw and only two per side on the lower jaw); and four molars (one on each side and on both jaws). A cat's tongue is pink, long and flat, rather rough and is evenly wide and slightly rounded at the tip. It is not only used to finish off tearing food residues, but also to smooth and clean its fur.

Paws

A cat's paws are used for walking (they walk on the tips of their toes, making cats a digitigrade) and for climbing, and also for grabbing and holding their prey. Their front limbs can carry out wide, agile, refined movements, while their rear limbs are always a little bent and are long and powerful. Some breeds of domestic cats have sturdy paws, with wide, circular feet; others have thin paws and oval feet. In all cases, cats' legs are long, strong and flexible, joined to the torso by mobile, elastic joints and powerful muscles. The rear paws each have four digits; the front paws have five, but one of these (corresponding to the human thumb) does not sit on the ground but stays basic on the medial side of the 'foot', forming a kind of spur. Each finger can be spread out and has thin, sharp claws that are usually retracted, but can be exposed and protracted for defence, to climb or to grip the prey better. There are elastic, skin pads on the sole of each foot, which are raised and semi-oval in shape, and they serve to soften impact and noise made by the paws as they hit the ground. There is a pad under each digit, and one larger one at the centre of the paw.

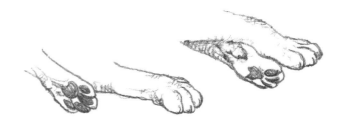

Schematic appearance of a cat's retracted claws. The retracted claw seems hidden in a vertical opening at the end of the digit, only revealed by a small parting in the fur.

Schematic structure of the claws, when retracted and protracted.

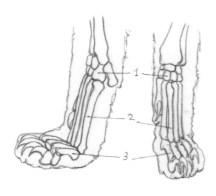

Skeletal diagram of the front left limb (in a lateral, frontal projection):
1 – carpal; 2 – metacarpal; 3 – phalanges.

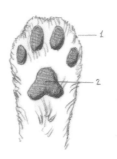

Arrangement of cutaneous pads:
1 – digital pads; 2 – plantar pads

Appearance of a typical cat's front and rear paws.

PROPORTIONS AND PERSPECTIVE

PROPORTIONS

A cat's body is normally covered in thick fur, hiding its main anatomical structures and skeletal landmarks which can provide the artist with important reference points when establishing proportions. For this reason, tracing a part or all of the body in a lateral projection and within a square can be a useful and effective approach for evaluating proportions, even when the cat is twisted or foreshortened (see 'Perspective' below). A cat's body (and those of felines in general) is rather long compared with its height. To measure the ratios between the various body parts, it may be useful to choose an element that can easily be recognized and compare all the others with it. For example, we can take the length of the head and compare it with the width and length of the body, or the legs. If only the head is being drawn, the measurements of the eyes and nose can be used as reliable references.

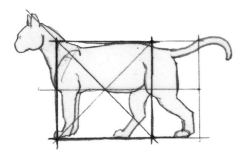
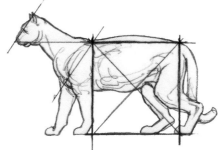

Average proportional ratios between an adult cat and an adult human being.

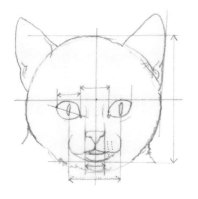

Some notes on the proportion of the head.

In several cat breeds, the profile of the head (seen from the front and not including the ears) is almost circular. The eyes are placed under the diameter line, slightly sloping and well distanced from each other. The nose is narrower than the space between the eyes. The width of the snout is the same as the distance between the centre of the pupils. The lateral rim of the outer ear, seen from the front, continues the head's profile line.

PERSPECTIVE

Like all three-dimensional objects, a cat's body is located in a space and in an environment. An oblique linear perspective (as seen on the right in both diagrams) can be useful when placing it in correct relation to other figures (animal or human) or with other surrounding elements, to evaluate the foreshortening of the individual body parts, and to outline the extension and direction of any shadows. An oblique linear perspective requires the subject (the cat) to be placed in relation with the horizon (always at the observer's eye level), and with two vanishing points at varying distances on the horizon, with which the imaginary oblique lines tangential to the body converge. Sometimes, it is sufficient to use only one of the two vanishing points, entrusting a kind of simplified, intuitive perspective.

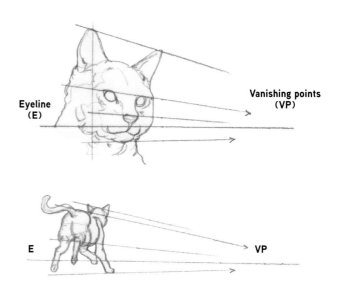

Eyeline (E)

Vanishing points (VP)

E VP

BASIC DRAWING TECHNIQUES

There are almost as many ways, techniques and styles of drawing as there are individual styles of writing: from objective, analytical and documentary drawings to summary, emotive drawings; and from patiently elaborated drawings to rapid, 'gestural' drawings. In fact, when drawing animals, it is important to try to render their vitality and agility on paper, and adopt a technique and style that are suited to rapid, 'free' work. I would like to spend a moment on two sometimes antithetic, but more often complementary, procedures that are especially useful for drawing natural, biological forms.

Linear drawing

This style involves an analysis of the shapes, to form 'constructive' structures and the outline of the profiles. It is summary observation that attempts to identify the line where it actually does not exist, but separates and defines the relations between the individual body parts and the overall shape of the body. 'Sharp' tools are preferred for linear drawing, such as an ink pen, a hard graphite (H or HB) stick and a ballpoint pen.

Tonal drawing

The tonal approach, on the other hand, concentrates on modulating tones and emphasizing the *chiaroscuro* effects. Lines establishing structure and shape give way to the contrasts and relationships of adjacent tones, as these alone are enough to hint at the volume of the body. Tools which offer greater texture are ideal for tonal drawing, such as charcoal, soft graphite (2B, 4B or 6B) sticks and watercolours.

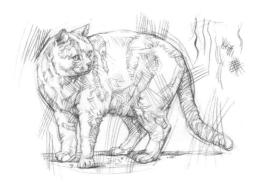

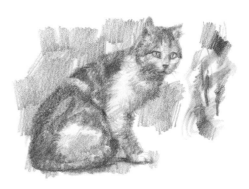

STRUCTURAL SIMPLIFICATION DIAGRAMS

Through practice and experience, every artist finds their own personal way of drawing shapes: some begin by portraying the outer appearance of what they wish to represent. Others prefer to investigate the structural, constructive lines first of all, building a kind of 'skeleton' that helps to find the best ratios between the body parts and the entire shape, or the 'gesture' of the movement. The diagrams below suggest some simple ways for interpreting and drawing the shape of a cat. For example: the structural relation lines between limbs and spine can be identified, or the main articular joint points, or the slight changes in overall shape of the head that, while on average is round, can appear to be oval or triangular in some breeds.

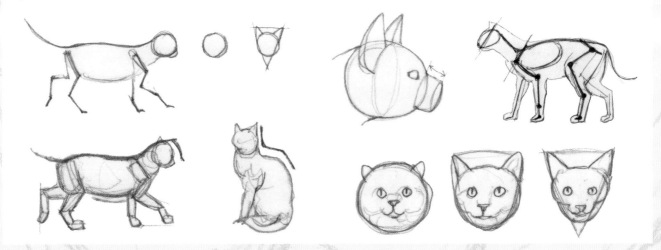

THE GRID METHOD

Of the many 'mechanical' procedures – which includes photocopying, projection, photographic and digital zooming – that can be used to reproduce a flat reference picture (whether drawing or photograph), that of using a grid is the simplest and oldest. While providing great precision for transferring the outlines of an image's basic structure, it also allows full freedom for the artist to develop the drawing further. The procedure is simple and intuitive, and can be summarized as described below.

Step 1 – A number of parallel lines (horizontal and vertical) are traced directly (or onto tracing paper) onto the reference image (or a photocopy) to form a grid of squares which vary in size, depending on the degree of precision with which one wishes to transfer the image.

Step 2 – Lightly drawn pencil lines are used to produce the same grid on the drawing surface (paper, canvas, etc.). Changing the distance between the lines creates larger or smaller squares.

Step 3 – The main outlines and shapes within each square on the reference image are transferred to the corresponding square on the drawing surface's grid, until the whole outline of the subject has been traced. Before working on the transferred image and applying more free-hand procedures, it is advisable to rub out the grid lines.

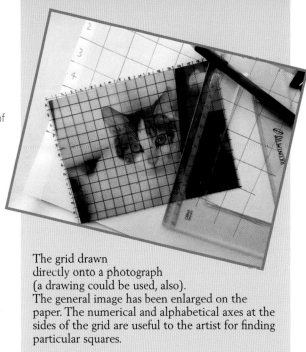

The grid drawn directly onto a photograph (a drawing could be used, also). The general image has been enlarged on the paper. The numerical and alphabetical axes at the sides of the grid are useful to the artist for finding particular squares.

PRACTICAL CONSIDERATIONS

Where to find cats Cats can be classified as 'pedigree' or purebred, or crossbred when they are the result of casual mating. The latter can easily be found in homes or roaming almost anywhere: there are many of them in the countryside (on farms) and in towns (stray sometimes, or in cats' homes or animal shelters). Pedigree cats, on the other hand, can be found less frequently, mostly on breeders' farms and in specialist shops or in competitions and exhibitions. Of course, there is a great abundance of photographs (published in newspapers, magazines and books) and television documentaries, or images available on the internet. Generally, they are images protected by copyright, but they can be consulted for reference and as sources of inspiration.

Understanding cats The cat is a domestic animal with a marked personality: it is autonomous; opportunistic; territorial; and has weak social organization, often inclined to 'equal' rather than hierarchical relations. It has an extremely strong sense of smell which it uses to identify its territory, search its environment and to recognize its 'friends'. The cat is an agile animal that moves stealthily, but also tends to assume characteristic and repeated positions. For example, it will curl up to rest in quiet places or spend a lot of time smoothing its fur with its tongue. These are the best moments to draw a cat. When it is calm, it will play and purr, kneading its front paws; when it is irritated or in defence, it will arch its spine, its fur will stand up and its ears will be pushed back.

How to portray cats A cat's movement is often sudden and unpredictable: it is advisable to position yourself at a certain distance if it is unknown to you (to avoid alarming or disturbing it), observing it carefully and committing the salient elements to memory before starting to draw. Naturally, the most suitable poses are the static ones, but those in 'tension' also work – where the start or conclusion of an action is shown. If possible, it is also advisable to choose the position from which to portray the cat: as it is a small animal, it is usually seen from above, with high perspective angles and with foreshortening. The artist can position themselves at the same level as the cat, sitting on the floor, or place the cat on a table or an armchair to achieve a lower angle.

Using photographs These are almost always essential for 'fixing' an interesting temporary or rapid stance. However, photographs are even more useful if preceded or accompanied by rapid summary sketches, drawn with the purpose of capturing the 'nature' of the action or of the position and overall conformation of the animal. This avoids having to depend unquestioningly on the photograph and allows information to be added, correcting unavoidable distortions in perspective. A cat's fur, however thick and long (except in some breeds that have hardly any fur), hides the actual anatomical shapes and suggests the use of softer tools (such as charcoal, soft graphite, watercolour and pastels), which are more suited to rendering a cat's soft, blurred outlines. Whether you are working on the summary sketch or from a photograph, it is necessary to consider the fluffiness of the fur.

CAT GALLERY

HOW TO FOLLOW THE GALLERY

The drawings printed in this section (from page 172 to page 240) are intended to give ideas and elements for practice, in order to be able to observe and study proportions and shapes of a static or moving cat. The graphic style that I have used in drawing them is somewhat 'neutral', and involves a *chiaroscuro* with soft transitions. The reasoning for this was to provide as objective a portrayal of the subject as possible, leaving the artist with a general drawing to use as a starting point so that he or she could elaborate on it with his or her own interpretation, according to the styles and techniques that are the most suitable and fitting for his or her own aesthetic awareness and sensitivity.

Each cat is accompanied by rapid preliminary studies, or 'steps' – these are drawings of the outlines, shapes and tones I observed, carried out in a short time with a soft lead pencil, in a much more liberal style than the one then applied to the more elaborate, contemplated drawing (see the drawing below). These preliminary studies serve almost as 'visual notes', to aid in the making of the final, elaborate drawing. For example, in step 1, the overall size of the cat, the space it takes up on the sheet, together with a suggestion of its action are indicated, using a few light

lines; in step 2 the supporting structure of the cat (trying to guess what is underneath its fur, which can be of varying thickness), its greater volume and the direction of its main axes are established generally; in step 3, key shadows for modelling the volume are introduced, while modulating the *chiaroscuro* tones.

Most of the more elaborate drawings in this section of the book were drawn using graphite (HB and B) on paper (15 x 21cm / 6 x 11in). The tonal studies that accompany almost all the portraits were drawn using softer graphite (4B and 6B) sticks on larger sheets of paper (21 x 28 cm /8¼ x 11in, or US letter).

The grid suggested for each figure can be used as an initial guide to reproduce the basic outline of the cat's body (after having also traced it on to the drawing surface, at the desired size). After this summary indication of the overall dimensions, the next developmental stages concern checking proportions, identifying the constructive planes and establishing tonal effects. The grid can be drawn directly onto the reference image that is to be reproduced, be it a photograph or drawing. I prefer to use tracing paper and then use this to draw only the most summary body parts on it, just enough to begin the next drawing stage.

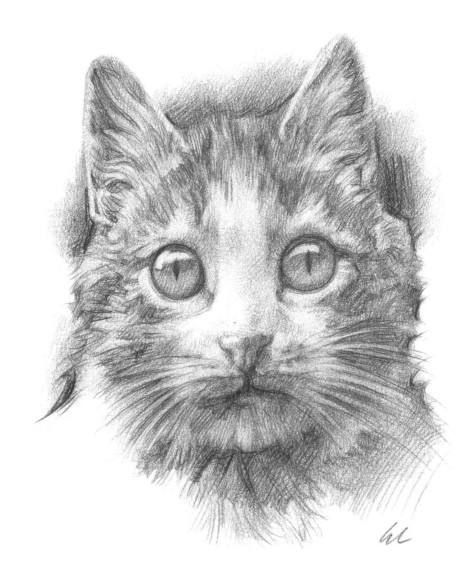

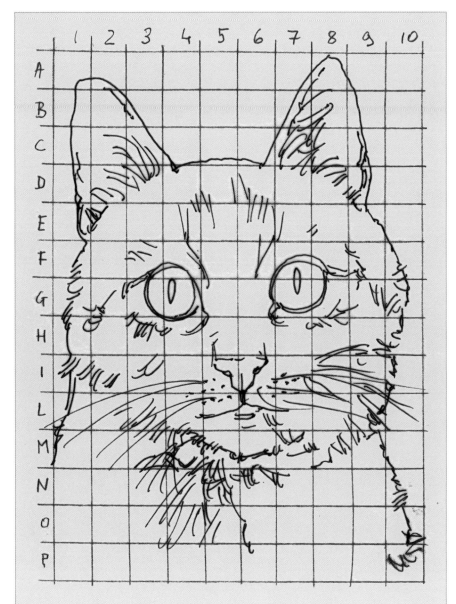

Step 1: Overall shape and size

Step 2: Structure and proportions

Step 3: Volume and shadows

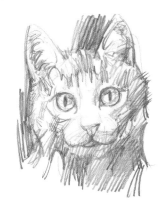

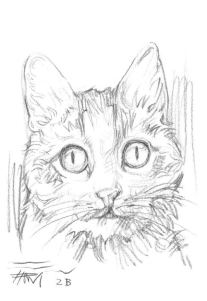

Linear study

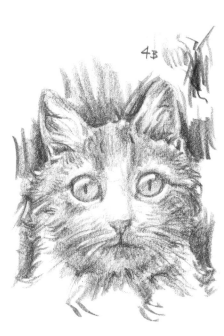

Tonal study

Step 1: Overall shape and size Step 2: Structure and proportions Step 3: Volume and shadows

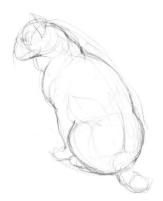 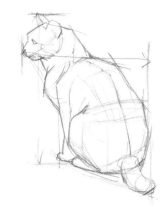 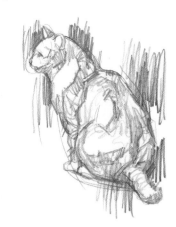

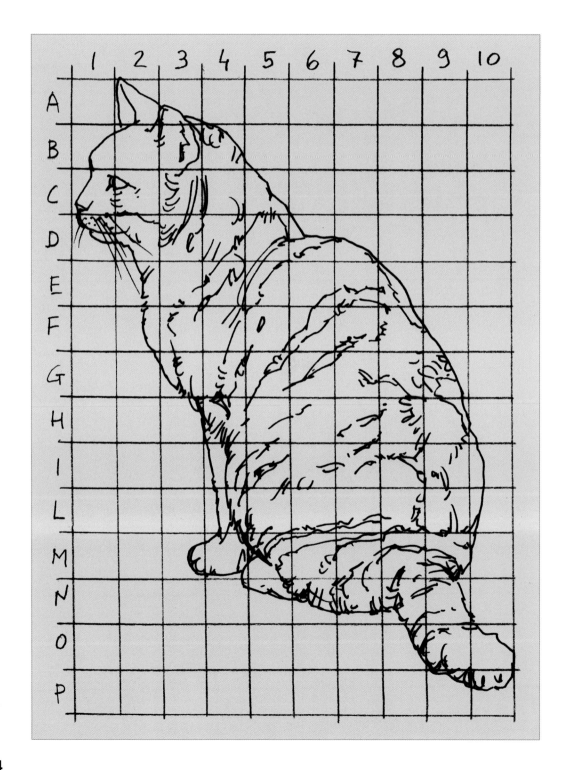

Tonal study

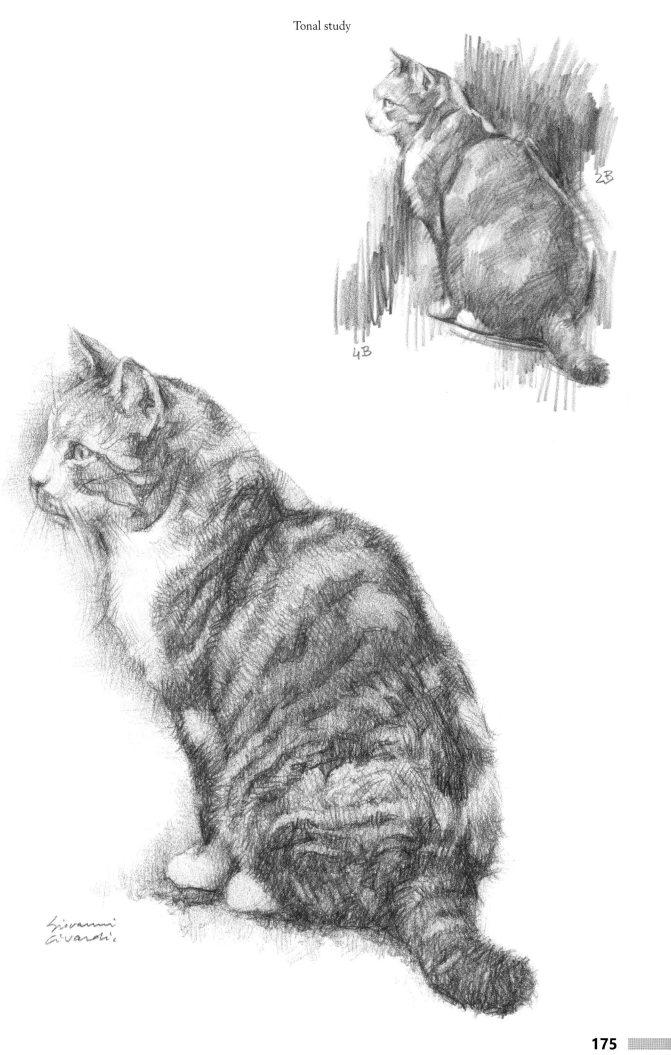

2B

4B

Giovanni
Givardi

Step 1: Overall shape and size

Step 2: Structure and proportions

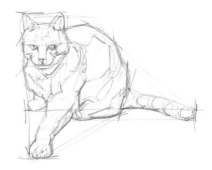

Step 3: Volume and shadows

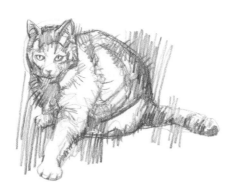

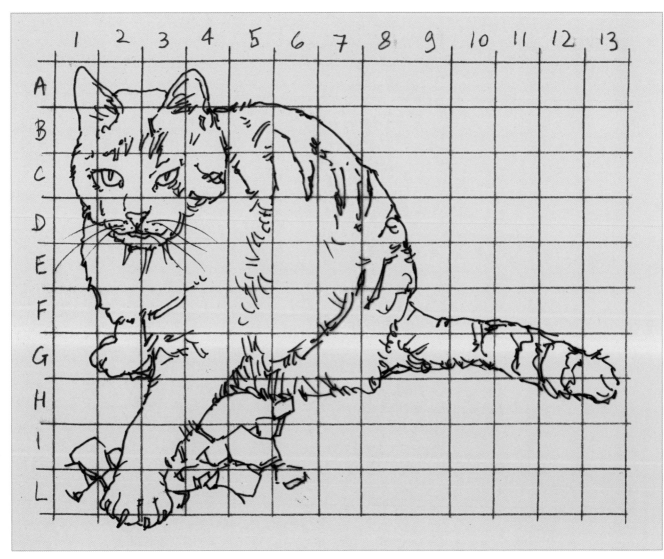

Tonal study

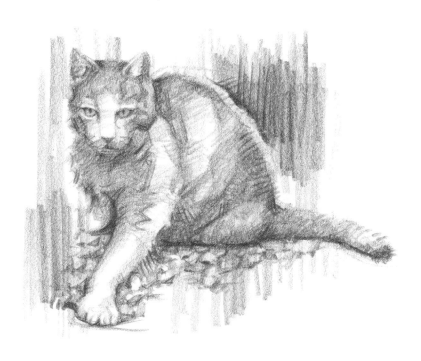

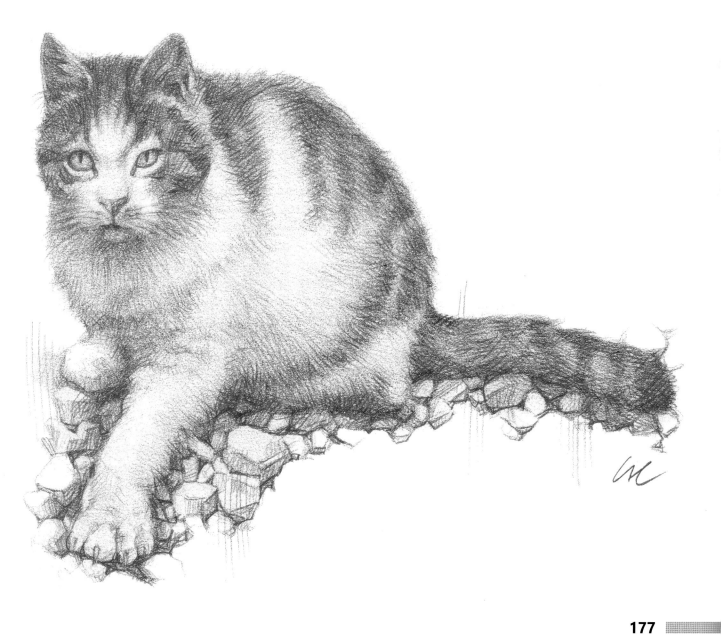

Step 1: Overall shape and size

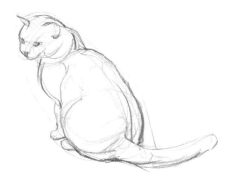

Step 2: Structure and proportions

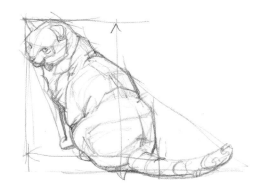

Step 3: Volume and shadows

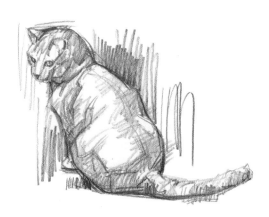

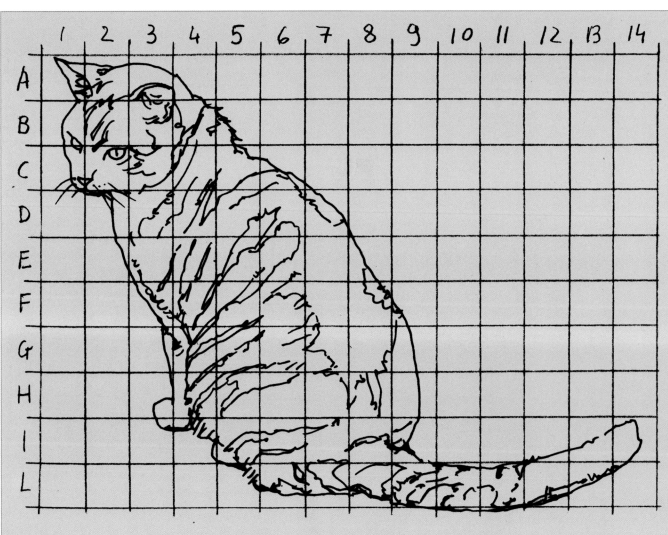

Tonal study

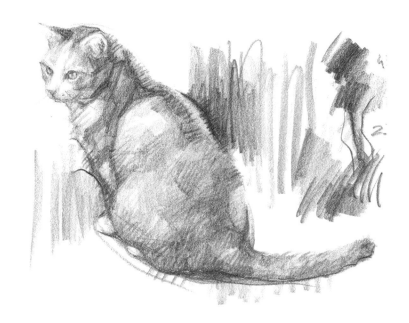

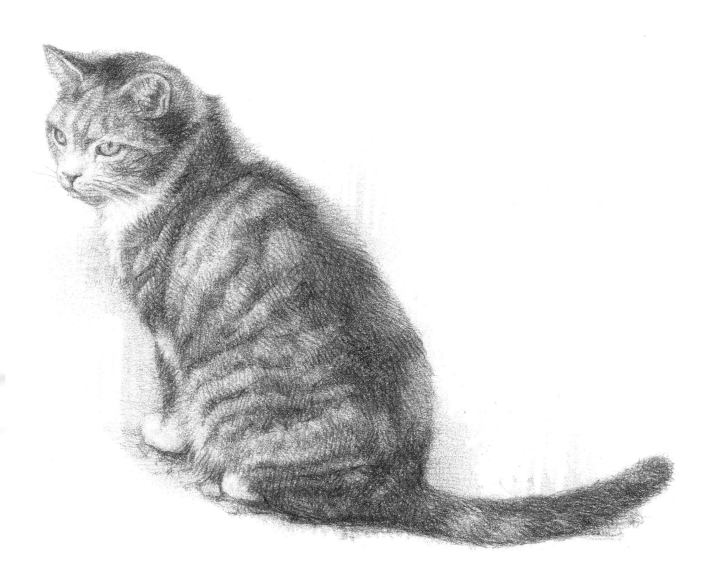

Step 1: Overall shape and size

Step 2: Structure and proportions

Step 3: Volume and shadows

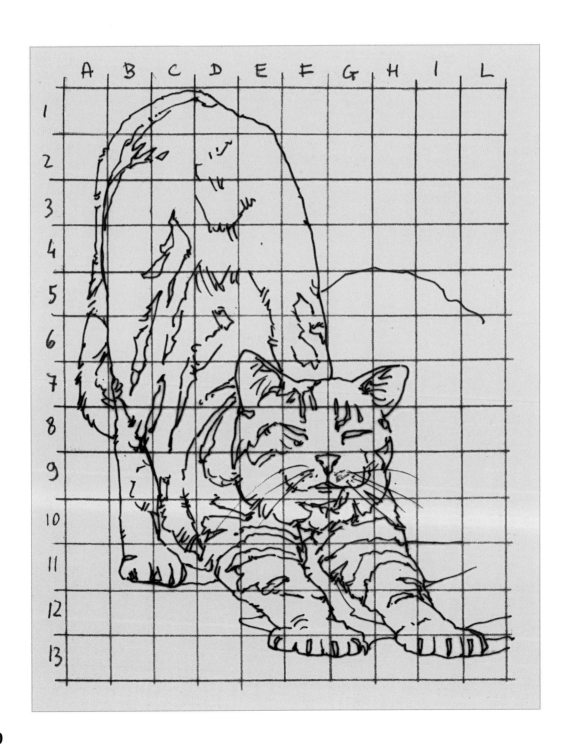

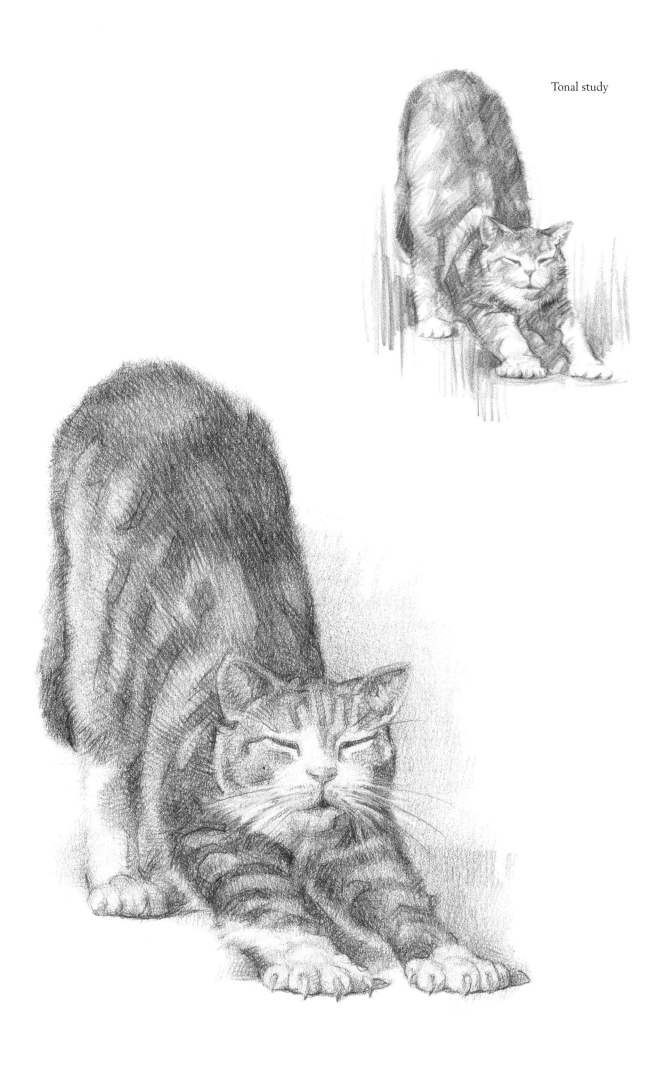

Tonal study

Step 1: Overall shape and size

Step 2: Structure and proportions

Step 3: Volume and shadows

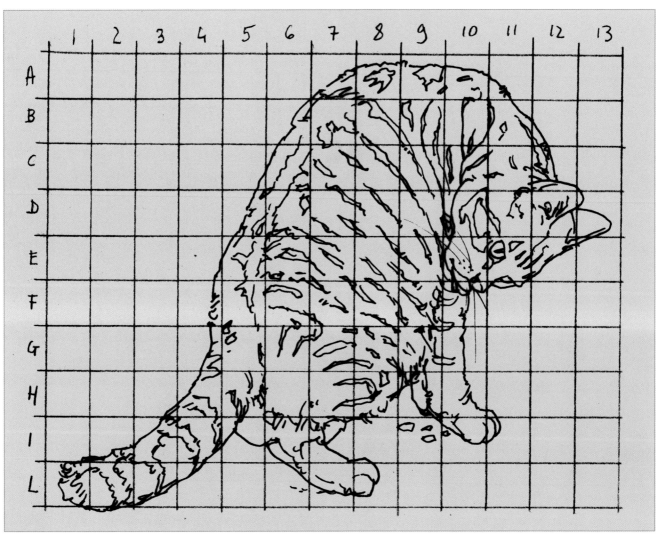

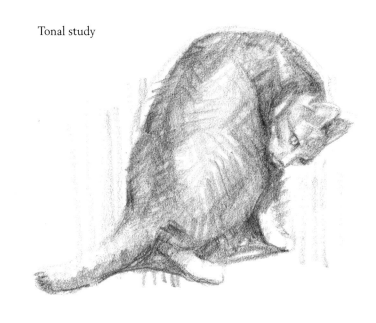

Tonal study

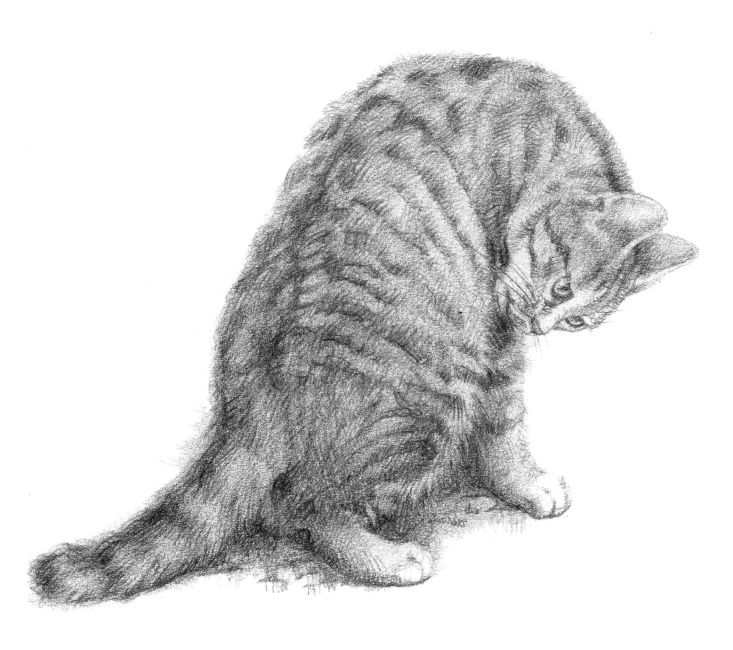

Step 1: Overall shape and size

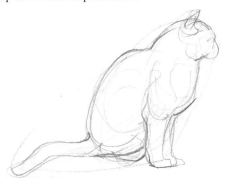

Step 2: Structure and proportions

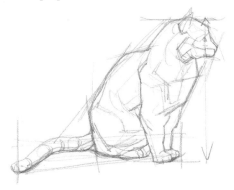

Step 3: Volume and shadows

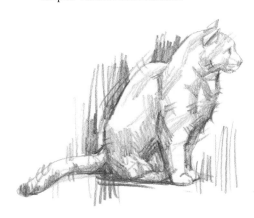

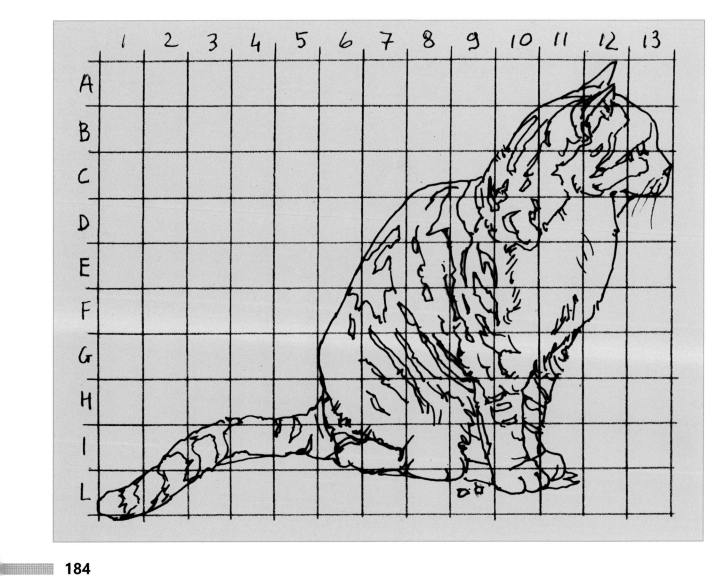

Tonal study

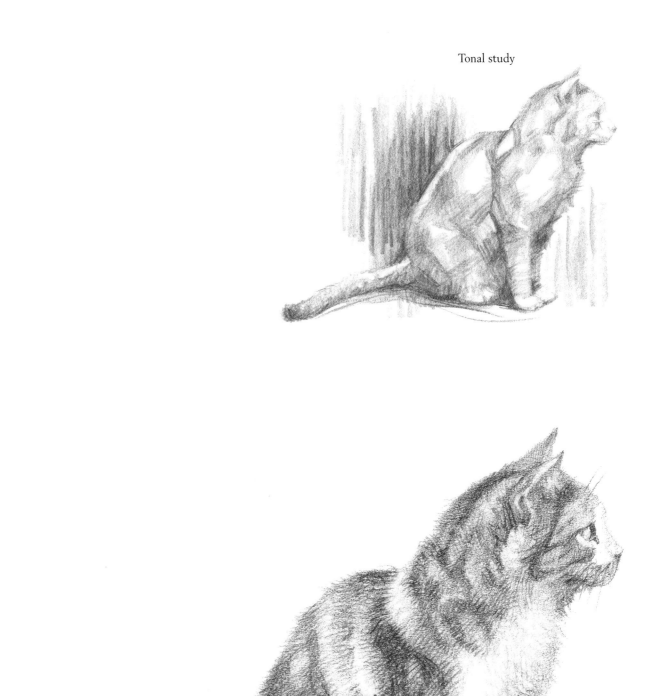

Step 1: Overall shape and size Step 2: Structure and proportions Step 3: Volume and shadows

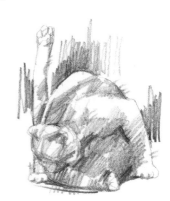

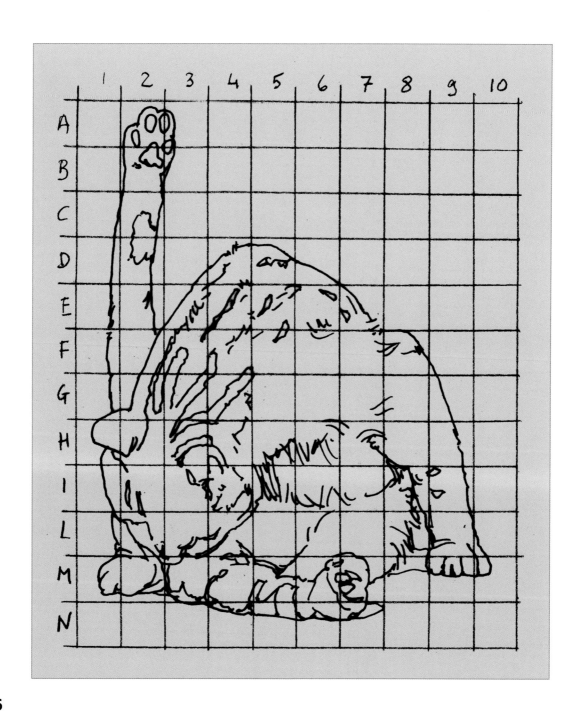

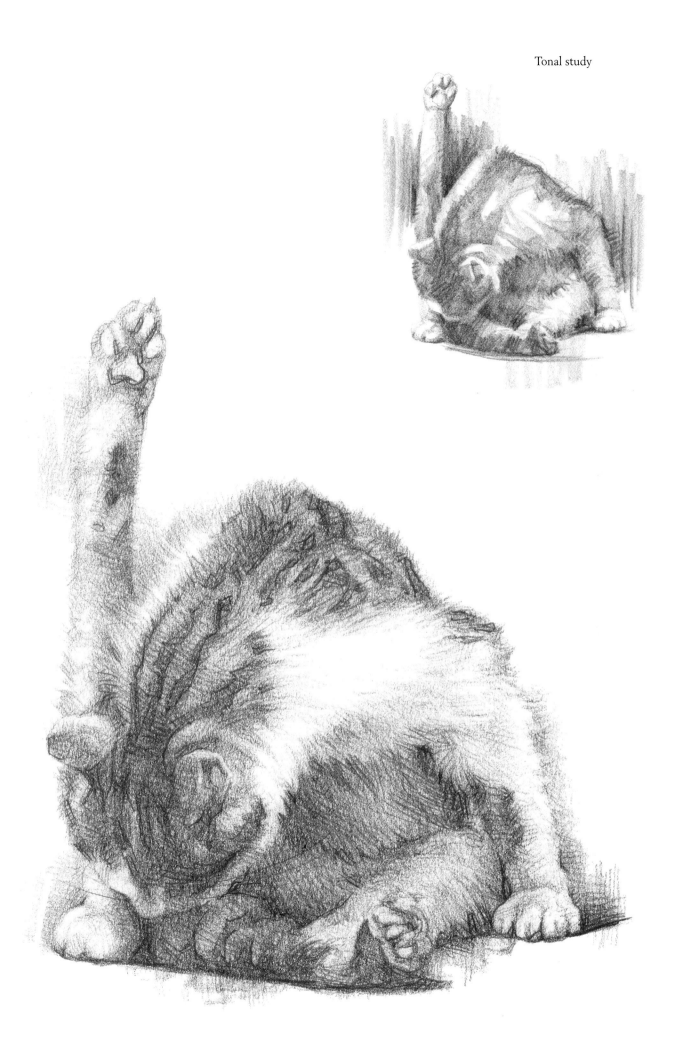

Tonal study

Step 1: Overall shape and size Step 2: Structure and proportions Step 3: Volume and shadows

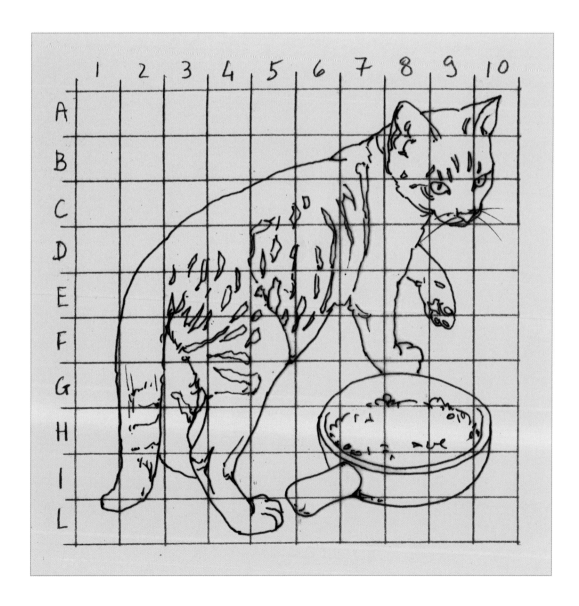

Tonal study

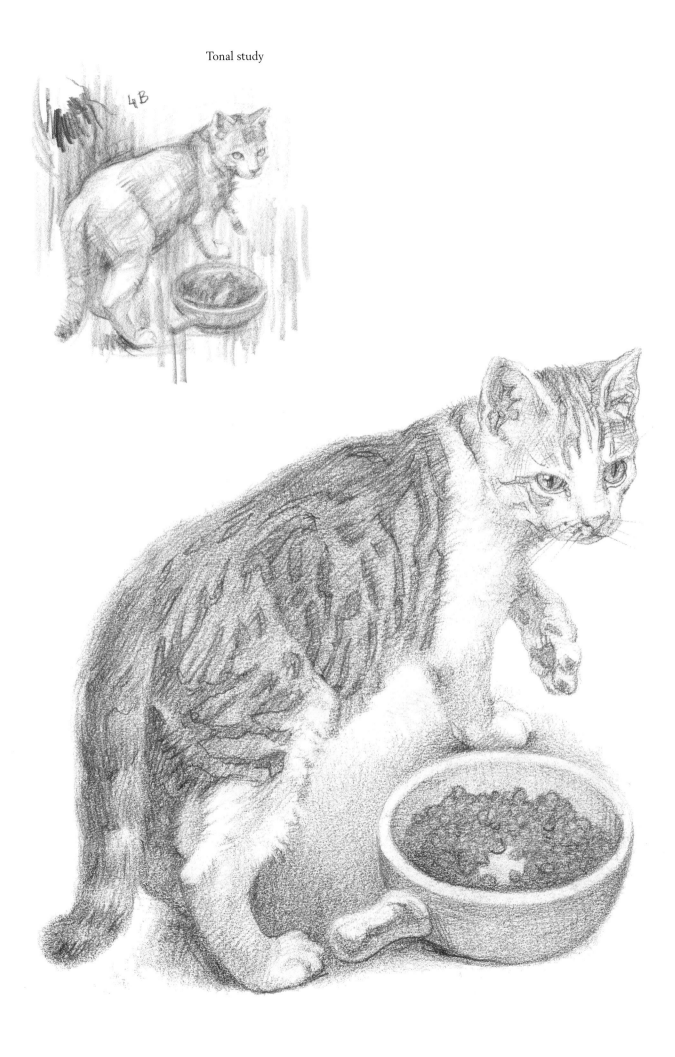

Step 1: Overall shape and size

Step 2: Structure and proportions

Step 3: Volume and shadows

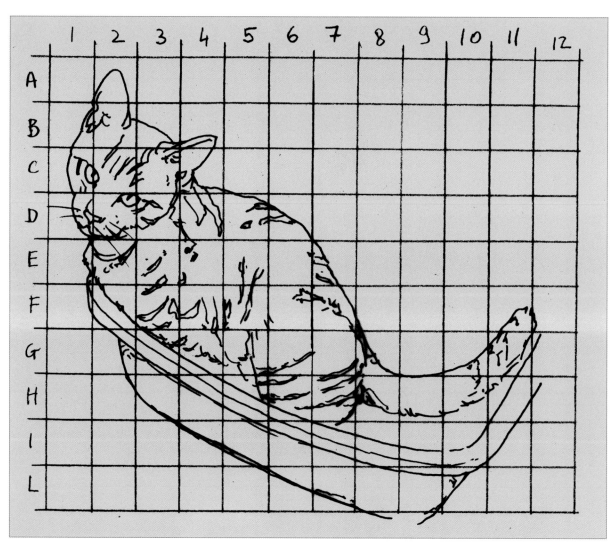

Linear study

Tonal study

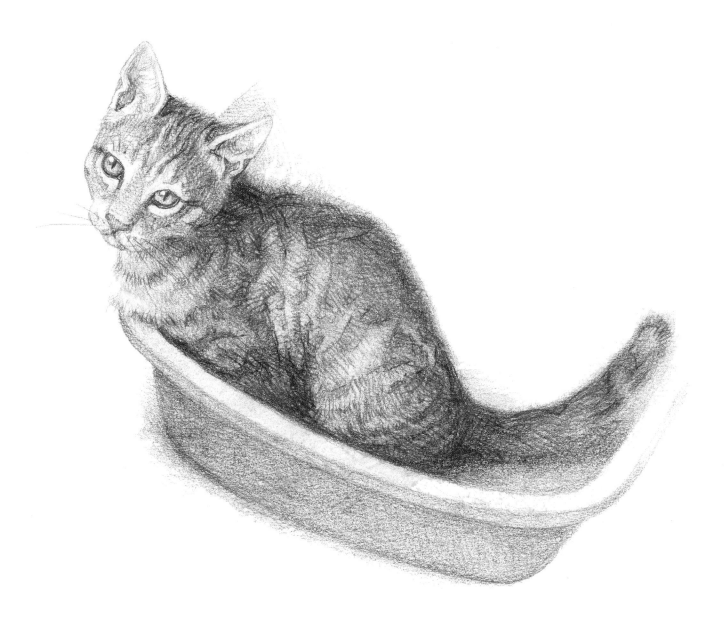

Step 1: Overall shape and size

Step 2: Structure and proportions

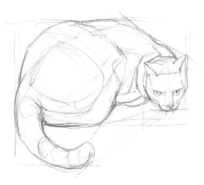

Step 3: Volume and shadows

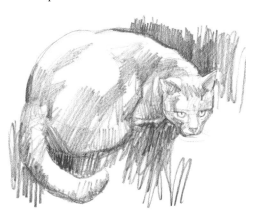

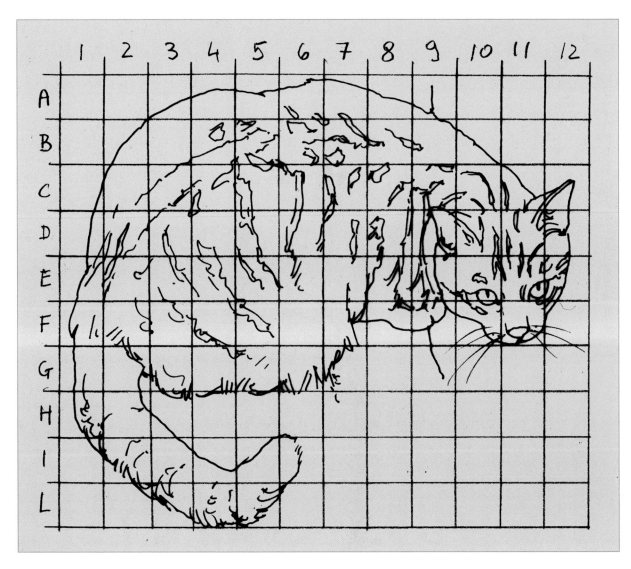

Tonal study

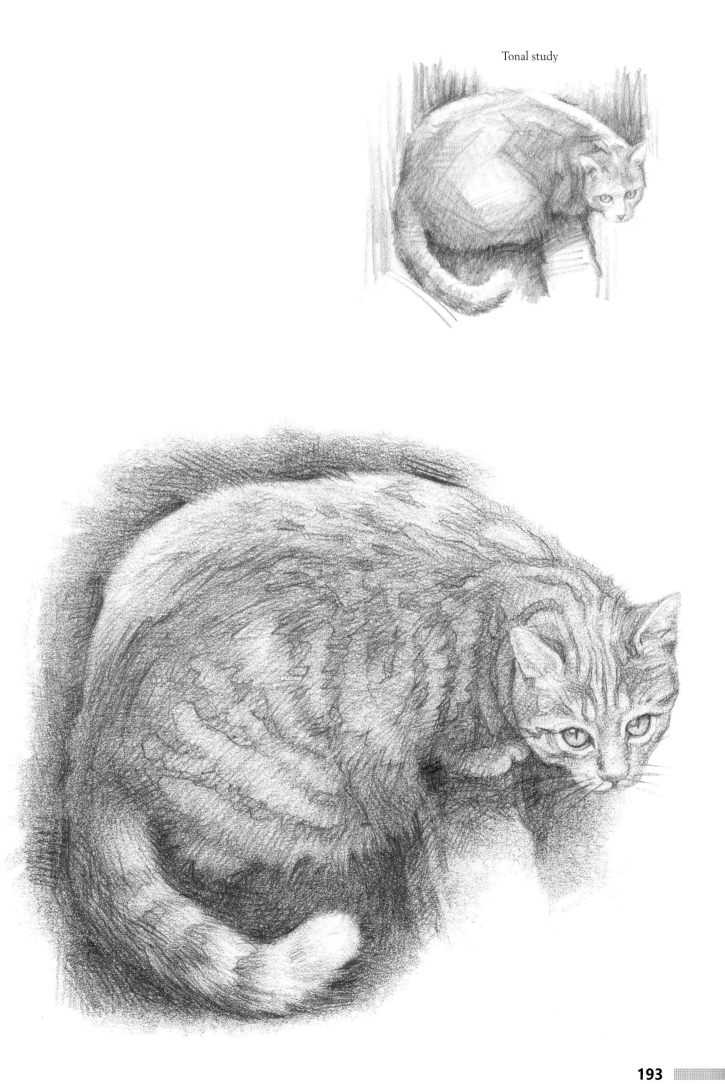

Step 1: Overall shape and size

Step 2: Structure and proportions

Step 3: Volume and shadows

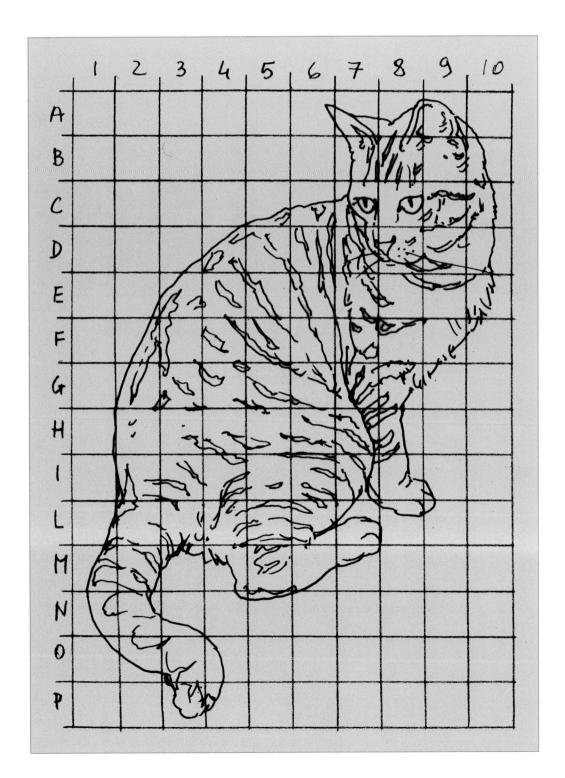

Tonal study

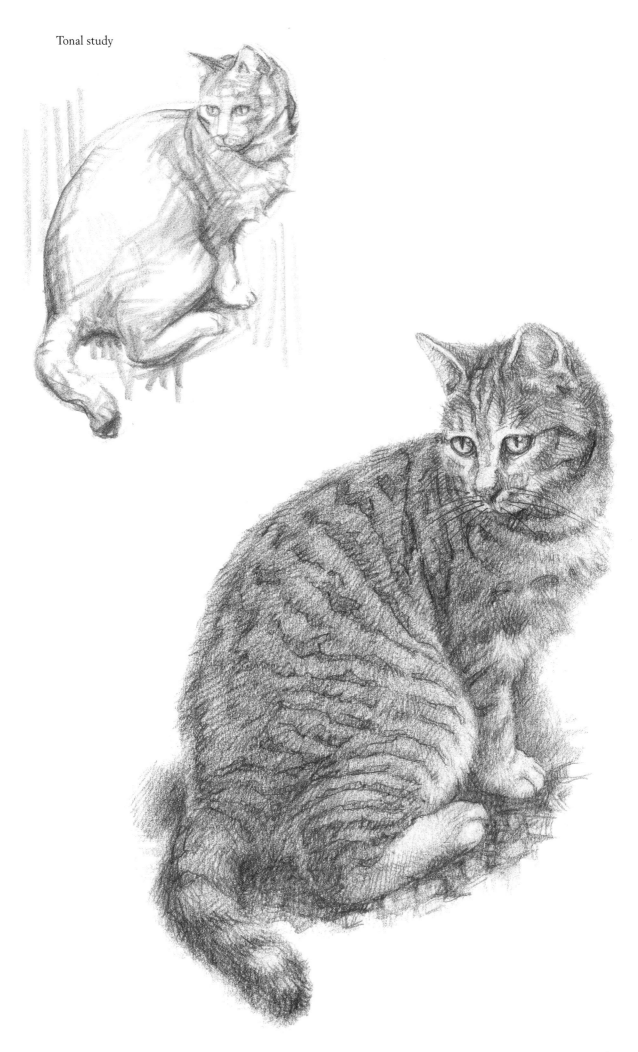

Step 1: Overall shape and size

Step 2: Structure and proportions

Step 3: Volume and shadows

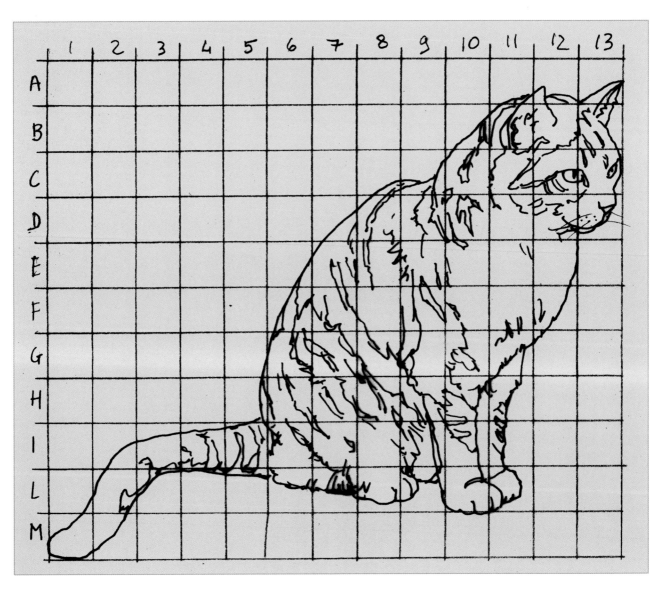

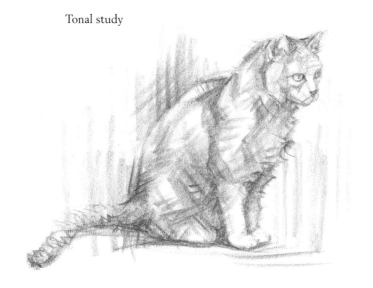

Tonal study

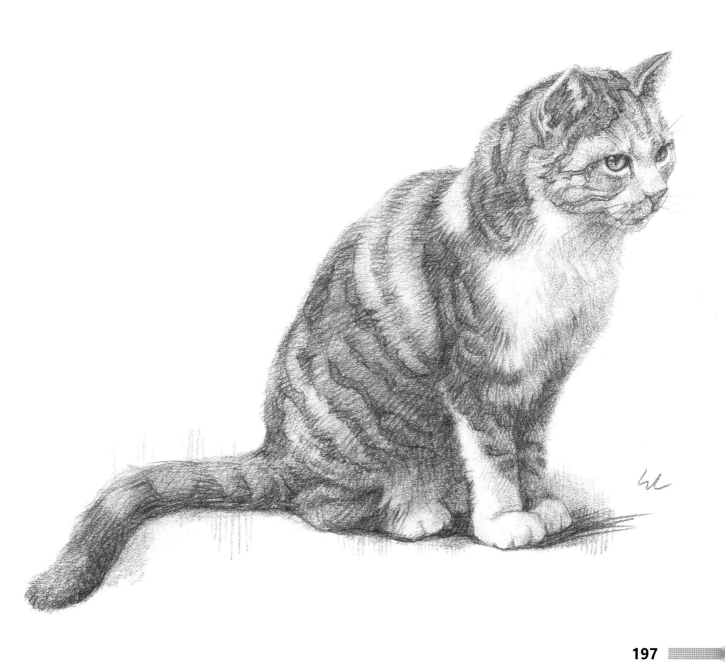

Step 1: Overall shape and size

Step 2: Structure and proportions

Step 3: Volume and shadows

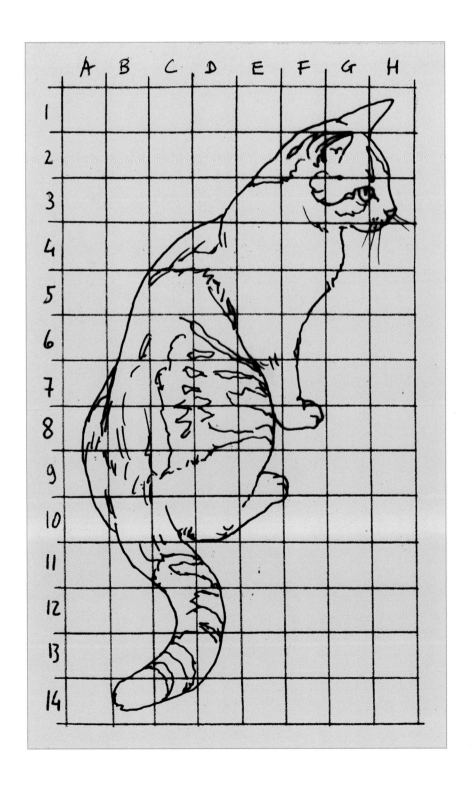

Tonal study

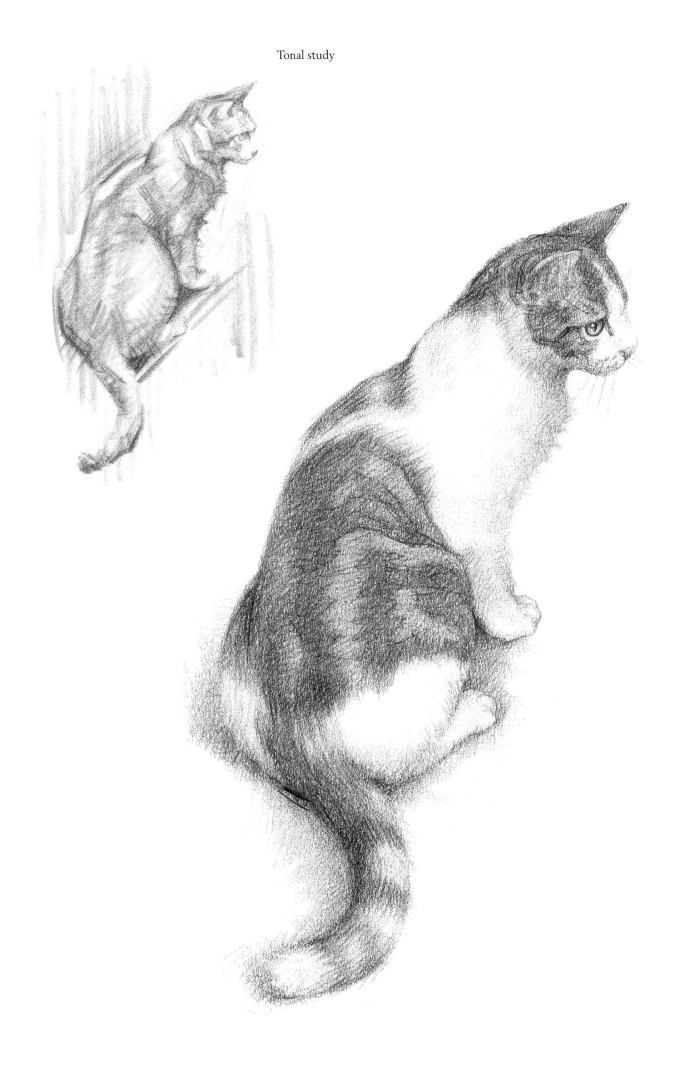

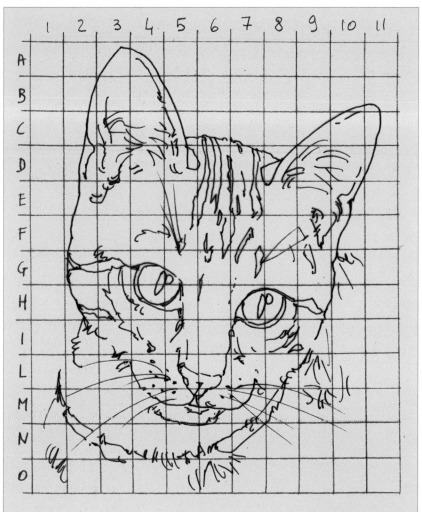

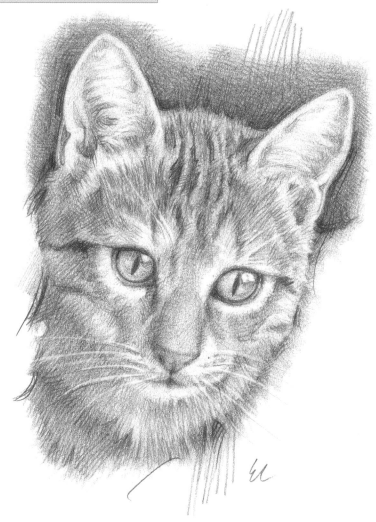

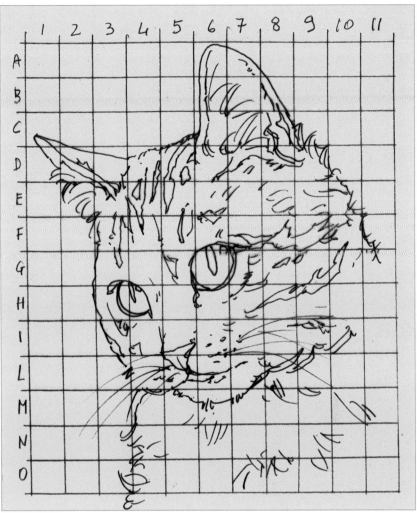

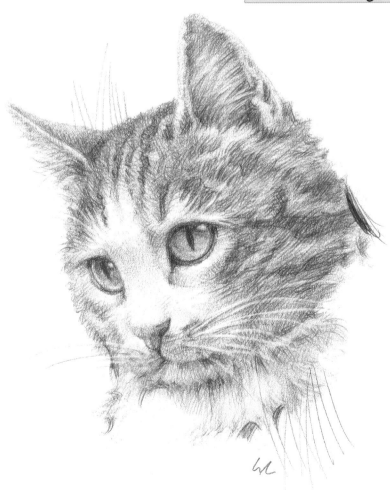

Step 1: Overall shape and size

Step 2: Structure and proportions

Step 3: Volume and shadows

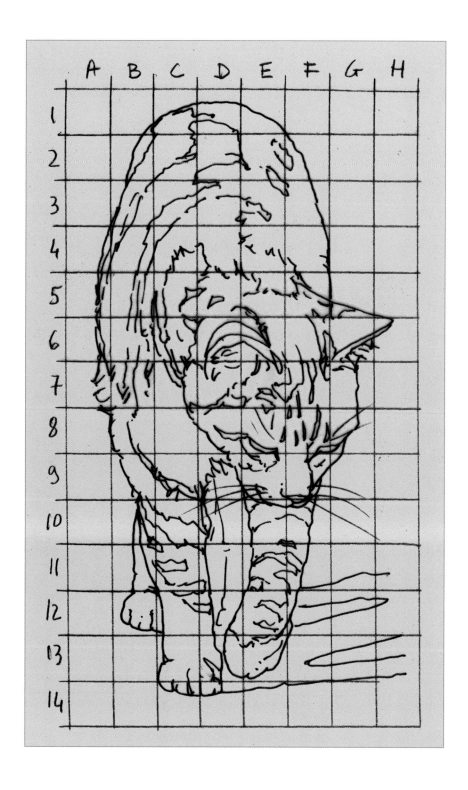

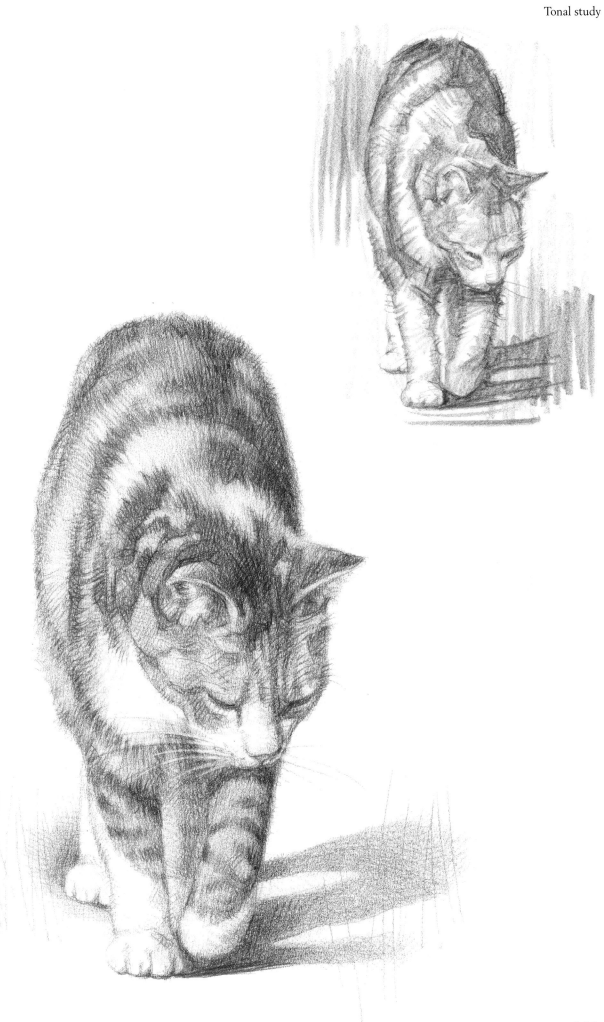

Step 1: Overall shape and size Step 2: Structure and proportions Step 3: Volume and shadows

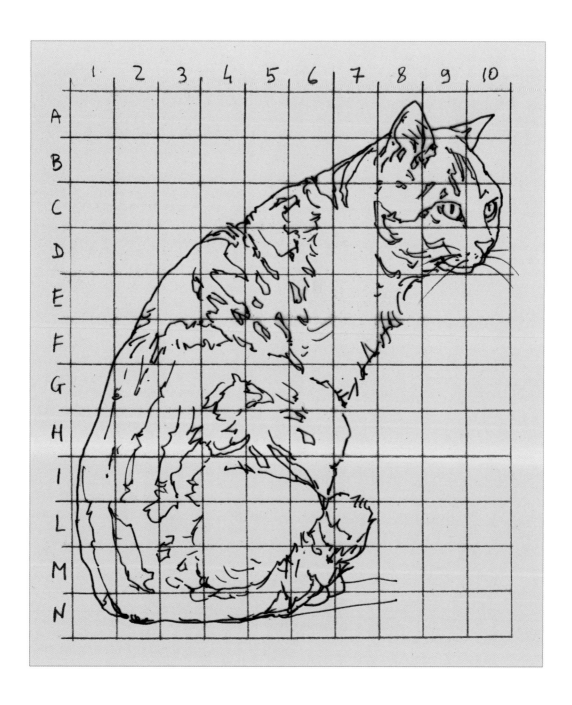

Tonal study

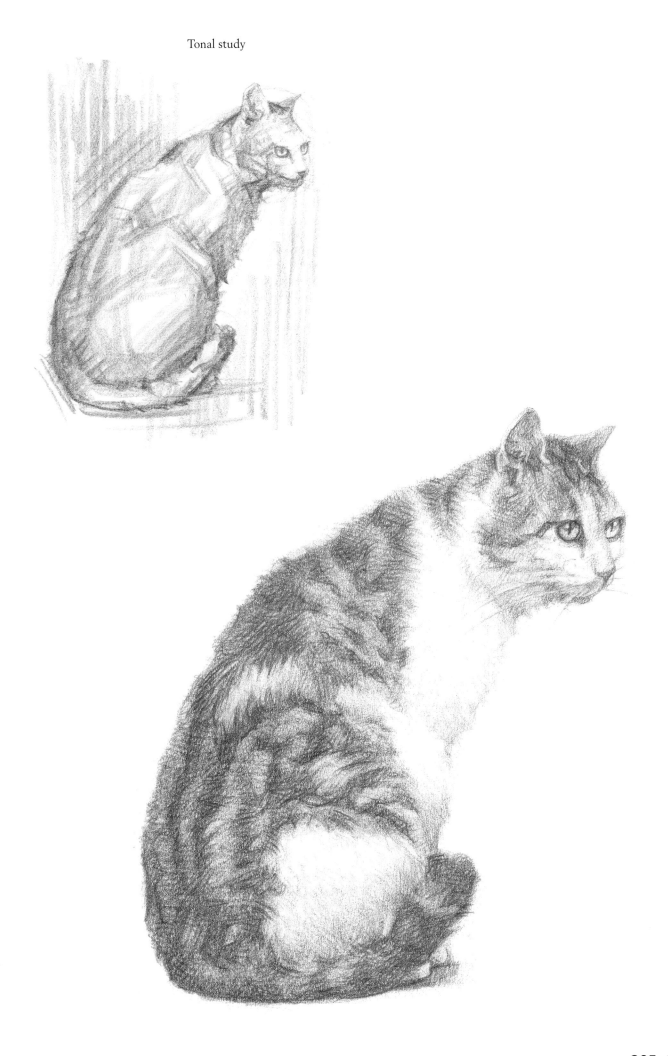

Step 1: Overall shape and size Step 2: Structure and proportions Step 3: Volume and shadows

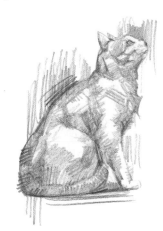

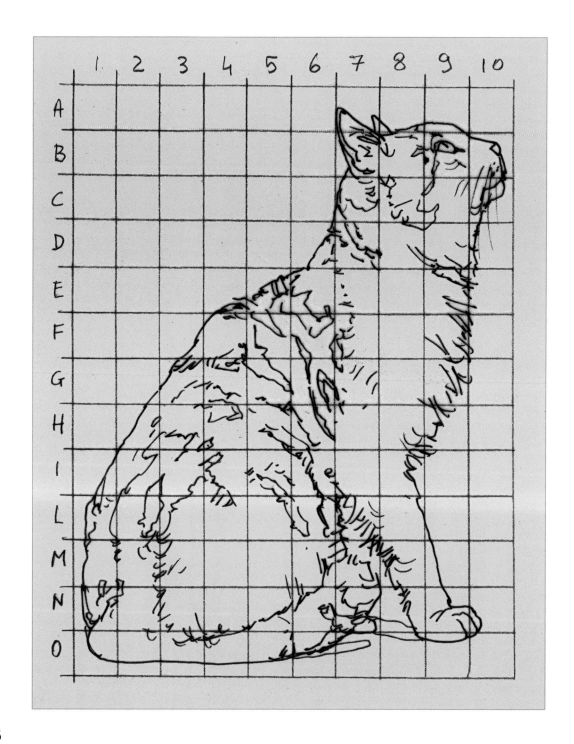

Tonal study

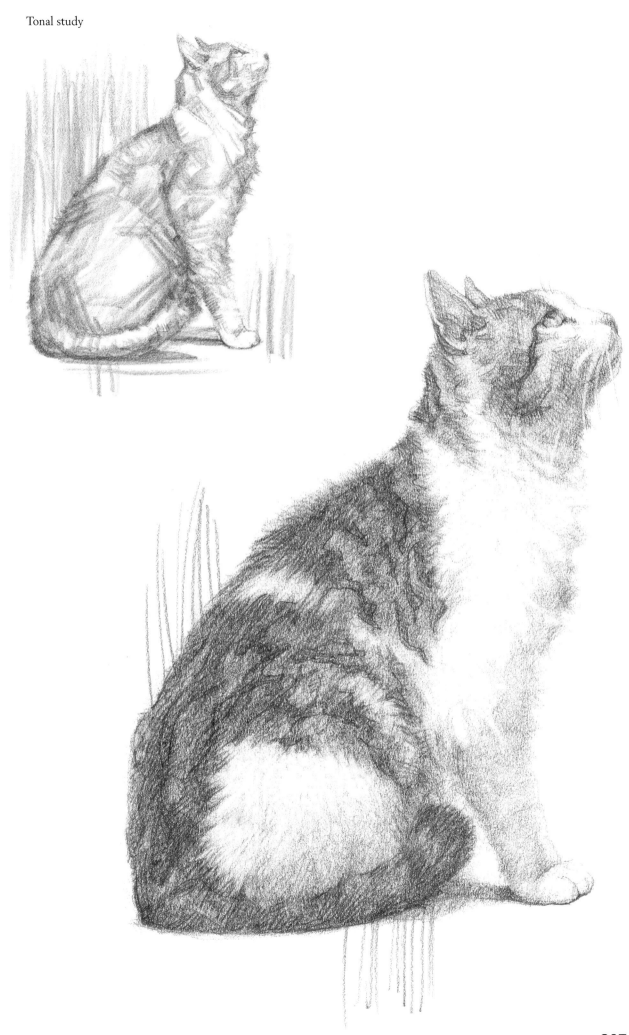

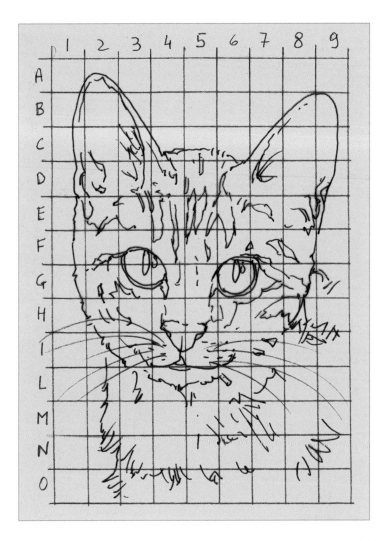

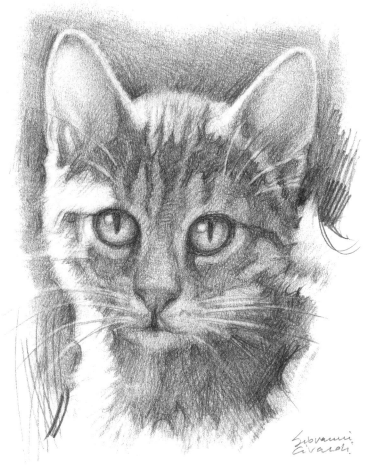

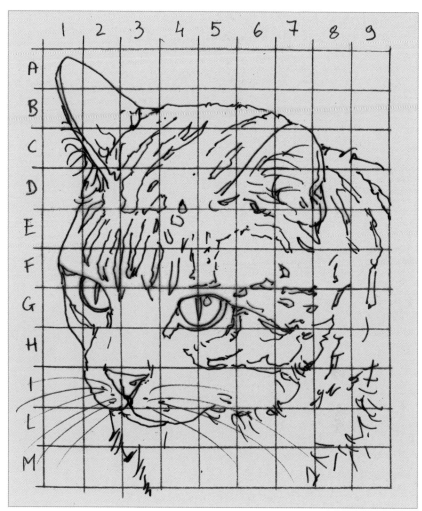

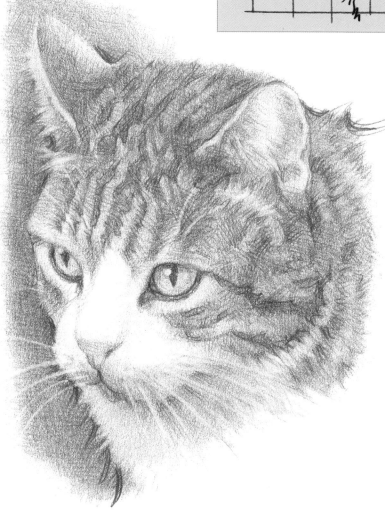

Step 1: Overall shape and size

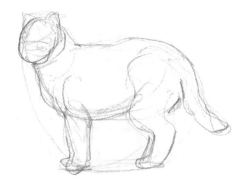

Step 2: Structure and proportions

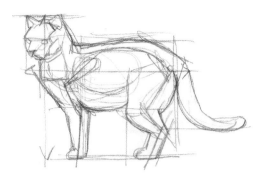

Step 3: Volume and shadows

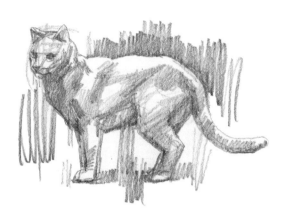

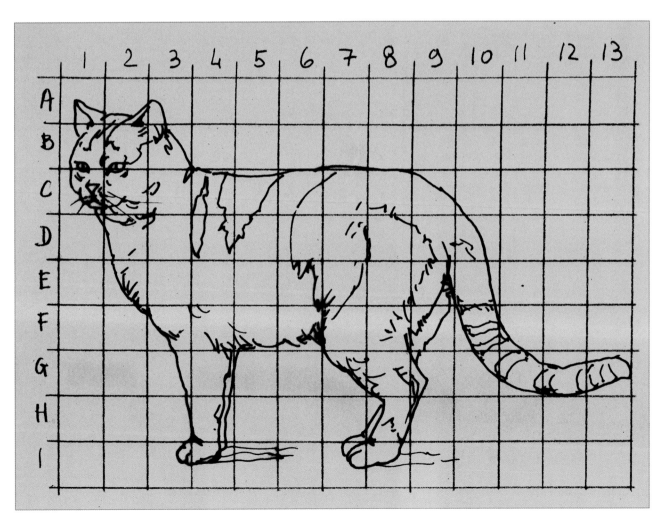

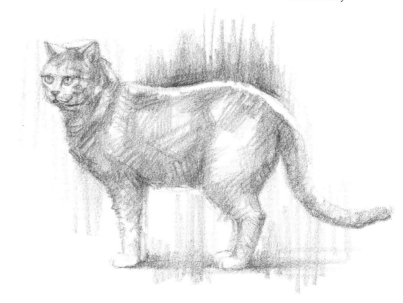

Tonal study

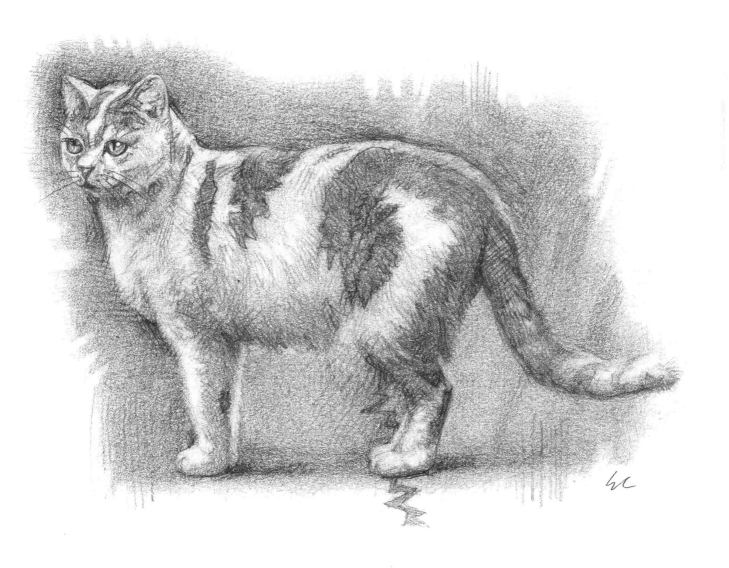

Step 1: Overall shape and size Step 2: Structure and proportions Step 3: Volume and shadows

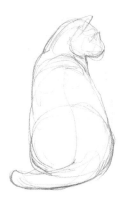
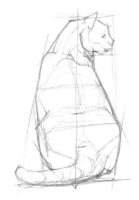
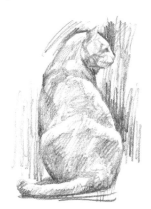

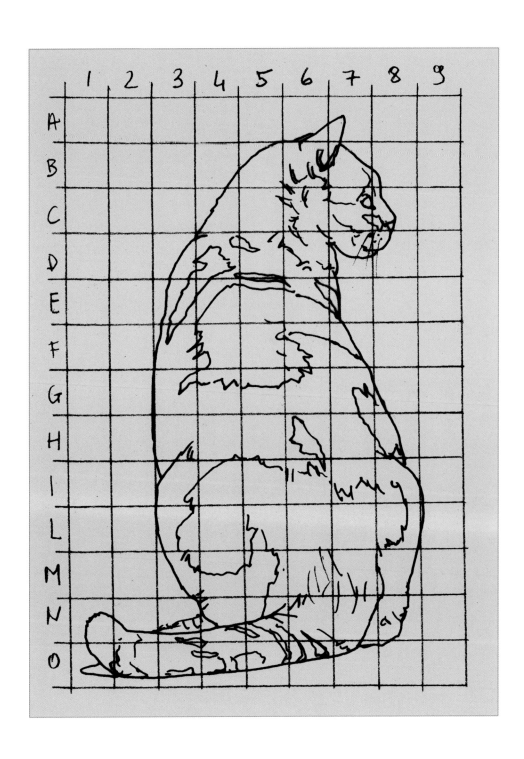

Tonal study

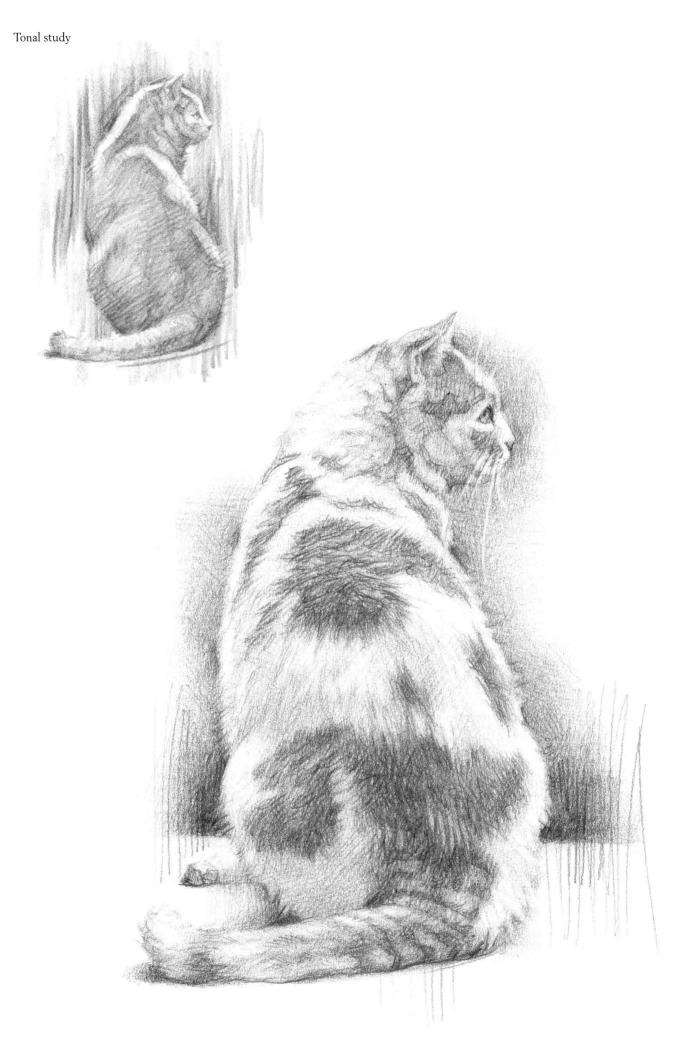

Step 1: Overall shape and size Step 2: Structure and proportions Step 3: Volume and shadows

 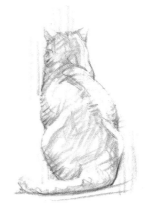

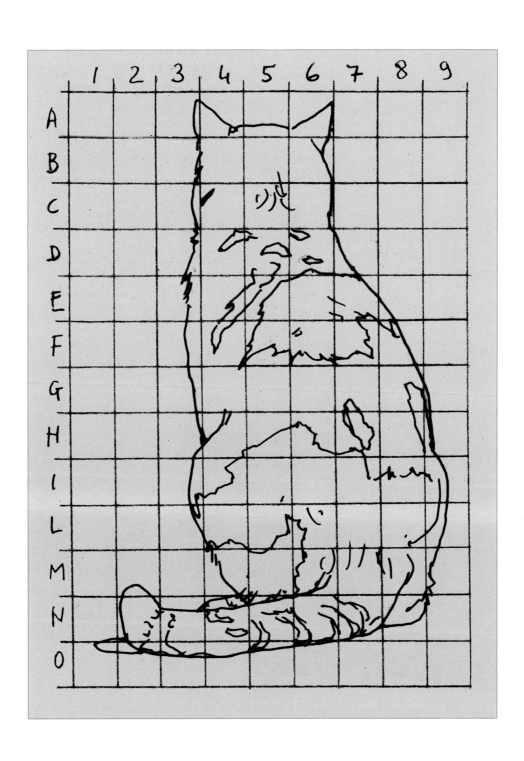

Tonal study

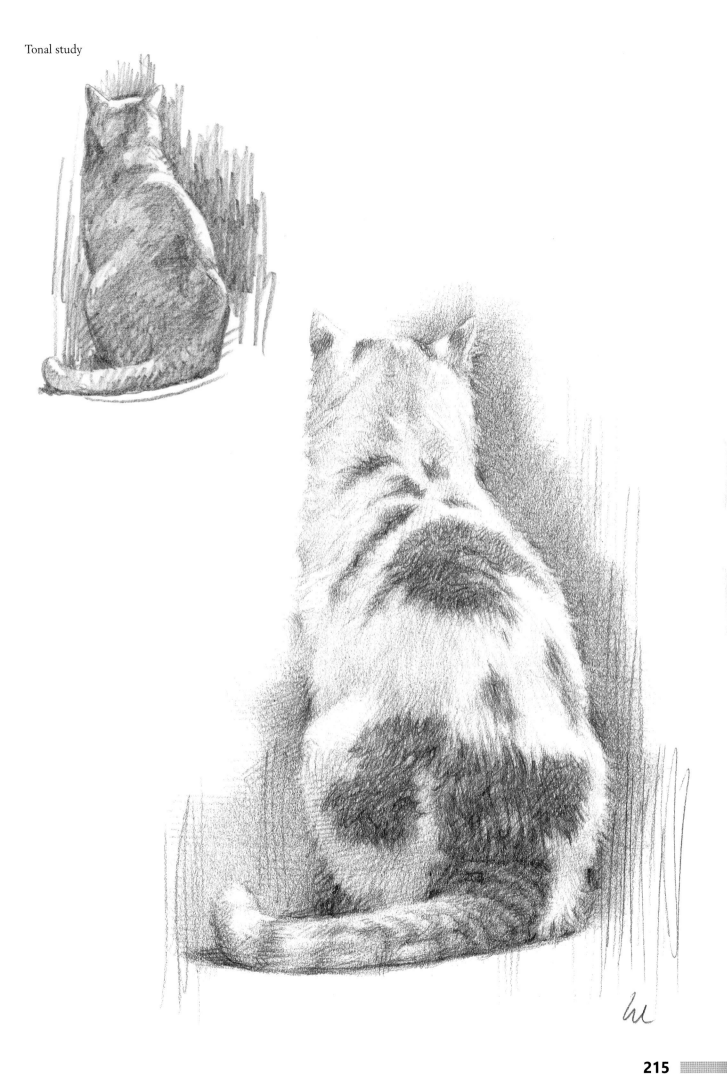

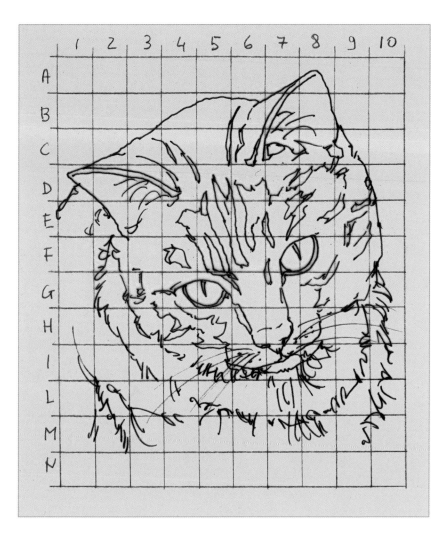

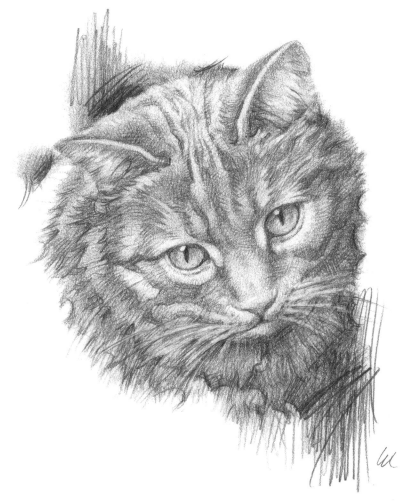

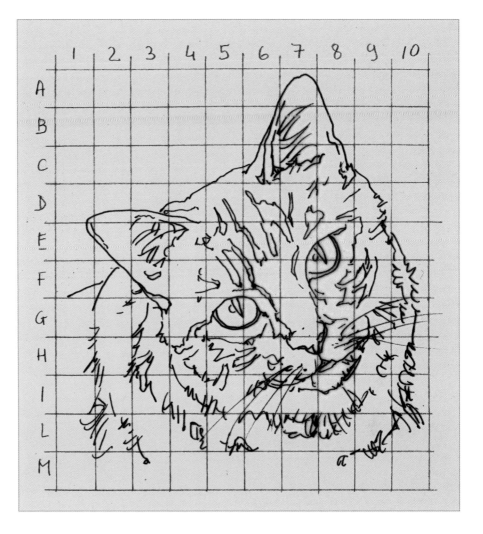

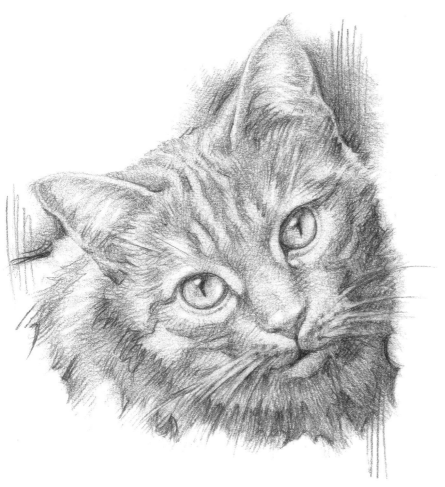

Step 1: Overall shape and size

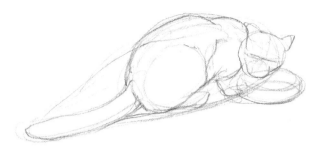

Step 2: Structure and proportions

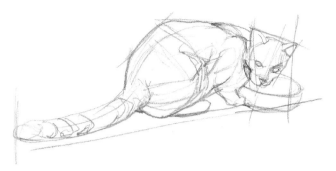

Step 3: Volume and shadows

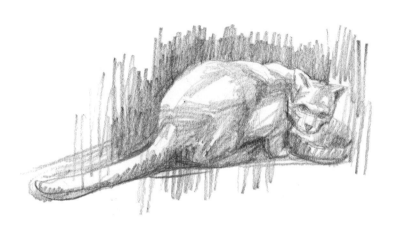

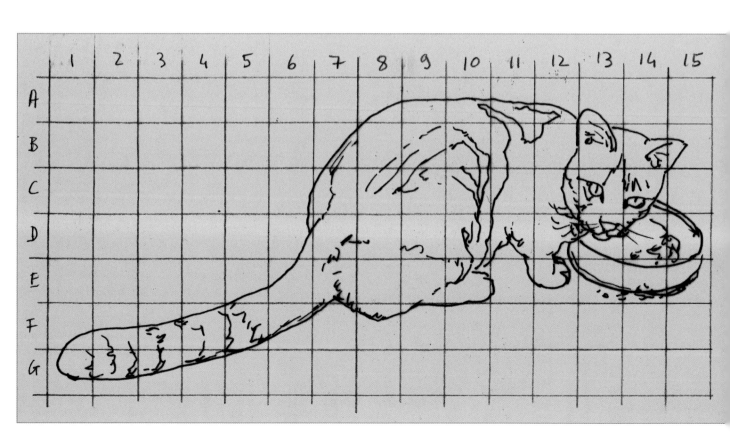

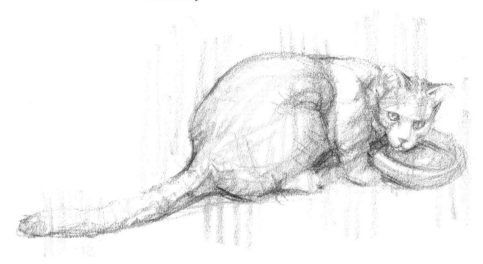

Tonal study

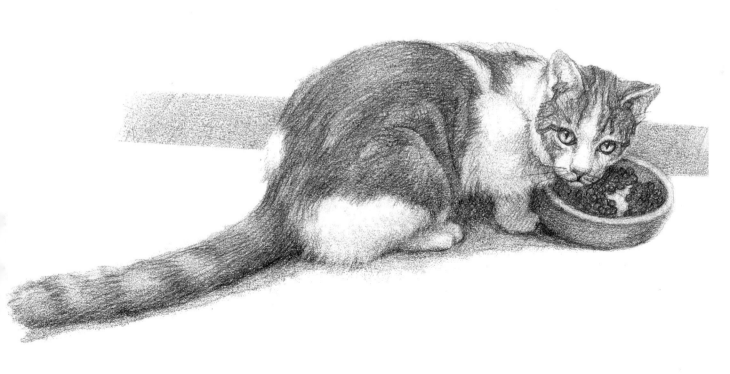

Step 1: Overall shape and size

Step 2: Structure and proportions

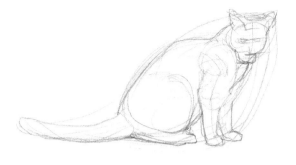
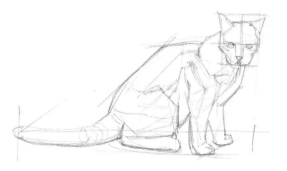

Step 3: Volume and shadows

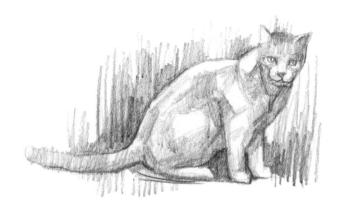

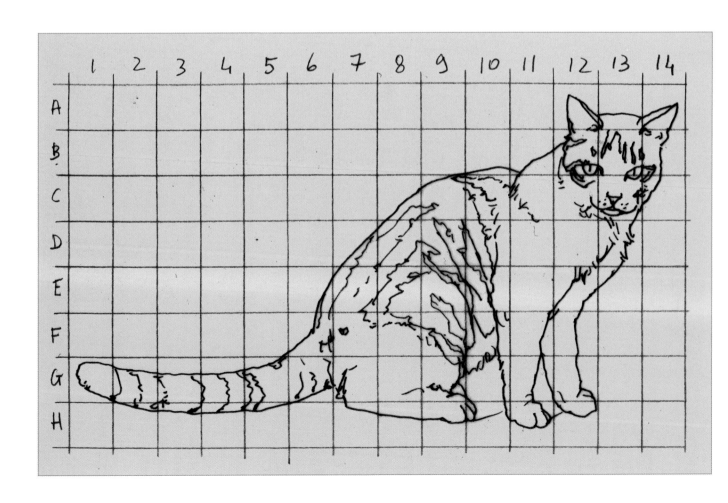

Tonal study

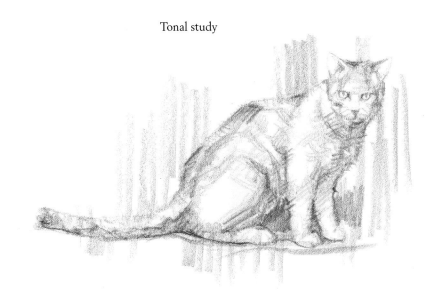

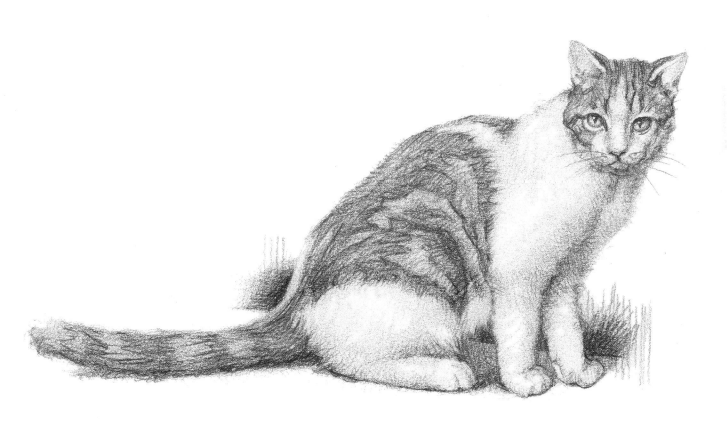

Step 1: Overall shape and size

Step 2: Structure and proportions

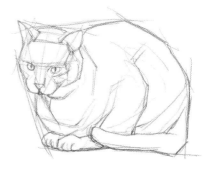

Step 3: Volume and shadows

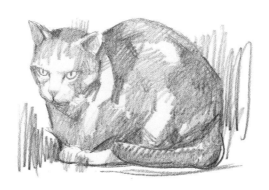

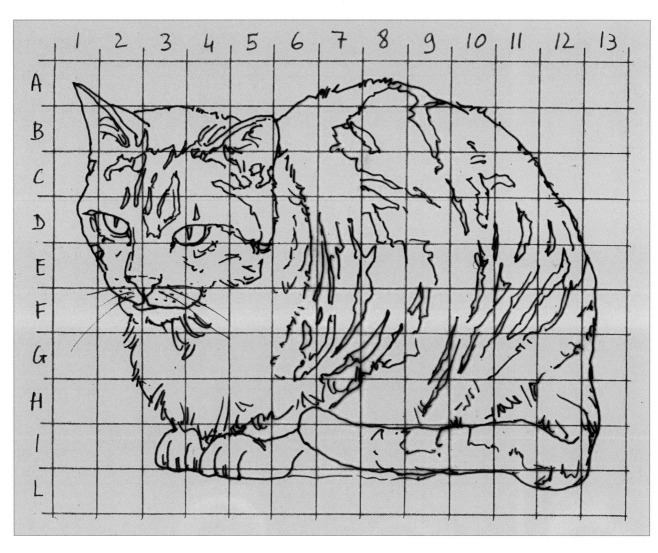

Tonal study

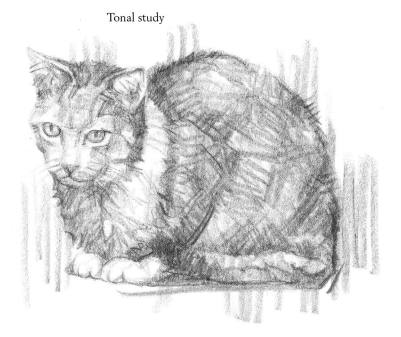

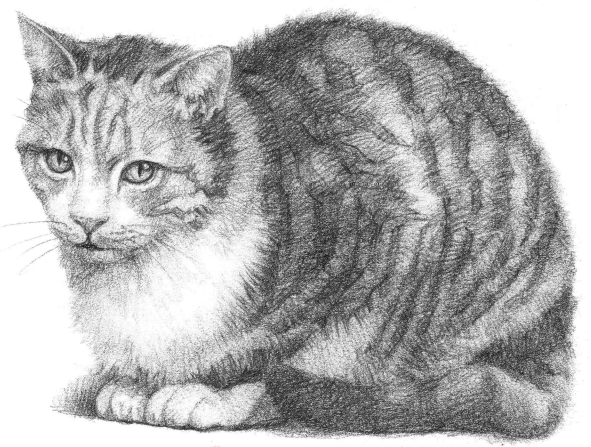

Step 1: Overall shape and size

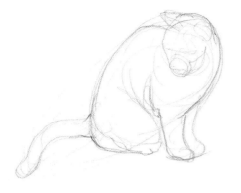

Step 2: Structure and proportions

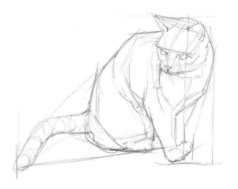

Step 3: Volume and shadows

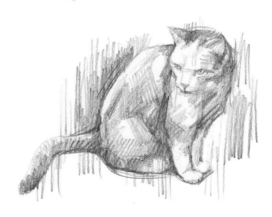

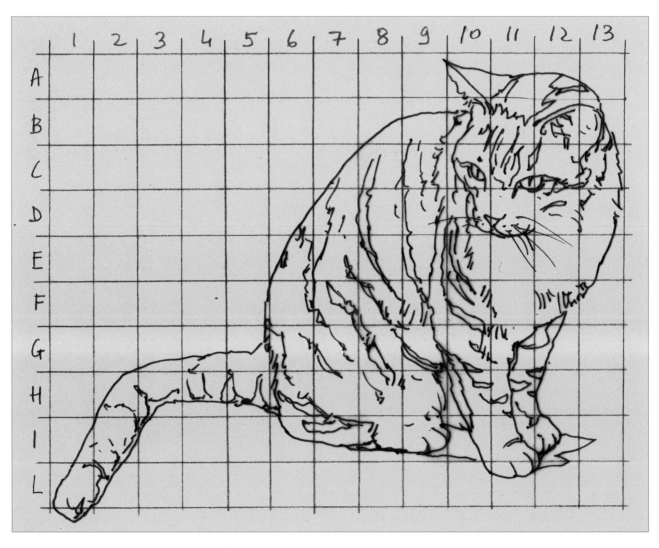

Tonal study

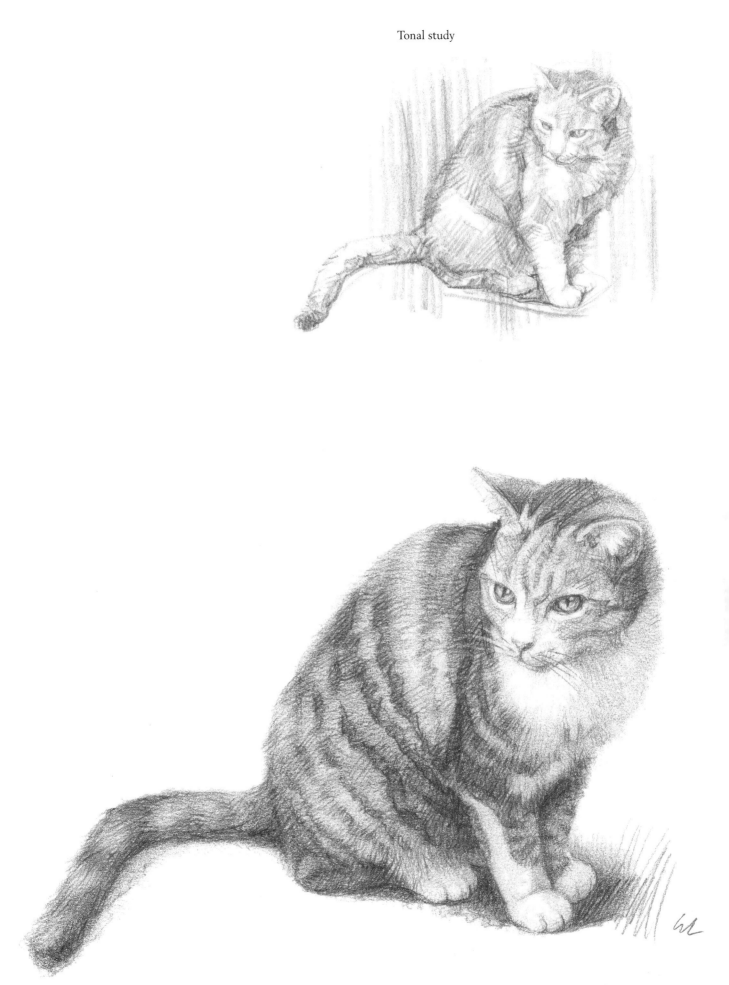

Step 1: Overall shape and size

Step 2: Structure and proportions

Step 3: Volume and shadows

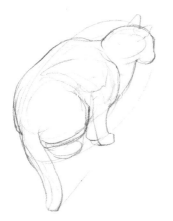

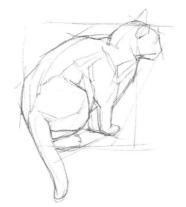

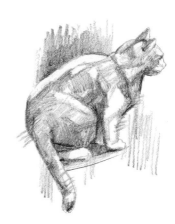

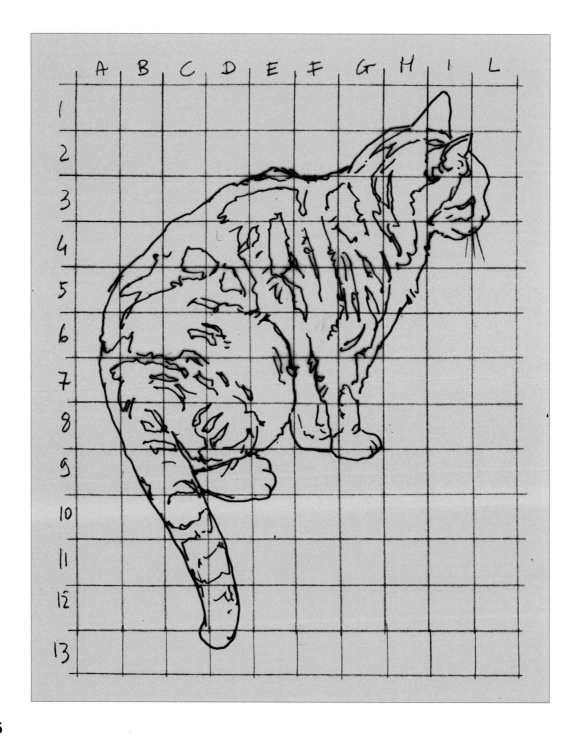

Tonal study

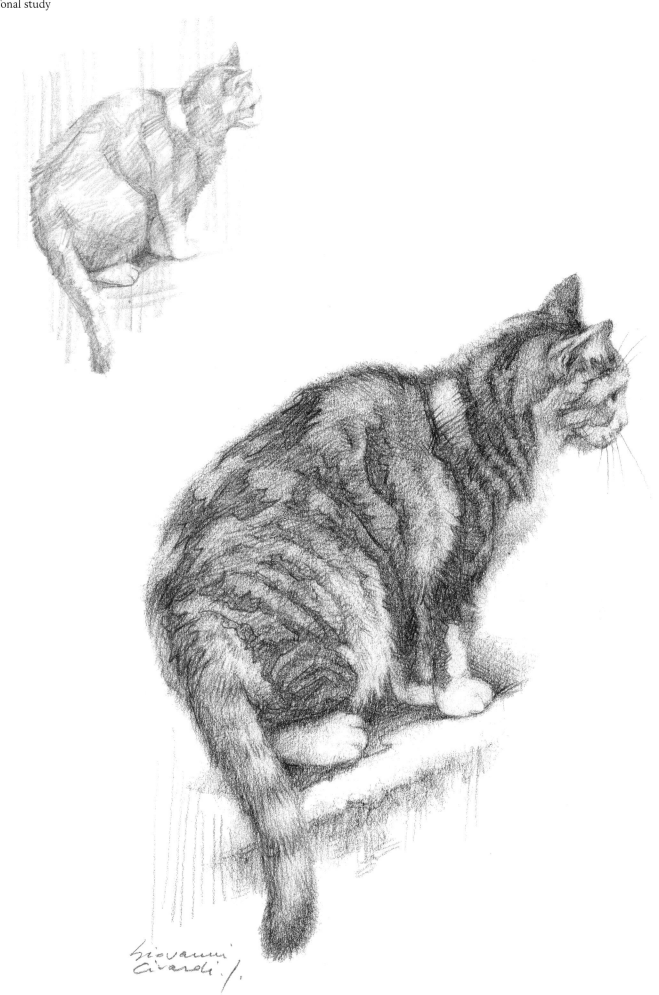

Giovanni
Civardi.

Step 1: Overall shape and size

Step 2: Structure and proportions

Step 3: Volume and shadows

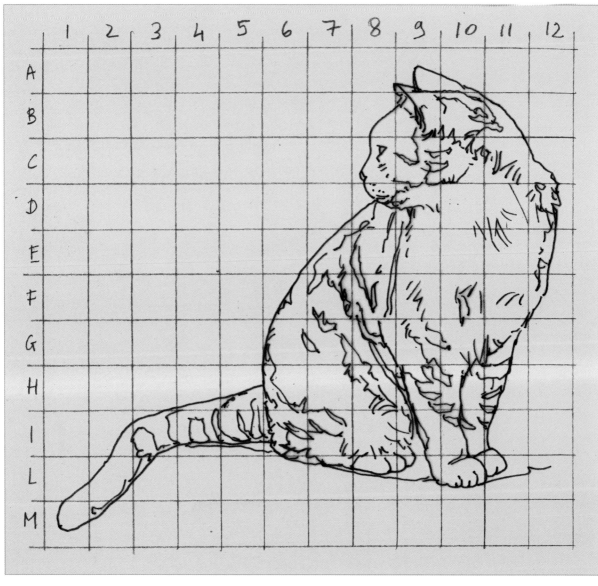

Tonal study

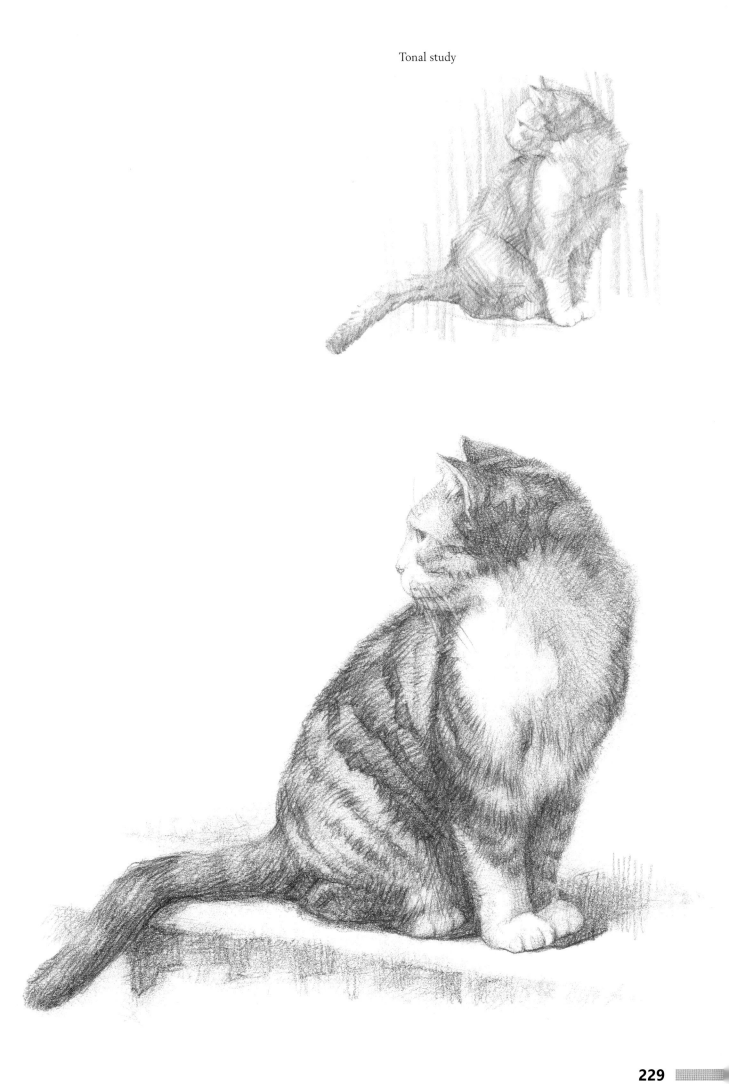

Step 1: Overall shape and size

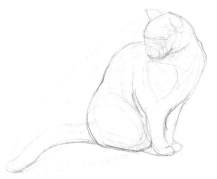

Step 2: Structure and proportions

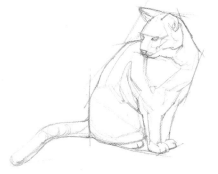

Step 3: Volume and shadows

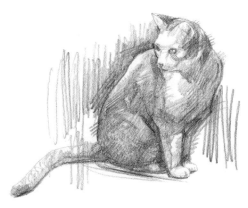

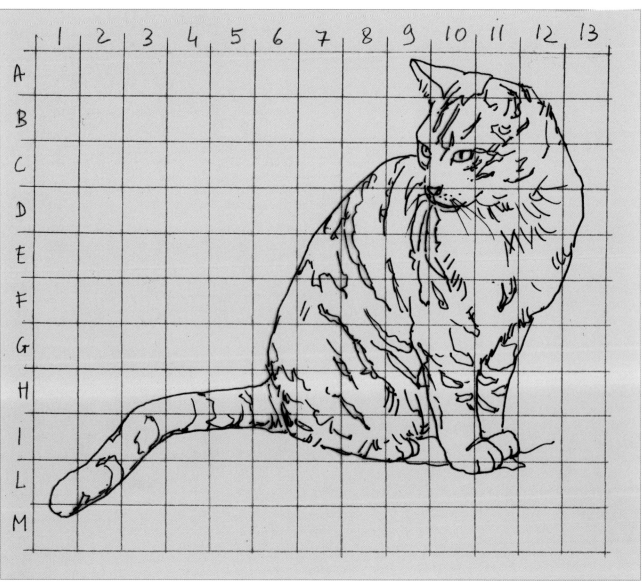

Tonal study

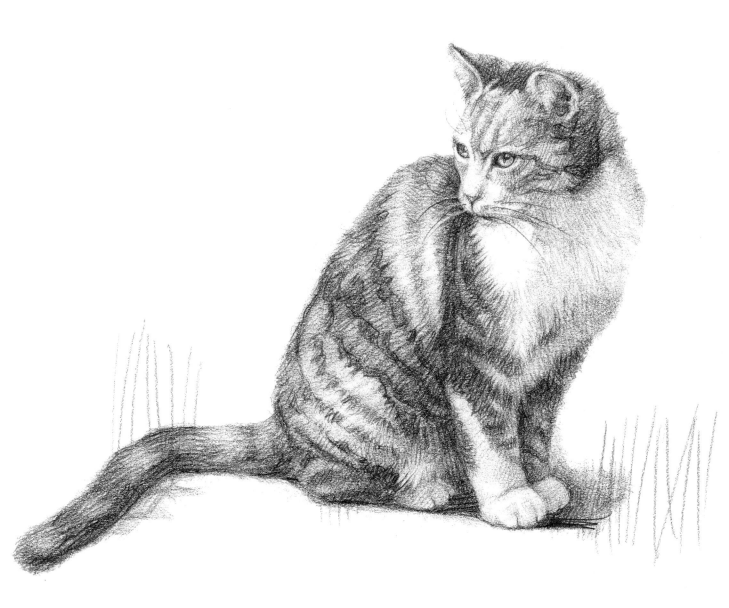

Step 1: Overall shape and size

Step 2: Structure and proportions

Step 3: Volume and shadows

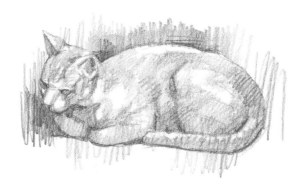

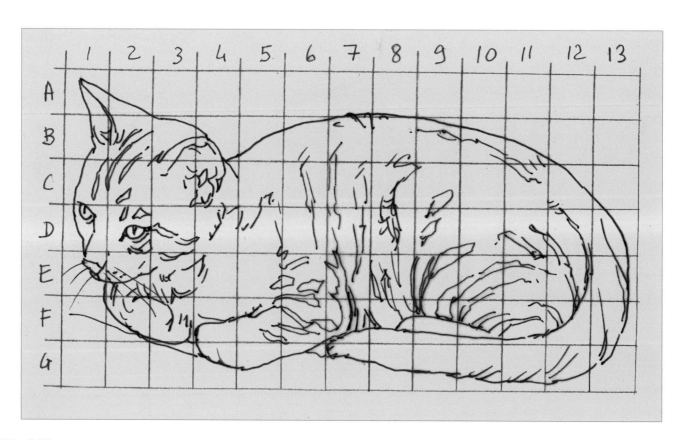

Linear study

Tonal study

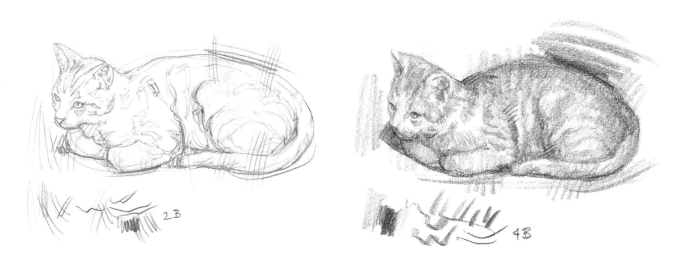

2B

4B

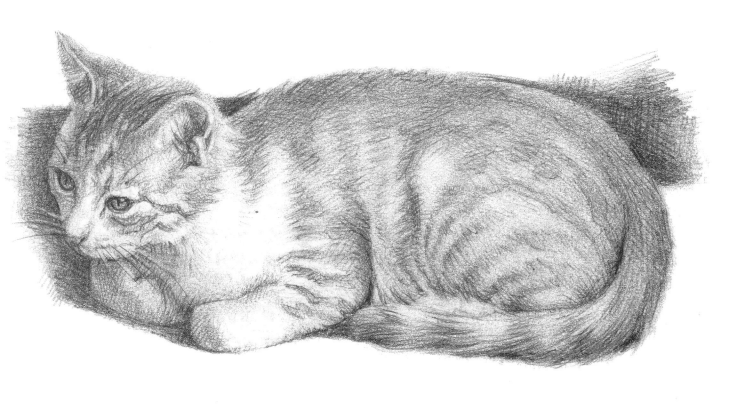

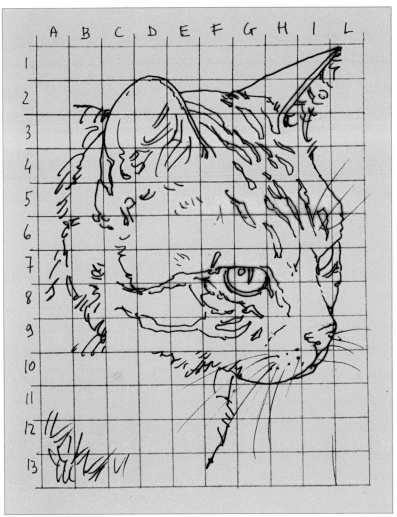

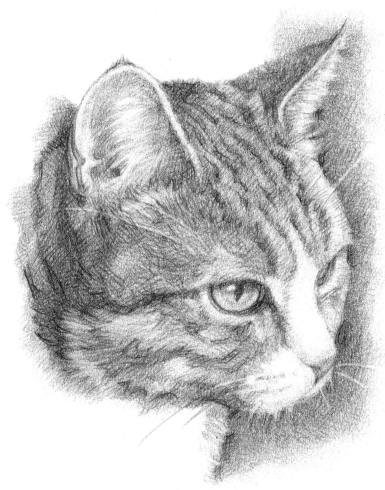

234

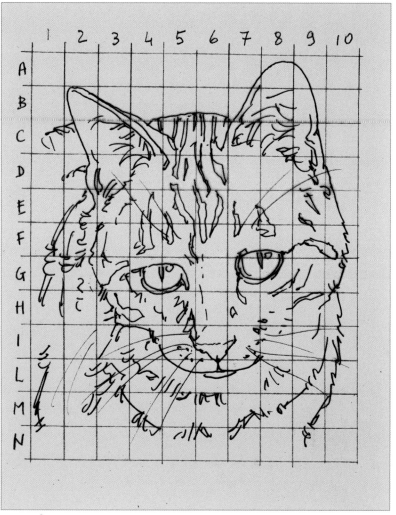

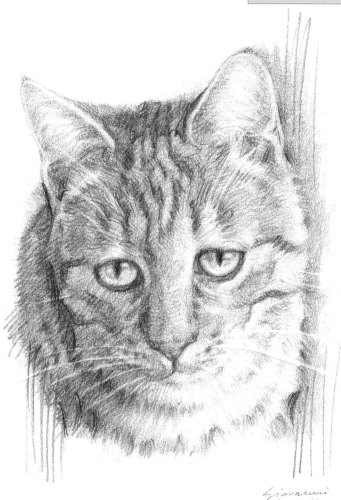

Step 1: Overall shape and size

Step 2: Structure and proportions

Step 3: Volume and shadows

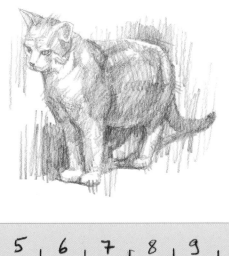

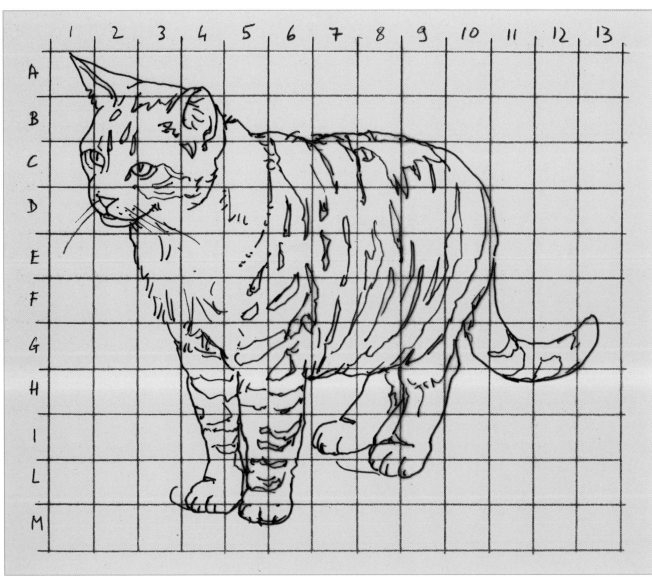

Tonal study

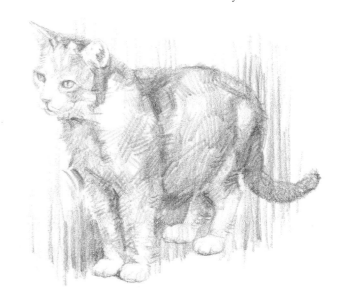

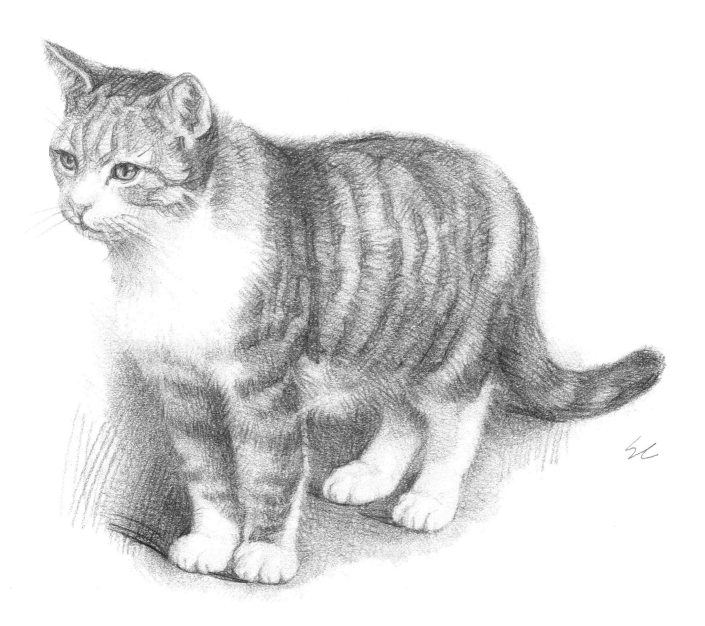

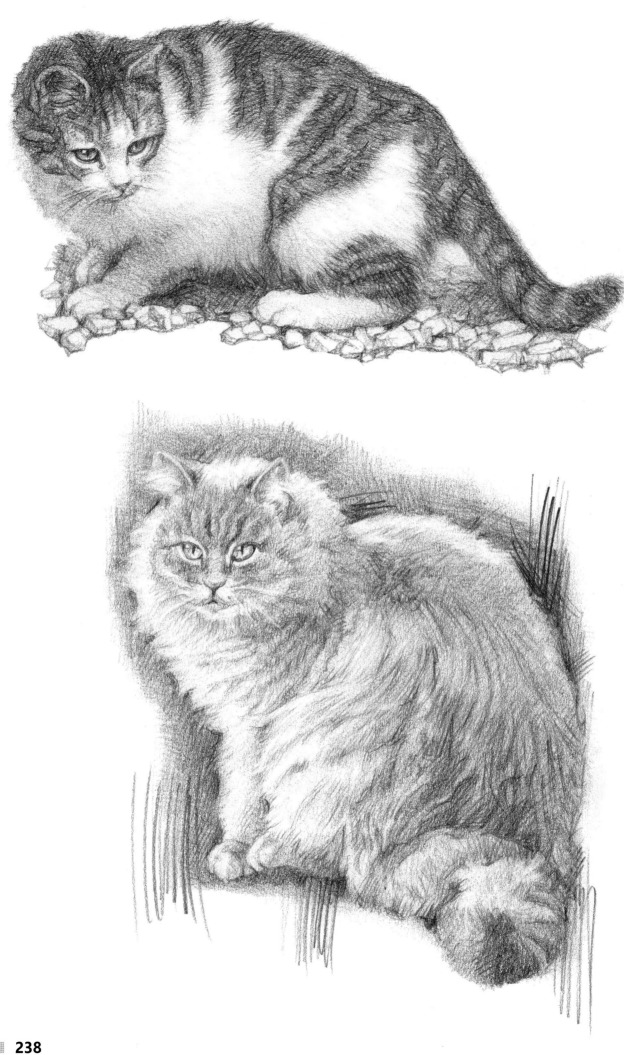

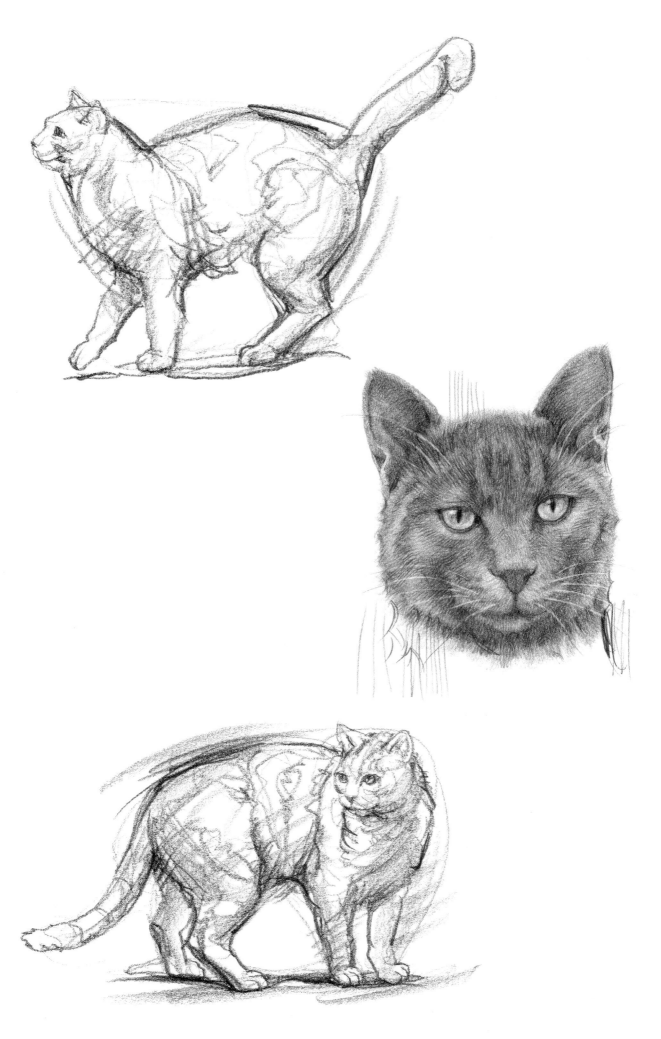

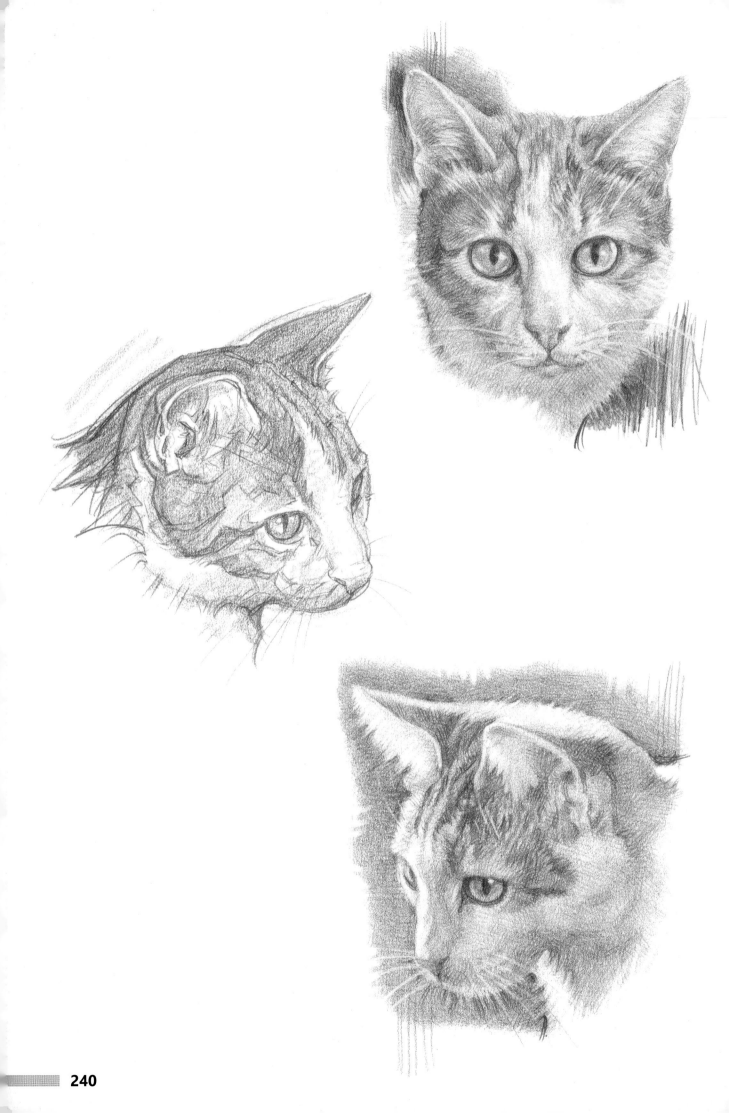